Picturing

★ TEXAS ★

POLITICS

FOCUS ON AMERICAN HISTORY SERIES
The Dolph Briscoe Center for American History
University of Texas at Austin
Don Carleton, Editor

Picturing
★ TEXAS ★
POLITICS

A Photographic History from Sam Houston to Rick Perry

CHUCK BAILEY

Historical Text by
PATRICK COX

Introduction by
John Anderson

UNIVERSITY OF TEXAS PRESS 🐂 AUSTIN

Publication of this book was made possible in part by support from Clifton and Shirley Caldwell and the National Endowment for the Humanities.

Requests for permission to reproduce material from this work should be sent to:
 Permissions
 University of Texas Press
 P.O. Box 7819
 Austin, TX 78713-7819
 http://utpress.utexas.edu/index.php/rp-form

∞ The paper used in this book meets the minimum requirements of ANSI/NISO Z39.48-1992 (R1997) (Permanence of Paper).

Library of Congress Cataloging-in-Publication Data

Bailey, Chuck L., compiler.
 Picturing Texas politics : a photographic history from Sam Houston to Rick Perry / Chuck Bailey ; historical text by Patrick Cox ; introduction by John Anderson. — First edition.
 pages cm — (Focus on American History series)
 Includes bibliographical references and index.
 ISBN 978-1-4773-0254-5 (cloth : alk. paper)
1. Texas—Politics and government—Pictorial works. I. Cox, Patrick L., 1952–, writer of added text. II. Title. III. Series: Focus on American history series.
 F391.B2115 2015
 320.09764—dc23
 2014047947

doi:10.7560/302545

To my wife Sharmon and
my daughters Sara and Catherine

CONTENTS

PREFACE

A pictorial history should be just that, a chronology of people and events as captured on film or with other, newer technology. A written history can be supported by illustrations, including photographs, but in a pictorial history it is the image that tells the story. A photograph takes a story from the mind's eye and puts it before the actual eye. In a glance, the image tells who, what, where, and when.

In Texas, photography began about the same time as the birth of the Republic. So, while there were no war photographers at the Alamo or San Jacinto, they arrived soon after to immortalize, on film, Sam Houston, David G. Burnet, Mirabeau B. Lamar, and many other founding fathers of Texas. The children of William B. Travis and Sam Houston and the nephews of Stephen F. Austin were photographed so that the echoes of the past could be preserved.

But this book is more than echoes of the past. Through photography, the military, social, and political history of Texas has been recorded. As if looking through a time machine window, you can glimpse Santa Anna, Edward Burleson, Houston, and Lamar, and remember that they were actually at the Battle of San Jacinto. Jim Hogg, the first native Texan to serve as governor, was bigger than life, and equally impressive were the unique paths blazed by Henry B. González, Mickey Leland, and Minnie Fisher Cunningham.

Power and political savvy are readily apparent in the images of Lyndon B. Johnson and Bob Bullock. The photos of the Hobby and Bush families show an unmatched dedication to Texas. And, of course, the pictures of Ann Richards, Barbara Jordan, and Kay Bailey Hutchison show the growing influence of women in the political world.

The book is divided into four chronological chapters. The early years, through the Civil War and Reconstruction, primarily consist of formal, non-smiling portraits of Texas leaders. The second chapter, on reform and growth from the nineteenth century to the twentieth century, illustrates the

movement of the camera out of the studio and into the political world at large. The third chapter covers Texas from the 1930s through the Great Depression and World War II. Photography had begun to show campaigning, the family life of politicians, and the growth of politics throughout the entire state. Finally, in the modern era, photography exploded into new political territory thanks to ever-expanding technological advances. Photos can be altered, as demonstrated by the Lyndon Johnson campaign in 1941 when a photograph of Johnson, Governor James Allred, and Franklin Roosevelt was changed to take Allred completely out of the picture. Now, with photoshopping, editing, and other technological advances, photography offers abundant new opportunities to politicians and their campaigns. But that is a subject for another place and time.

The scope of the book is limited to politicians and campaigns. Political movements and causes, the day-to-day operations of the Texas Legislature, and other political events are, and by and large, not part of this book. The images reflect important, colorful politicians, both well known and not so well known, at work, on the campaign trail, or at home. In photos showing them shooting guns, eating watermelon, riding horses, smoking cigars, and wearing boots, these men and women clearly show that they are Texans.

The book was vastly improved by the succinct and thoughtful writing of Patrick Cox. He brought an academic background and a popular storytelling style to his descriptions of the images, allowing them and their eras to come to life. As Patrick's writing shows, he understands Texas, its history, and its leaders. The book would not be what it is without his contribution.

Photographs show a time that has passed. And like the photos themselves, the political world is transitory. If any current politicians think otherwise, they need only look at the images in this book.

ACKNOWLEDGMENTS

The gathering of materials for this book resulted in a much larger project than I anticipated, so I have a lot of folks to thank.

The guidance and patience of my editors, Allison Faust and Casey Kittrell, kept me focused and on track when I verged on becoming obsessed with finding every Texas political photograph in existence. A special thanks to Dave Hamrick, who now occupies the right job at UT Press.

The staff at many libraries, universities, and museums made the project much easier than it otherwise would have turned out. Thanks to the following: Beth Steiner at the Moore Memorial Library in Texas City, Ginger Frembling at the Bell County Museum, Geoff Hunt at the Texas Collection at Baylor, my good friend Ben Rogers at the Pogue Library at Baylor, Mike Miller at the Austin History Center, Aryn Glazier at the Dolph Briscoe Center for American History at the University of Texas at Austin, Tara Carlisle at the University of North Texas's Portal to Texas History, Tom Shelton at the University of Texas at San Antonio and the Institute of Texan Cultures, May Finch at the George Bush Presidential Library and Museum, and Randy Vance and Janet Neugebaur at the Southwest Collection at Texas Tech University.

Also, I want to thank Adrienne Pierce at the Dallas Public Library, Linda Briscoe Myers at the Harry Ransom Center, Anne Peterson and Cindy Boelke at Southern Methodist University's DeGolyer Library, Rick Whiteaker at the Port Arthur Public Library, Alice Specht at Hardin Simmons University, Karen Hagar at Lockheed Martin, Carol Myers at the San Diego History Center, Joel Durant at the Houston Public Library, Cathy Gonzales at the Associated Press, my friend Casey Greene at the Rosenburg Library in Galveston, Yolanda Logan at the Jimmy Carter Library, Cathey Spitzenburger at the University of Texas at Arlington, Samantha Dodd at the Dallas Historical Society, Lisa Hopkins at Southwestern University, and Margaret Harmon at the LBJ Library at the University of Texas at Austin.

A special word of thanks goes to Dr. David Carr and Dudley Morse for sharing family photos, and to my good friend and colleague Jack Wilson for his advice and help.

Thanks and appreciation go to the director of the Dolph Briscoe Center for American History at the University of Texas at Austin, Dr. Don Carleton. Governor Briscoe once told me that Don Carleton was the man to solve problems and, as always, he was right.

I appreciate, more than she knows, my friend and coworker Angela Dunn, who, along with Dorothy Hasty and Julie Neal, translated my handwriting.

I want to thank Patricia Nuhn for her patience, common sense, and ability to navigate the technical side of publishing. Without her help I would still be trying to figure out "downloading."

Thanks to my high school classmate Margaret Johnson, who is, without a doubt, the premier visual materials consultant in the United States.

Finally, thanks to John Anderson both for his insightful essay on political photographs and for helping me negotiate his world.

Picturing

★ TEXAS ★

POLITICS

PHOTOGRAPHY
and
POLITICS

John Anderson

A s Edward Burleson's daughters tell it, they had traveled the short distance into town one day in 1850 and passed a photographer's studio.[1] Their father was unshaven and dressed "in his every day farm suit." General Burleson had served in the Second Congress, had been elected vice president of the Republic of Texas, and had run against Anson Jones for president of Texas, later serving as president of the Texas Senate pro tempore until the end of his life in 1851. From today's perspective, his curriculum vitae reads like that of a politician. But according to his cousin Rufus Burleson, the general was much more a statesman than a politician—and intentionally never had his photograph made until he gave in to his daughters' loving entreaties that day in San Marcos.

In 1887 Rufus Burleson recounted his late cousin's "utter disregard of notariety [*sic*] or rather his unutterable contempt for seeking fame," and explained that Edward had not had his photographic likeness made because "he had such contempt for all the tricks and artifice that little souls rise [*sic*]

to magnify themselves . . ."[2] That day in San Marcos, Edward Burleson bent to family politics, if no other politics, and sat for the iconic daguerreotype portrait now held in the Texas State Archives.

Ten years later, in 1860, William DeRyee set out on a different venture— to photograph all the major figures in Texas state government in Austin. A Bavarian by birth, DeRyee was an inveterate experimenter, an inventor, a miner, a chemist, and an entrepreneur. He began experimenting with photography in New Braunfels in the late 1850s—in the twentieth century we might have said he "caught the bug"—and he soon became a successful commercial photographer in San Antonio.[3] DeRyee's partner for the Austin project was R. E. Moore, a person about whom we know little, though he may well have been the R. E. Moore practicing photography in Houston in the late 1850s.[4]

As accomplished and skillful as DeRyee and Moore may have been, they had their work cut out for them. Wrangling more than 120 Texas senators, representatives, and other officials to sit for portraits is a formidable task in any era. Governor Sam Houston, infamous for his mercurial temperament, might have been one of the easier subjects. Among the multitude of activities Houston seemed to enjoy in life was creating a costume and a character. Whether it was simply what he had put on the day of the sitting or something he consciously chose to wear for the portrait, Houston turned out in a vest made from a jaguar pelt.

The fruit of DeRyee and Moore's work was *The Texas Album, of the Eighth Legislature, 1860,* of which only a few copies are known to exist today.[5] Though inexpensively printed and bound, this very limited-edition album featured actual photographic prints of the stunning portraits hand-pasted onto pages opposite printed text.

Egos, personalities, and other human dynamics involved in the *Texas Album* project aside, simply making the photographs was a difficult and tedious job. Though on its way to extinction in the twenty-first century, in 1860 photographic film was still twenty-five years from making its appearance as a practical and reliable tool. Using somewhat uncomfortable exposure times, photographers captured portrait images on sheets of glass "plates" prepared by coating them with a syrupy light-sensitive emulsion in the dark. Where the photographers set up their light-tight "darkroom" wagon, or tent, and backdrop that served as a studio for the project is unknown. We can imagine it might have been in, or at least at the site of, the old limestone Capitol (which survived the Civil War, but burned in 1881), where the present, magnificent pink-granite Capitol now stands.

These 1860 portraits were made as events steadily unraveled to push Texas to the brink of secession and the United States to civil war. Sam Houston's opposition to secession ended his governorship in March of 1861, when he resigned and was replaced by Lieutenant Governor Edward Clark.

Though superficially, perhaps, it is merely a compilation of individual

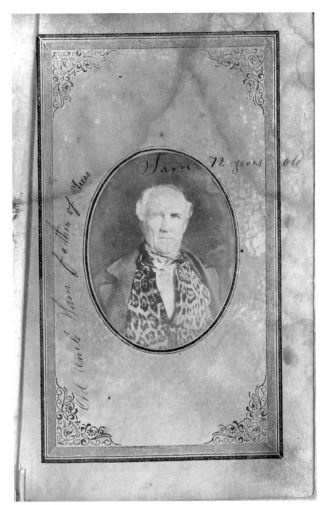

From The Texas Album, of the Eighth Legislature, *1860. Left, Sam Houston. Right, the title page.*

portraits, *The Texas Album, of the Eighth Legislature, 1860* is arguably the first significant work of Texas political photography.

Included among the portraits are many notable subjects. Former governor Hardin Runnels and ex–lieutenant governor Francis Lubbock were at least pragmatic proponents of conscription, a devastatingly bitter hardship for Texans. James W. Throckmorton was one of the few delegates to the Secession Convention who voted against secession, but he went on to serve Texas and the Confederacy loyally. Senator Martin Hart resigned the legislature after secession. Though an outspoken opponent of secession, he was awarded a Confederate officer's commission and formed a company in Arkansas. Hart later turned his forces against the Confederate cause and was ultimately tried and hanged in Fort Smith, Arkansas, in 1863.[6] Also a Unionist, John Leal Haynes fled to Mexico, subsequently served in the U.S. cavalry, and survived the war.[7] For every man pictured in the album, there is a story of how that person's life and career were interwoven with the most chaotic and destructive political events in U.S. history.

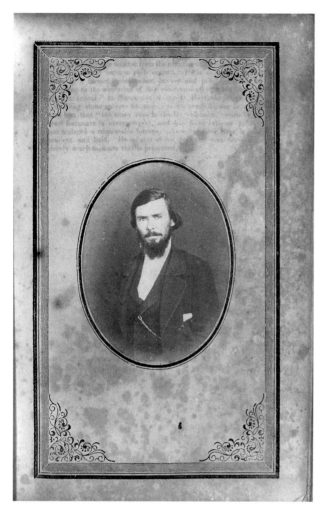
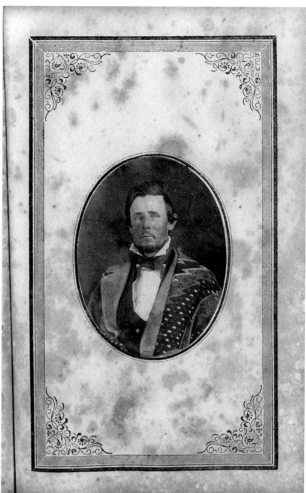

Both photographers and non-photographers, at least ones given to such amusements, have often engaged in squabbles about the semantics of whether photographs are *made* (planned and crafted) or *taken* (conveniently plucked from reality). Preeminent twentieth-century photographer Ansel Adams consistently spoke of making photographs. Using a musical analogy, he compared the negative to the composer's score and the print to the orchestra's performance. For photojournalists on assignment in a fast-moving world, the balance of photos made and taken probably shifts with the circumstances of the day.

William Crawford, who has written extensively on the syntax of photography, reminds us that "the photographer can only do what the technology available at the time permits . . ."[8] We remember DeRyee tediously making his own cumbersome wet plates in a makeshift darkroom. That era steadily gave way to commercially produced glass "dry" plates, faster emulsions, flexible film, portable cameras, interchangeable lenses, flash bulbs, strobes, electronic light metering, motor drives, and now digital photography. Details of the technical advances seen to this day are almost endless.

From The Texas Album, *of the Eighth Legislature, 1860. Left, Martin Hart. Right, John Leal Haynes.*

The successful photographer is likely the one who best understands and exploits the tools available when photographic opportunity arises. We don't know that much about many of the early photographers represented in this book, but talking with twentieth- and twenty-first-century photographers gives us some insight into what it took to get the photos.

Bob Thomas's formal photographic career began in the U.S. Marine Corps; later he spent over thirty years with United Press International in Dallas, Denver, and Austin. His photojournalism career ended when UPI closed the Austin Capitol Bureau, owing him at least one paycheck. When Thomas started out working for UPI in Dallas, photographers were using large press cameras, usually the Speed Graphic or Crown Graphics models. They were called "4×5s" because they used thick 4-inch by 5-inch sheets of black-and-white film loaded by the photographer into reusable holders. Thomas soon began using a lighter and faster 35mm camera that he purchased himself. A man of few words, Thomas modestly attributed his success as a news photographer to being "steady and reliable."[9]

Retired Associated Press photographer Harry Cabluck got the bug as a teenager and learned darkroom fundamentals from an uncle when he was about fourteen. When Cabluck started "chasing wrecks" in Fort Worth he had probably never heard of Arthur Felig ("Weegee"), the legendary New York street photographer, but to some degree Harry became an energetic, younger, Texas version of Felig. The Cabluck family business was running a tow truck service, so Harry had access to accident calls years before police radio scanners were commonly in use. It didn't hurt that he gave photos to the police department gratis. His self-assigned work paid off when he sold his pictures of a major auto collision to an insurance company and made enough money to pay for a semester of college tuition. Eventually Cabluck's photography got the attention of Fort Worth's *Star-Telegram*, which led to his thirty-year career with the AP.

Cabluck is a delightful mix of technician, curmudgeon, and teddy bear. He talks expansively about the details of making the fastidious color separations that he would send out on the wire. He says he worked well with almost everyone he encountered in his assignments and travels throughout his career. When asked if there were any exceptions, he shakes his head in puzzlement, still not understanding his inability to connect with the Ohio politicians at one of his posts, the statehouse in Columbus. At the end of that stint, he relished coming back to Texas and working at the Capitol. "The best thing they [politicians] can do for you when you are photographing is ignore you," he claimed. Summing up his career, he said, "In the end, I always let the camera do the talking."[10]

I handed Cabluck copies of some Russell Lee photos being considered for inclusion in this book. After holding and studying each of the prints silently, he finally smiled, shook the prints enthusiastically, and voiced approval. He

said he was fortunate to have met and worked with Lee at Cliff Edom's Missouri Photo Workshop. When I asked him how he thought Lee was able to make such intimate photos of everyday people at political events he said that "Lee respected people"; he tried to put himself in their place and used his camera accordingly. He suggested that Lee was probably holding and operating his rangefinder camera in a less confrontational way—lower and closer to his chest—to get more natural and candid photos. "Russell Lee didn't go charging in," he said.

Animated, Cabluck went on, saying, "The young people call themselves *shooters*, not photographers." Cabluck is not the only photographic thinker to note semantic differences with regard to photography, tied to changes in technology. Susan Sontag, the filmmaker and photography philosopher and essayist, has observed, "There is an aggression implicit in every use of the camera."[11]

In addition to the encouragement of her ex-husband, Austin photographer Ave Bonar credits Russell Lee with sparking her career in photojournalism. She says that Lee worked to preserve the dignity of those he photographed during the hard times of the Farm Security Administration (FSA) project. Bonar studied and admired Lee's subsequent photos of progressive Ralph Yarborough's unsuccessful 1954 campaign for governor. She later met a highly motivated young photographer, John Van Beekum, who had taken time off from school in 1972 to capture an impressive account of Ben Barnes's failed run for governor. Bonar almost literally missed the boat when her own chance came, to cover Ann Richards's 1989 kickoff.[12] In the end she built a profoundly intimate portrait of Richards's campaign for governor against opponent Clayton Williams.

I asked Bonar, a thoughtful and soft-spoken woman, if she ever had to fight for a photo during the Richards campaign.[13] Normally, Bonar carefully choreographed her movements to lithely slide through a crowd to get to where she needed to be, but even as the official photographer she couldn't always predict where and how the candidate would enter and move within a room. At the Dallas luncheon where Richards and Williams infamously collided, she found herself pressing through the crowd in frantic determination, while, to Bonar's disbelief, another photographer, also a woman, pulled her back by the collar and tried to gain the advantage.

Bonar made it to the fateful spot where Richards and Williams met, and where Williams refused to shake the hand of his lady adversary, possibly losing the election due to his breach of Texas etiquette.

At another "meet the candidate" event in Victoria, a TV cameraman flagrantly hipbumped Bonar away from his position. In a rare display of ire Bonar solidly bumped him back, only to learn later that they were on the same team; the cameraman had been hired to provide video for the Richards's camp.

Bonar says that Russell Lee's mentoring awakened her talent for seeing

and portraying the truth in the photos she makes, and that her relationship with Ann Richards honed that ability. She mused that she is still more comfortable photographing people she knows, but, when pressed, allowed that she has steadily learned to sort out the truth in images of all the subjects she photographs.

For more than twenty years, Bill Malone was the Texas State Archives' contract photographer and, in that capacity, had photographed the administration of every governor from Preston Smith to Ann Richards before his retirement in September of 1991.[14] Over the years Malone charmed his way into the Governor's Mansion; onto the floor of both chambers of the legislature; into countless parties, galas, and events; and into his spot in the governor's public reception room in the Capitol where legislation and proclamations are signed and constituents and VIPs are ceremonially greeted.[15] Malone's medium-format "two and a quarter" roll film camera was worn, clunky, and badly outdated, but he knew the focus, depth of field, and flash settings for any event in the room by touch.

A younger-generation video journalist recounted how he had snagged a front-and-center spot in the reception room for a major, newsworthy bill signing many years ago, when he was just starting out on Capitol assignment. Bill Malone—tall, angular, dignified, and always smartly dressed in a good, if creased and pipe-tobacco-fragranced, suit—arrived only moments before the event was to begin. Malone eased up to the young TV cameraman, looked down at where the lad's feet were planted, and with a smile, but with authority in his deep voice, explained gently, "This is where I shoot."

Bill Malone's successor Bill Kennedy observed, "Malone made photography [around the Capitol] into a utility—something as reliable as flicking a light switch." Or maybe you didn't even need to flick the switch. A former administrator of the Governor's Mansion once vented to me with frustration (and some vitriol) that when Bill Malone was the archives' photographer, you didn't need to call him, you didn't need to schedule or arrange for him to be at an event . . . he just appeared, and made wonderful pictures that everyone liked, regardless of their politics, and everyone was happy.

In September of 1992 Richards was already eighteen months into her term and Kennedy had been on the Archives beat for a year. Inspired by Ave Bonar's in-depth coverage of the Richards's campaign, Kennedy and I needed to establish some behind-the-scenes photographic access to an administration that had pretty much ignored the archives. For a start, we had been working to lock in an appointment to make the official Archives photo portrait of Governor Richards, at an exclusive sitting in the comfortable privacy of the Governor's Mansion.

We were delighted to get the appointment on a Sunday morning in September, but it turned out not to be the exclusive audience with the governor that we had somewhat naively hoped it would be. The archives' time slot followed

Richards's extended family Christmas photo shoot, which included small children and an irritable governor. The story had just broken the night before that Lena Guerrero, Richards's handpicked interim appointee to the Texas Railroad Commission and now candidate for a six-year term, had not graduated from the University of Texas as she had claimed on her résumé.

Governor Richards, as the expression goes, was "no one's sweetheart" that morning. She clattered headlong down the stairs and into the parlor on her high heels, then demanded to know what this photo was about. I answered that it had become a tradition to do an exclusive, official photo portrait for the archives. She sat down in a chair, calmed herself for a moment, and then said she was very interested in libraries and archives and that we had five minutes to make the photo. It was more like two or three minutes at best. I held a small flash strobe on a cord at arm's length over my head and Kennedy carefully clicked off a couple of frames, but almost immediately her campaign press secretary Chuck McDonald entered the room, ready to whisk the governor off to an impromptu damage control meeting.[16]

Kennedy and I had stashed all the portrait lighting gear we had not had the opportunity to use that morning beneath the west bank of windows in the small family dining room at the back of the mansion. We were doing our best to shake off what had just happened and had gone back to pick up the equipment when we saw a dramatic subject framed in the window that looked out onto the veranda. Richards was sitting at the metal patio table with two of her closest advisers, McDonald and Governor's Office Press Secretary Bill Cryer. The gravity of the crisis of confidence was evident on the advisers' faces. Then the governor buried her head in her hands.

Kennedy and I looked at each other quickly and, in seconds, weighed the question of whether he should snap the picture, a photo that was there begging to be taken. We agreed not to. The archives had been given an appointment to make a specific portrait. If Richards and her high-level staff, only a few feet away, saw us take the photo, we might jeopardize future opportunities for critical historical access.

At this writing, Ann Richards and Lena Guerrero have been gone for some time, McDonald and Cryer have graduated to other successful careers, two governors have succeeded Richards, and several railroad commissioners have completed their terms of office since that Sunday morning. In hindsight, of course, I wish we had made that photograph, or even taken a snapshot with the quiet-shutter rangefinder camera that Kennedy had in his bag. Even a grabshot of that scene for the archives would have informed scholars, researchers, and political junkies of later eras. With the distance of time, it would not be so much a political photograph as a document of the anguish of leadership.

Chuck Bailey has nurtured a lifelong passion for politics, especially, of course, Texas politics—a passion that is informed and devoted. In his

overlapping careers as an attorney, prosecutor, lobbyist, chief of staff for the irascible Bob Bullock, and discriminating collector, any native naiveté he may have had about politicians evaporated long ago. What Bailey has cultivated in his work seems to be an almost pure appreciation for the process and trappings of politics.

The many pictures that Bailey has selected for this book are extraordinary examples of Texas photography, images not only political but also remarkably human. This is a collection of photographs both *made* and *taken* by visionary photographers who exploited the technology available to them in their time.

Some of the photographers represented here are well known, while the names of others are already lost. Most of the photographers were steady and reliable. They strove to recognize the truth in their subjects and they captured that truth in their photos. For the most part, they were charismatic people who liked to get along, but they also did what they needed to get their shot. They found their spot and they let their cameras do the talking. We the viewers, the voters, the citizens, the Texans, are the ones who have benefited.

John Anderson
Preservation Officer, Texas State Library and Archives Commission

REPUBLIC OF TEXAS
to
CIVIL WAR
and
RECONSTRUCTION

W e have only a written record of Texas's earliest history, from the Spanish and Mexican colonial eras through the Texas Revolution and early statehood. While Joseph Nicéphore Niépce created the first photograph a decade prior to the Texas Revolution, no photographs from the Texas colonial or revolutionary periods exist. No photographers were present to record Stephen F. Austin signing agreements with the Mexican government to issue land grants. We can only visualize Sam Houston signing the Texas Declaration of Independence with his famous, "I am Houston." No photographic images exist of William Travis, James Bowie, or David Crockett fighting and dying at the Alamo.

Texas declared its independence from Mexico in 1836. After disasters at the Alamo and Goliad, and a long retreat, a force led by Sam Houston defeated Santa Anna, the president of Mexico and the leader of its army, at San Jacinto on April 21, 1836. Following the Texans' victory, the Republic of Texas existed for nearly a decade prior to its annexation by the United States. The infant

republic endured and awaited admission into the United States as the nation debated the extension of slavery and the admission of slave and free states.

Around this time, we begin to see some faint images of the people and places of the era. A lifelike portrait of Stephen F. Austin was taken before his untimely death in 1836. A miniature photo of Lorenzo De Zavala and images of his granddaughter Adina provide more information about these two early Texas citizens. A shadowy 1849 daguerreotype of the battle-scarred Alamo chapel provides one of the first pictures of the shrine and one of the earliest known photos taken in the state.

Beginning with the era before the Civil War and the decades that followed the great American conflict, photographs of Texas and Texans became a larger part of the historical record. No one was photographed in Texas more than Sam Houston, the hero of San Jacinto. Houston became president of the Republic of Texas and a U.S. senator when Texas joined the Union, and was elected governor on the eve of the Civil War. A flamboyant dresser and the best-known (and often reviled) Texan of his era, Sam Houston enjoyed having his photo taken and distributed throughout the state. His old opponent Santa Anna, who survived the Texas Revolution and overcame that defeat to lead the Republic of Mexico again, also had his picture captured for posterity. Before and after the Civil War, many Texas leaders, including Mirabeau B. Lamar, José Antonio Navarro, Albert Sidney Burleson, David G. Burnet, Thomas Jefferson Rusk, James Pinckney Henderson, and Hardin Runnels (the only politician to defeat Sam Houston in his illustrious career), preserved their legacy through photographs.

THE CIVIL WAR

As the Civil War approached, political leaders made fateful decisions to stay loyal to the Union or support secession and join the Confederacy. Houston, Burnet, Andrew Jackson Hamilton, Elisha M. Pease, and Edmund J. Davis sided with the Union. Supporters of secession who became political leaders in Confederate Texas included Lieutenant Governor Edward Clark (who succeeded Sam Houston when the legislature removed him as governor for his refusal to take an oath of allegiance to the Confederacy), Francis R. Lubbock, Oran M. Roberts, John H. Reagan, Pendleton Murrah, Louis T. Wigfall, and W. S. Oldham.

Texas, as the westernmost state in the Confederacy, became the last of the Confederate governments to fall at the end of the Civil War. Governor Murrah and other state and military officials fled south to Mexico in the summer of 1865. Andrew Jackson Hamilton became the first governor of Texas in the Reconstruction era—a difficult time for former Confederates and loyal Unionists alike, as well as for the thousands of newly freed slaves in the state. Many prewar political leaders returned to support efforts by the federal government

to restore order and provide protection and opportunity for African Americans. But the times were filled with racial tensions, resistance to military occupation by U.S. troops, and widespread lawlessness in many areas of the state. Prominent leaders in this era were Edmund J. Davis, Alexander Jackson Hamilton, James W. Throckmorton, John Salmon "Rip" Ford, Richard Coke, Oran M. Roberts, and Sul Ross.

Popular demand for photos increased dramatically during the Civil War. Americans wanted photographic images of family members who were involved in the war, thousands of whom were killed or wounded or never returned home. As a result of this interest, the number of photographers and studios soared, as did the publication of photos. Following the war, the commercial photography business grew throughout the country as people, businesses, and politicians began to understand the impact that an image could have on various audiences. Photographs of Texas political leaders from organized parties and political movements became more available.

RECONSTRUCTION

Republicans, led by Governor Davis and other supporters of Reconstruction, held power in Texas until 1872. In 1874, the election of a Democratic legislature followed by Richard Coke's narrow victory over Governor Davis effectively ended Reconstruction in the state. Initiatives to improve public education, bolster frontier defense, and provide protections for African Americans had been the centerpieces of Republican efforts to transform the state and the political system; however, most Anglo American Texans of this era opposed the public expenditures associated with these changes, and resented efforts to assist the former slaves.

Most of the reforms enacted during the Reconstruction period were overturned within a few years. The Constitution of 1876 severely curtailed the power of state government and elected officials. The state legislature would only meet in biennial sessions. The governor had limited powers, few appointees, and no control over other local or elected officials. Public education benefited from the establishment of a permanent fund receiving income from the sale of state lands. But funding for education came from a new poll tax of $1, no provisions were made for local *ad valorem* taxes, and segregated schools were established. While popular at the time for correcting the "excesses" of Reconstruction, the 1876 constitution failed to allow for transformation in a state that would grow and change in the coming decades. Reconstruction was barely over before new political challenges arose from a diverse group of Texans. These men and women desired more opportunity and land, protection from unregulated large corporations, an end to hostilities on the frontier, and improvements to the transportation and education systems in the state. A new era of reform soon descended on Texas.

Moses Austin Bryan

Moses Austin Bryan—the second son of Emily Bryan, the sister of Stephen F. Austin—was born in Missouri in 1817. Moving to Texas, he served as his uncle's secretary while Austin traveled in Mexico. He fought at San Jacinto and served as an interpreter for Sam Houston and Santa Anna after the battle. He was appointed secretary to the Texas delegation to Washington, took part in the Somervell Expedition, and was a major during the Civil War. Bryan died in 1895.

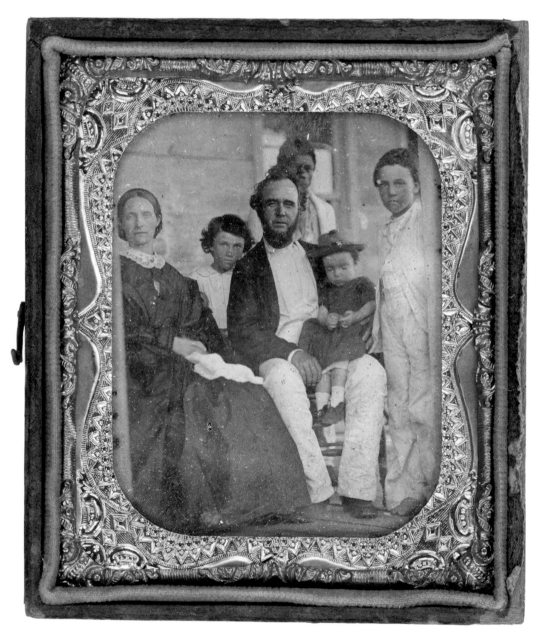

Moses Austin Bryan (1817–1895) and his family, circa 1850s.

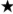

Guy Morrison Bryan (1821–1901) and his wife, Laura J. Bryan, circa 1860s.
(Note that Bryan is dressed in a Confederate uniform.)

Guy Morrison Bryan

Guy Morrison Bryan was the son of Stephen F. Austin's sister, Emily, and the younger brother of Moses Austin Bryan. While living in Brazoria County, he served as a courier and carried Travis's letter from the Alamo. He later served in the Texas House (1847–1853) and the Texas Senate (1853–1857). He was elected to the U.S. Congress in 1857 and served two years. He later returned to the Texas House and served as Speaker. He died in 1901.

Charles Edward Travis

Charles Edward Travis was a young boy living with a family in East Texas when his father, William Barret Travis, was killed at the Alamo. As an adult, he served in the Texas Legislature representing Hays and Caldwell counties, and later became a Texas Ranger. In 1855, he joined the U.S. cavalry as a captain but was disciplined for conduct unbecoming an officer while serving under Albert Sidney Johnston. Travis died in 1860.

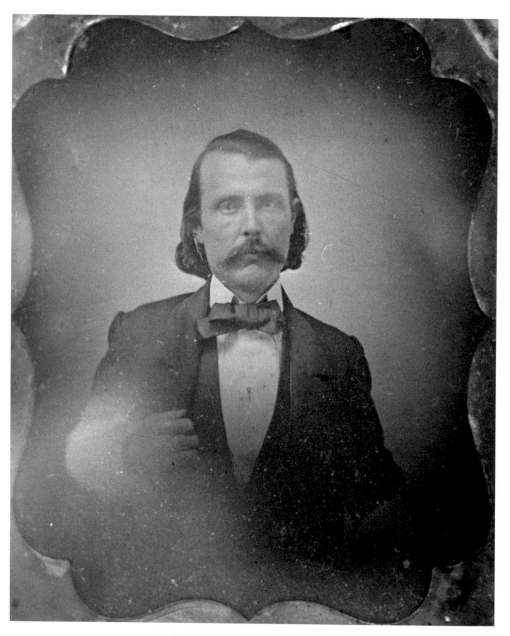

Charles Edward Travis (1829–1860), circa 1850s.

David G. Burnet

David G. Burnet, the first president of Texas, came from a political family back east. Through his mother, he was related to an American founding father, Gouverneur Morris; one brother was a U.S. senator from Ohio; and another was the mayor of Cincinnati, who sent the "Twin Sisters," a pair of cannons, to Texas, where they were used at the Battle of San Jacinto. (The cannons arrived before the battle and helped clear the way for the Texan charge. They disappeared after the war and their whereabouts remain a mystery to this day.) Burnet was elected president and served for eight months during the Texas Revolution. He was a vocal critic and opponent of Sam Houston. Burnet helped negotiate the peace treaty with Santa Anna and later served as vice president under Mirabeau B. Lamar. He died in 1870.

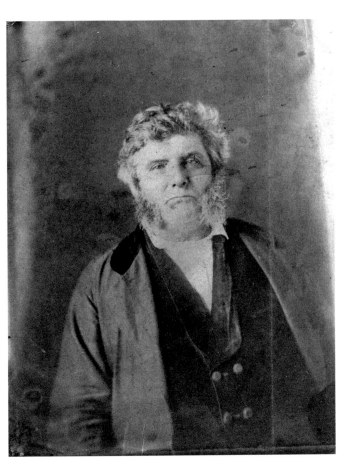

David G. Burnet (1788–1870), date unknown.

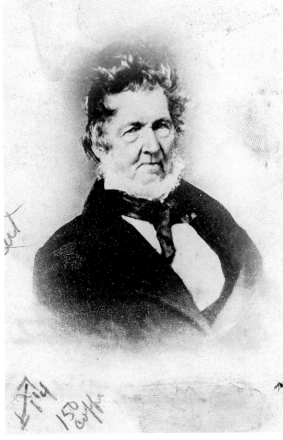

Photographed near the end of his life, Burnet maintained his sartorial splendor and sideburns.

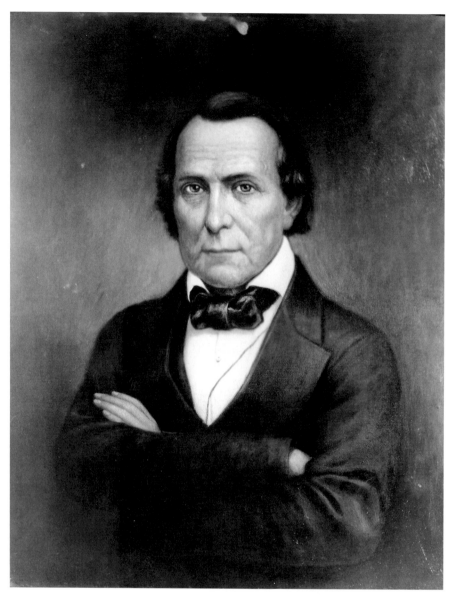

Mirabeau B. Lamar (1798–1859), date unknown.

Mirabeau B. Lamar

Mirabeau Buonaparte Lamar succeeded Sam Houston as president of Texas, becoming the second president of the Republic in 1838. Having served with distinction at San Jacinto, he was elected vice president in 1836. Once he became president, his administration's policies often were the opposite of Houston's. He chased the Native Americans from East Texas, moved the capital away from Houston to Waterloo (Austin), and pursued an aggressive policy toward Mexico. He was a poet and strong supporter of education, becoming known as the "Father of Education" in Texas. Lamar later served as America's ambassador to Nicaragua and Costa Rica. He died in 1859.

PICTURING TEXAS POLITICS

★ 18 ★

Thomas Jefferson Rusk

Thomas Jefferson Rusk fought at San Jacinto and served as secretary of war under President Sam Houston. He later served as the first chief justice of the Texas Supreme Court and was selected as one of Texas's first two U.S. senators. A year after the death of his wife in 1856, he committed suicide, leading Sam Houston to eulogize him on the senate floor: "As a soldier, he was gallant, his chivalry spotless, his honor clear; as a statesman he was wise, conservative, and patriotic; as a friend he had all of the high qualities that ennoble the heart . . ."

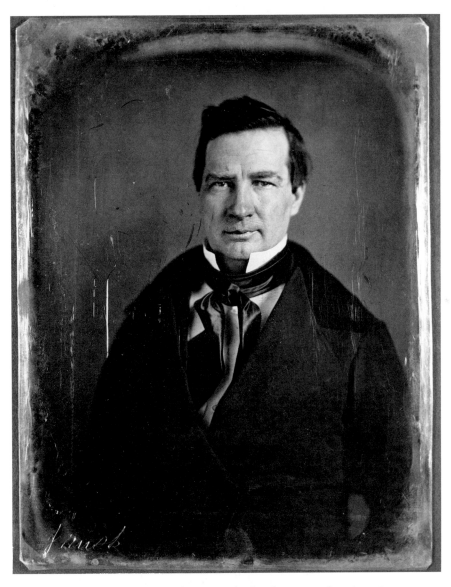

Thomas Jefferson Rusk (1803–1857). The photo was taken circa 1850, while Rusk was serving in the U.S. Senate.

John Wheeler Bunton

John Wheeler Bunton, a distant relative of Lyndon B. Johnson, fought at San Jacinto and signed the Texas Declaration of Independence. He later served in the first and third Texas Congress, representing Bastrop. The Mexican navy captured Bunton off the Texas coast in 1837 and he was briefly imprisoned at Matamoros.

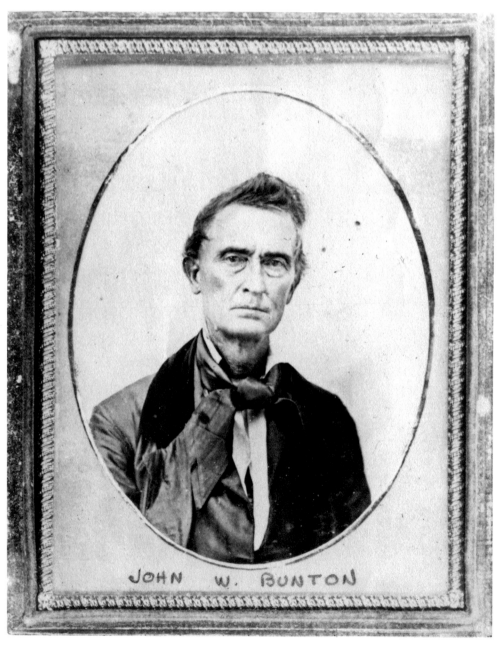

John Wheeler Bunton (1807–1879), date unknown.

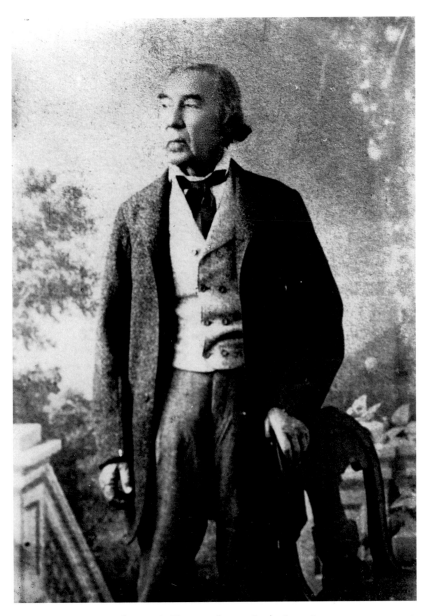

José Antonio Navarro (1795–1871), circa 1855.

José Antonio Navarro

Born in 1795, José Antonio Navarro was an early supporter of Texas independence, a close friend of Stephen F. Austin, and a leader of Texas during the Revolution and through the Republic and early statehood periods. He supported Texas's decision to secede from the Union in 1861.

Navarro served in the legislative bodies of Mexico, the Texas Republic, and the state of Texas. He was a signer of the Texas Declaration of Independence and was the only native Mexican to attend the Convention of 1845, which considered the annexation of the Republic of Texas to the United States. He died in 1871.

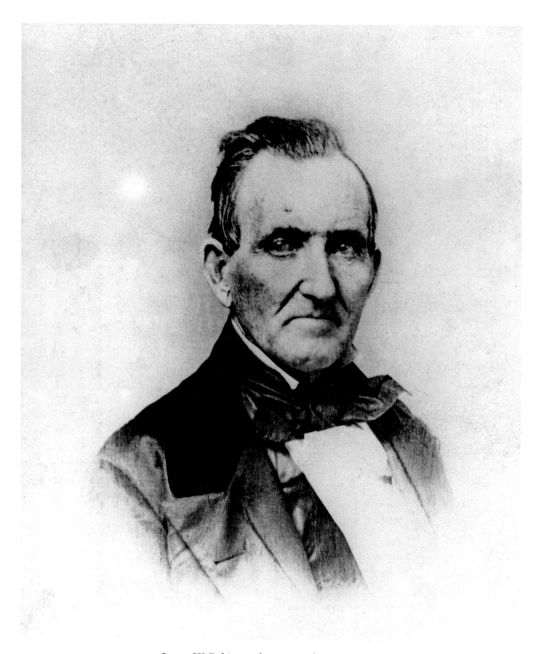

James W. Robinson (1790–1857), circa 1850s.

James W. Robinson

James W. Robinson was from Indiana where, early in his career, he practiced law with William Henry Harrison. He moved to Texas in 1833 and was elected provisional lieutenant governor at the 1835 Consultation. He later replaced Henry Smith as provisional governor of Texas when Smith was forced to resign. Robinson moved to California in the 1850s and served as district attorney in San Diego. He died in 1857.

Antonio López de Santa Anna

Antonio López de Santa Anna, the "Napoleon of the West," was president of Mexico at the time of the Texas Revolution. Elected in 1833, he assumed greater and greater power, personally leading the Mexican army into Texas to put down the revolt. After the Alamo and Goliad massacres, Sam Houston's army defeated and captured Santa Anna at San Jacinto, April 21, 1836. Although removed from office after losing Texas, Santa Anna returned to the Mexican presidency, phoenixlike, multiple times between 1839 and 1853. He died in Mexico City in 1876.

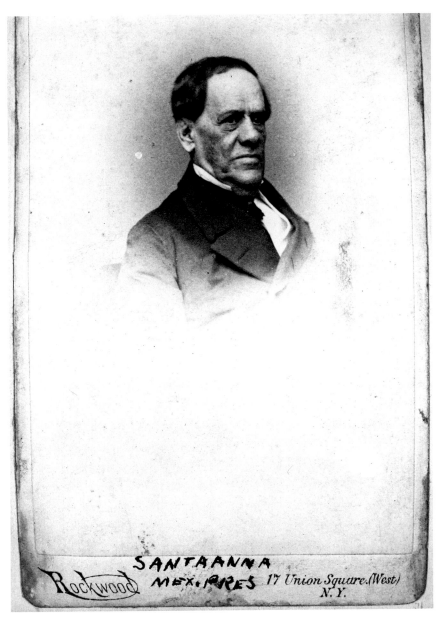

Antonio López de Santa Anna (1794–1876), circa 1870.

Sam Houston

Sam Houston was born in Virginia in 1793. A protégé of Andrew Jackson, he served as governor of Tennessee. Due to a scandal involving his marriage, he resigned and eventually ended up in Texas. He signed the Texas Declaration of Independence on his birthday, March 2, 1836. On September 5, 1836, and September 6, 1841, he was elected president of the Republic of Texas. Known for his flamboyant dress and inspiring oratory, Houston was elected one of Texas's first two U.S. senators after Texas joined the United States. He served for over a decade, then returned to Texas to run for governor. He was defeated in 1857, but won in 1859. In 1861 he was removed from office for refusing to accept secession from the Union. He retired, and died in July 1863 in Huntsville, Texas.

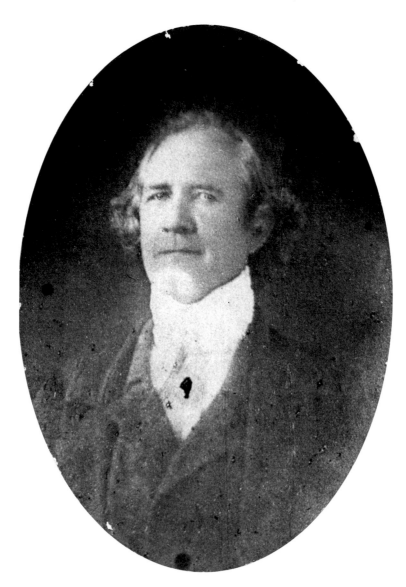

Sam Houston (1793–1863), circa 1838.

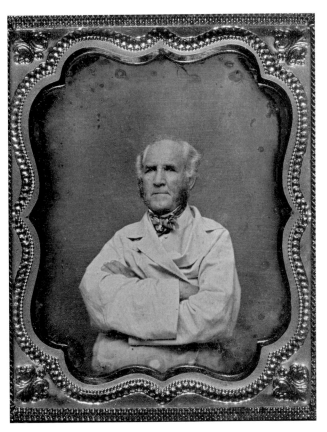

Houston, circa 1840s.

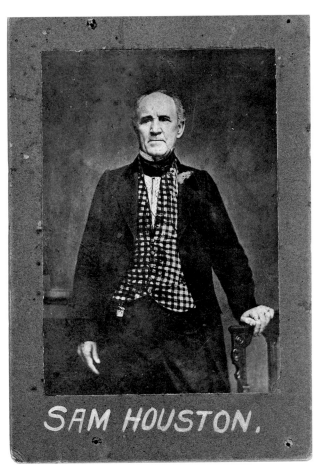

SAM HOUSTON.

Houston, circa 1859.

BLESSING & BRO.　　　PHOTO.

Houston, circa 1850s.

Francis R. Lubbock

Francis R. Lubbock came to Texas in 1835, where he participated in the Siege of Béxar. Sam Houston appointed him comptroller of the Republic of Texas. Lubbock was a founder of the Texas Democratic Party and was elected governor after secession in 1861. He finished one term and joined the Confederate military. While serving as an aide to Jefferson Davis, the president of the Confederacy, Lubbock and fellow Texan (and Confederate postmaster general) John H. Reagan were captured with Davis. Lubbock later served as Texas treasurer. He died in 1905.

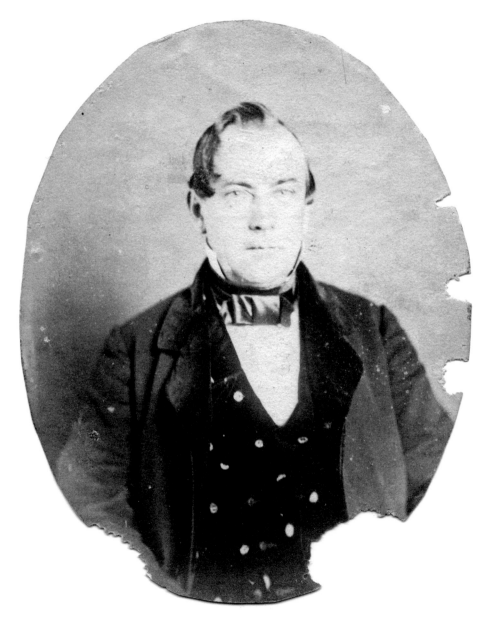

Francis Lubbock (1815–1905), circa 1860.

Edward Burleson

In 1830, Edward Burleson moved to Mina (Bastrop, Texas), one of Stephen F. Austin's colonies. He supported Texas independence and fought at San Jacinto. Burleson fought with Ben Milam in December 1835 when the Texas forces seized San Antonio from the Mexican general Martin Perfecto de Cos. Later he fought in the Cherokee War and was elected vice president of the Republic in 1841. After statehood, he served in the Texas Legislature as a representative from San Marcos until his death in 1851.

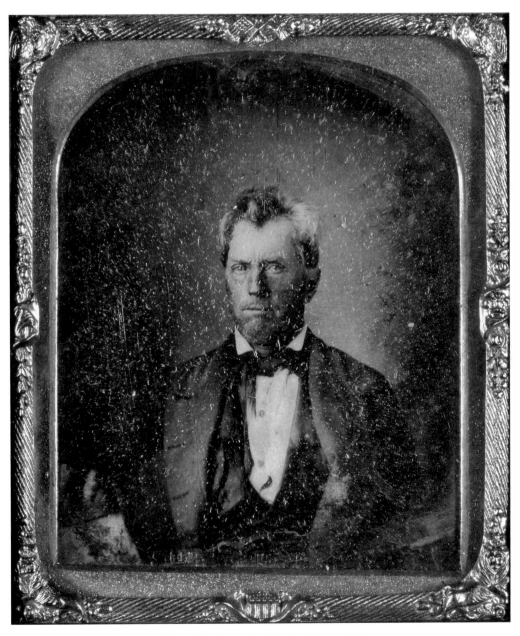

Edward Burleson (1798–1851), circa 1850.

James Pinckney Henderson

James Pinckney Henderson was the first governor of the state of Texas. As a diplomat, he served as Texas's minister to France and England and helped negotiate a treaty making Texas a state. He died in 1858, while serving in the U.S. Senate as the replacement for his law partner Thomas Jefferson Rusk.

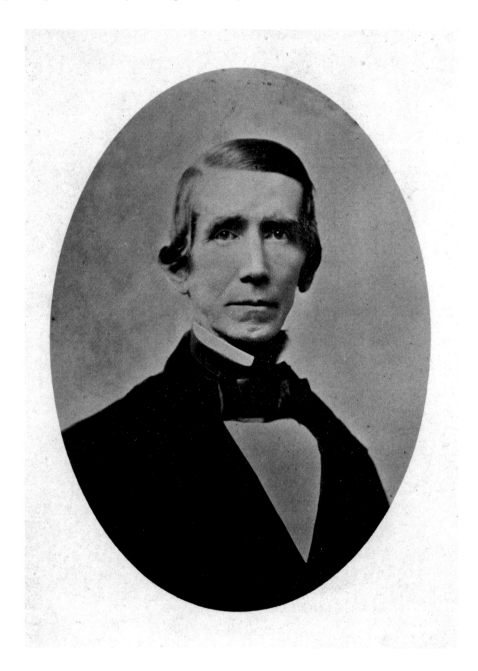

James Pinckney Henderson (1808–1858), circa 1857.

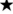

Elisha M. Pease (1812–1883), circa 1850s–1860s.

Elisha M. Pease

Elisha M. Pease was born in Connecticut but moved to Mina (Bastrop, Texas) in 1835. He was a supporter of Texas independence and fought at the battle of Gonzales. He was appointed comptroller of the Republic by Sam Houston and defeated W. B. Ochiltree for governor in 1853, then was reelected in 1855. After secession, Pease remained a Unionist, then dropped out of public life during the Civil War. In 1869, federal officals removed Texas governor James W. Throckmorton from office, then appointed Pease to replace him. Pease served until Edmund J. Davis took over the office after a contested election. Pease died in 1883.

Hardin Runnels

ardin Runnels was born in Mississippi and moved to Texas in the 1840s. After serving three terms in the Texas House, he was elected Speaker and served from 1853 to 1854. He then served as lieutenant governor and, in 1857, defeated Sam Houston for governor, the only electoral loss Houston ever suffered. Houston rebounded and defeated Runnels in 1859. Runnels died in 1873.

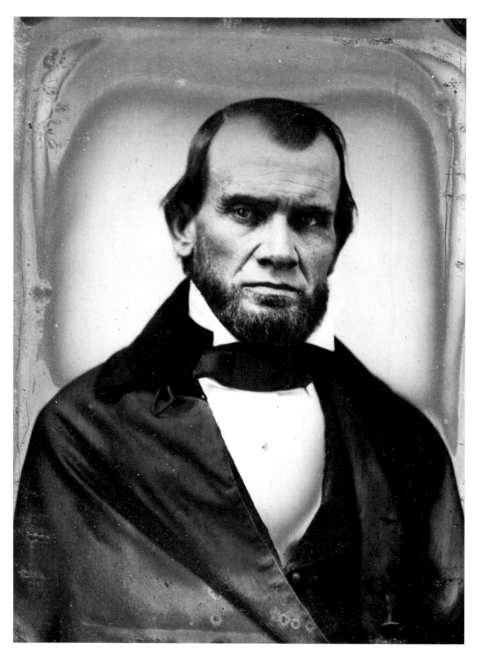

Hardin Runnels (1820–1873), circa 1850s.

Oran M. Roberts (1815–1898) in 1861, while he was serving as president of the Secession Convention in Austin.

Oran M. Roberts

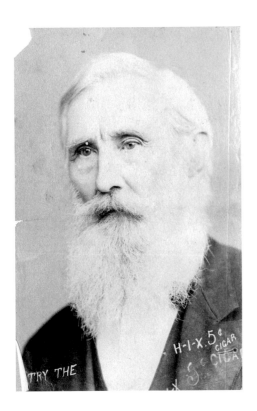

Oran Milo Roberts, originally from South Carolina, moved to Texas in 1841 to practice law in San Augustine, where he was appointed district attorney and district judge. In 1861 he was president of the Secession Convention and later served as chief justice of the Texas Supreme Court. He was elected governor in 1878 and later taught at the University of Texas law school where he was known as the "Old Alcalde." An avid historian, Roberts was a founding member of the Texas State Historical Association and served as its first president. He died in 1898.

Roberts portrayed in a cigar advertisement, date unknown.

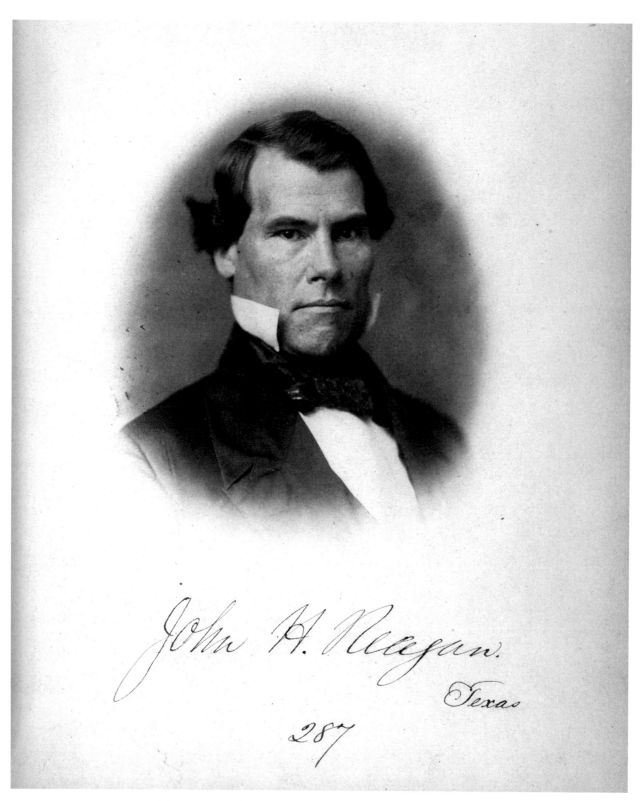

John H. Reagan (1818–1905) as a member of Congress, circa 1850s.

John H. Reagan

John H. Reagan came to Texas from Tennessee in 1839. A practicing lawyer, prosecutor, and judge, he was elected to Congress in 1857 and served until the outbreak of the Civil War. He served as postmaster general of the Confederacy and was captured with Jefferson Davis at the end of the war. After Reconstruction, he was elected to the U.S. Senate, resigning in 1891 to become chairman of the Texas Railroad Commission. Known as the "Old Roman," he considered running for governor in 1894, but was outmaneuvered by Colonel Edward M. House and his campaign for Charles Culberson. Reagan died in 1905.

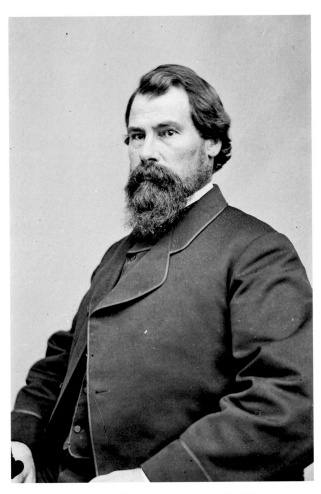

Reagan as the postmaster general of the Confederate States, circa 1860s.

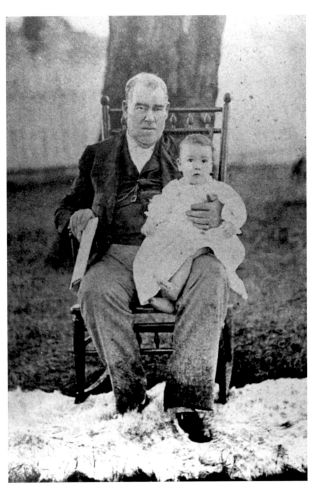

An older Reagan, circa 1880s, with a grandchild.

Memucan Hunt

A native of North Carolina, Memucan Hunt served presidents Houston and Lamar as Texas minister to the United States. He was appointed Texas secretary of the navy in 1838 and later served in the Texas Legislature. Hunt was appointed U.S. commissioner in 1853 and used his diplomatic skills in determining the southwestern border of Texas after the Mexican War. He died in 1856.

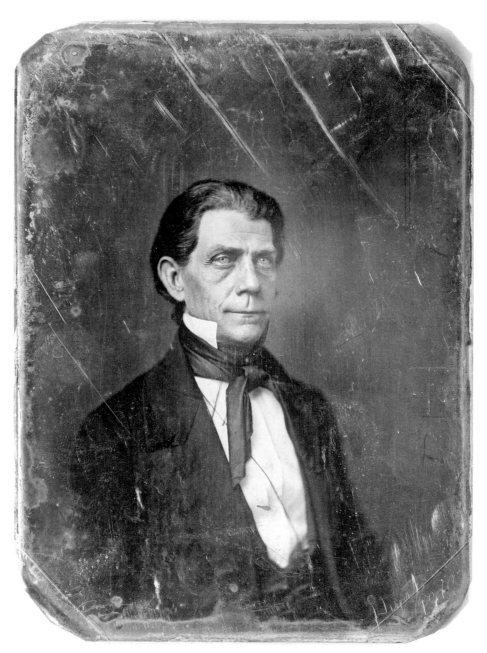

Memucan Hunt (1807–1856), circa 1850s.

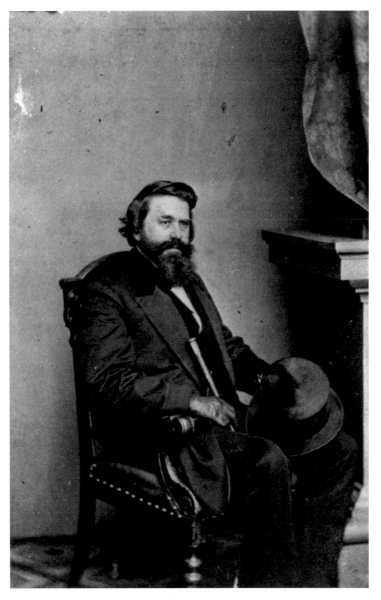

Louis T. Wigfall (1816–1874), circa 1860.

Louis T. Wigfall

Louis T. Wigfall was born in South Carolina, and from the beginning of his political career was an ardent supporter of states' rights. He moved to Texas in 1848, establishing a law practice with W. B. Ochiltree. Entering Texas politics, he became a bitter foe of Sam Houston and was elected to the U.S. Senate in 1859. He stayed in the Senate long enough to relay information to the new Confederacy and was personally involved in the battle at Fort Sumter. Wigfall served in the Confederate Senate and became an ardent critic of Confederate president Jefferson Davis. He died in 1874.

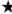

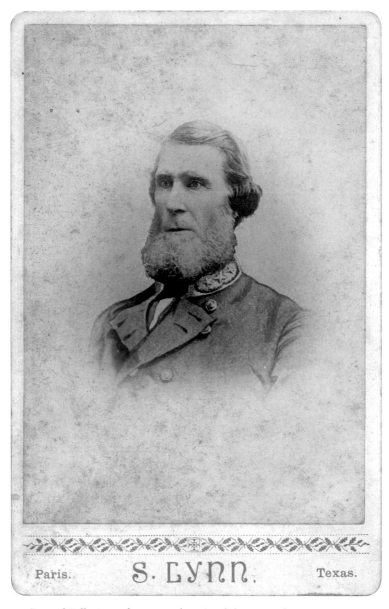

Samuel Bell Maxey (1825–1895), in Confederate uniform circa 1860s.

Samuel Bell Maxey

A graduate of West Point—where he roomed with Stonewall Jackson—Samuel Bell Maxey moved to Texas in 1857 to practice law. During the Civil War he served under Albert Sidney Johnston and attained the rank of major general. After the war, in 1875, he was elected to the U.S. Senate, where he later helped another old West Point classmate, President Ulysses S. Grant, deal with post–Civil War issues. He was defeated by John H. Reagan in 1887 and retired from the Senate to Paris, Texas, to practice law. Maxey died in 1895.

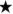

The "Immortal Seven"

The "Immortal Seven" were members of the Texas Secession Convention that met in Austin in 1861 to vote on secession from the United States and who were later immortalized in this iconic photograph. As each of them—A. P. Shuford, Wood County; future Governor James W. Throckmorton, Collin County; Lemuel H. Williams, George W. Wright, and William H. Johnson, all of Lamar County; Joshua Johnson, Titus County; and Thomas P. Hughes, Williamson County—voted "no," the crowd in the Capitol jeered and hissed. (Some sources say that an eighth delegate also voted against secession, but he was not present for the photograph.) These men were the only delegates out of 174 to vote against the ordinance of secession. Courage and wisdom united these men, who, along with Governor Sam Houston, stuck to their convictions—although most of them continued to support Texas after the vote.

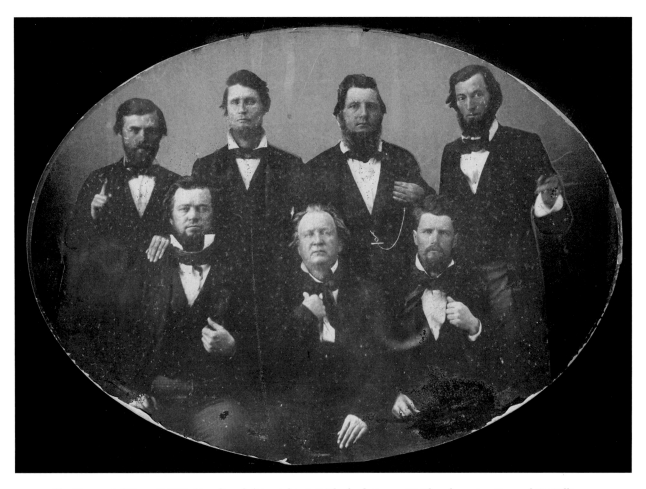

The "Immortal Seven," 1861. Standing, left to right: A. P. Shuford, James W. Throckmorton, Lemuel H. Williams, and Joshua Johnson. Seated, left to right: William H. Johnson, George W. Wright, and Thomas P. Hughes.

James W. Throckmorton

A medical doctor, James W. Throckmorton came to Texas in 1841. He entered politics and served in both the Texas House and Texas Senate. At the Secession Convention in 1861, he was one of the "Immortal Seven" who voted against Texas seceding from the Union. During the debate, and in response to jeers from secession supporters in the gallery, he is quoted as saying, "Mr. President, when the rabble hiss, well may patriots tremble." Despite his opposition to secession, he fought for the Confederacy. He was elected governor in 1866 but was removed by General Philip H. Sheridan as an impediment to Reconstruction. Throckmorton later served in Congress. He died in 1894.

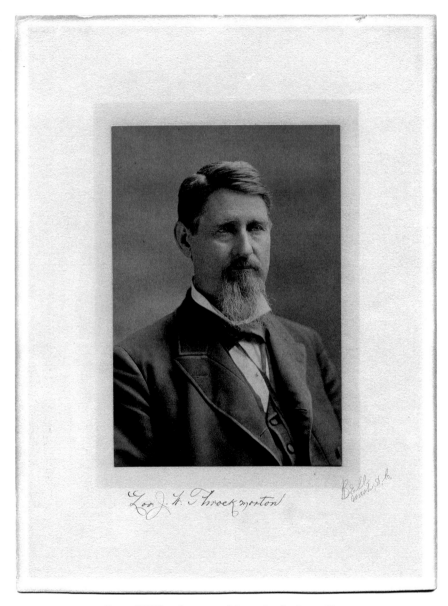

James W. Throckmorton (1825–1894), circa 1860s.

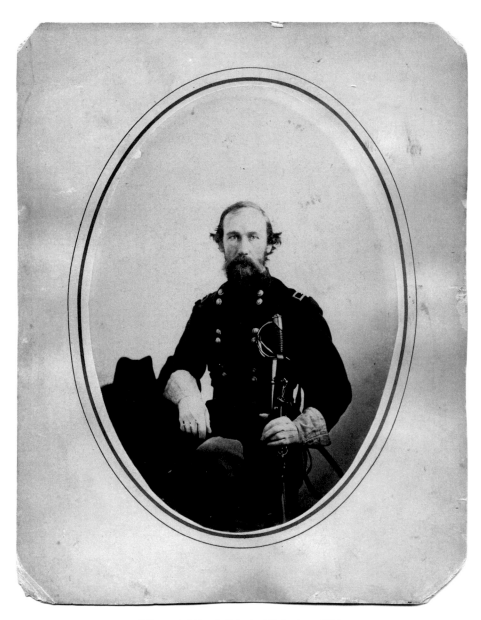

Edmund J. Davis (1827–1883), circa 1860s.

Edmund J. Davis

Edmund J. Davis came to Texas from Florida in 1838 and began practicing law. As a staunch Unionist, he went to Mexico, raised a regiment, and was a Union brigadier general by the end of the Civil War. He returned to Texas and, with northern support, was elected governor in 1870. In 1874, Richard Coke defeated Davis, who refused to leave office until President Grant declined to send help to keep him there. The Constitution of 1876 restricted the governor's powers in response to Davis's Reconstruction administration. Davis served as head of the state Republican Party until his death in 1883.

Richard Coke

A graduate of William and Mary College, Richard Coke began practicing law in Waco in 1850. During the Civil War, he attained the rank of captain. In 1874, he defeated incumbent Edmund J. Davis for governor, but could not take office until Davis was denied military help by President Grant. With his election as governor, Reconstruction in Texas came to an end. Coke later served as a U.S. senator from Texas. He died in 1897.

Richard Coke (1829–1897), circa 1870s.

John Salmon "Rip" Ford

John Salmon "Rip" Ford, born in South Carolina, came to Texas in 1836. A man of many talents, Ford was a medical doctor, a newspaperman, a state senator, and a captain in the Texas Rangers. Ford helped restore order in Austin when an armed crowd sought to forcibly remove Governor Edmund Davis from office at the end of Reconstruction. According to legend, he received his nickname, "Rip," while serving as adjutant during the Mexican War; he wrote a large number of letters to families of soldiers killed in action, signing each "Rest in Peace." He died in 1897.

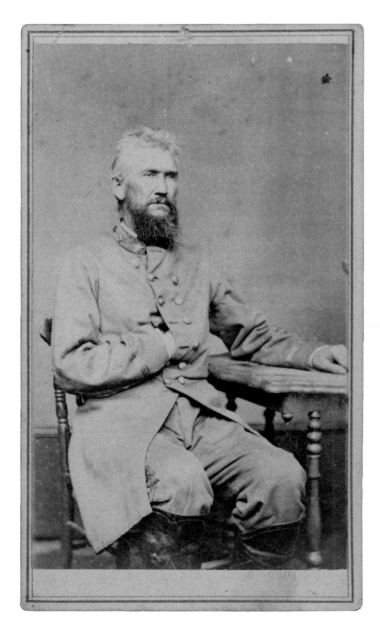

John Salmon "Rip" Ford (1815–1897), in Confederate uniform circa 1860s.

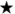

John Ireland

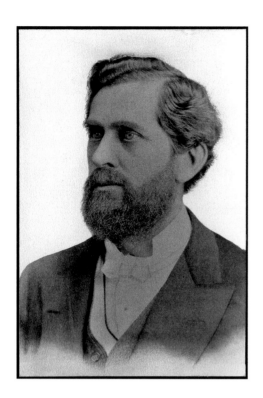

John Ireland, originally from Kentucky, moved to Texas in 1853 to practice law. He was active in the Secession Convention in 1861 and emerged from the Civil War a lieutenant colonel. Throughout his career, Ireland's opposition to subsidies to the railroad industry earned him a variety of nicknames, including "Oxcart John" (because his political opponents said only oxcarts would survive if his anti-railroad positions were carried out). He was elected governor in 1882 and 1884, during which time he signed a bill making fence-cutting a felony. Ireland died in 1896.

John Ireland (1827–1896), circa 1882–1885.

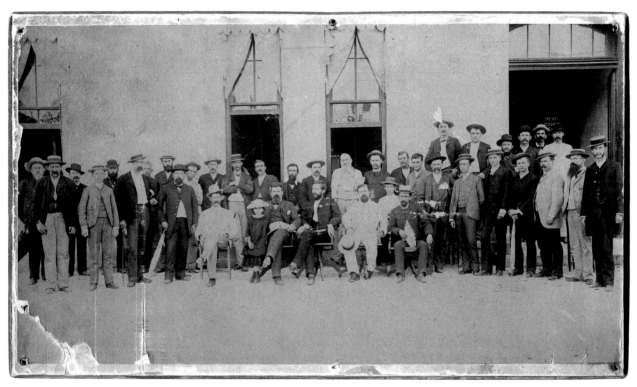

Governor Ireland, seated third from the right, with other Texas state employees, circa 1882–1885. The entry to the Treasury Department can be seen at the far right.

Sul Ross

Lawrence Sullivan "Sul" Ross was born September 27, 1838. After attending college at Baylor and in Alabama, he raised a Ranger company that famously recovered Cynthia Ann Parker, who had been captured many years earlier by the Comanche. After the Civil War, Ross was elected sheriff of McLennan County and state senator. He was elected governor in 1886 and again in 1888. Ross became president of Texas A&M University in 1891 and died near Bryan in 1898.

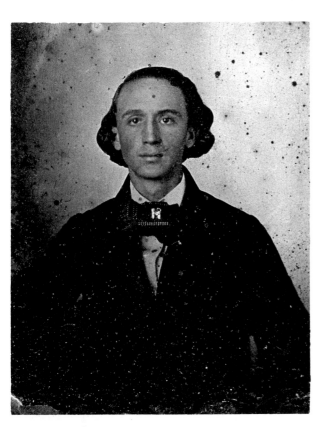

Sul Ross (1838–1898) as a young man, date unknown.

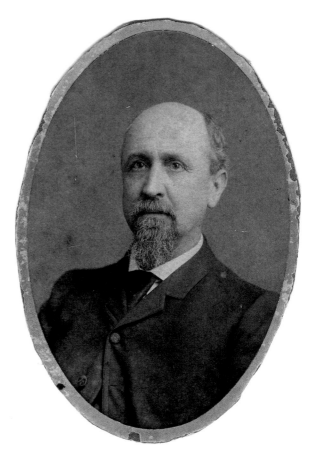

Ross as governor, circa 1880s.

REFORM AND GROWTH
from the
NINETEENTH
to the
TWENTIETH CENTURY

The era between Reconstruction and World War I is often referred to as the Gilded Age. Mark Twain also called it the "Great Barbecue" thanks to its many excesses, its unbridled greed, and its roller-coaster economy. In many areas of the nation, unprecedented growth, industrialization, immigration, and urbanization propelled the United States onto the world stage. But only a privileged few prospered.

As the nineteenth century closed, Texas remained an agricultural state firmly aligned with its neighbors in the defeated Confederacy. Most Texans lived on farms or ranches and had little in the way of public education or capital for business. Racial lines remained in place, as most of Texas was rigidly segregated. With the dawn of the twentieth century, the landscape began to change. Larger cities, improved infrastructure, a new petroleum industry, an improved financial sector, and a growing population pushed Texas toward a more modern era. Along with these changes, new Texas leadership had a notable impact on national policies that would forever change the role of the federal government and its relationship with states and local communities.

POPULISM AND JIM HOGG

The Populist era had its roots in Texas and furnished many colorful leaders. This grassroots movement unsettled the established political hierarchy and scared business leaders with its seemingly radical ideas. The movement grew out of the sense that millions of farmers in Texas and the rest of the nation were at the mercy of unregulated railroads and banks, unpredictable markets, extreme weather, and monopolies that controlled much of the nation's manufactured goods. While tycoons made fortunes on Wall Street, many rural Americans felt they were unfairly subjected to unscrupulous and unethical business practices. These impressions, combined with strong moral and religious beliefs, caused populism to sweep through the nation's heartland like a wildfire in the 1890s.

The movement began to take shape in Texas in 1879, when a group of disgruntled farmers met at the Pleasant Valley farm of J. R. Allen near Lampasas. The organization that emerged became the Farmer's Alliance. This group wanted to secure better credit for farmers and establish local alliances that allowed producers to organize and expand their influence. The movement strengthened in the 1880s as a desire for reform spread throughout the agricultural regions of the Midwest and South. The People's Party (the Populists) officially formed in 1891. Populism had its roots in and drew support from the Farmer's Alliance, the Grange, the Knights of Labor, and the Women's Christian Temperance Union (WCTU). The People's Party included prohibitionists, Republicans, disaffected Democrats, and Socialists. Meeting in 1892 in St. Louis, the Populists called for national reforms: a graduated income tax, public ownership of railroads and communication systems, federal management of commodities, and an end to the nation's gold standard.

Several Texans gained national prominence in the Populist movement. James H. "Cyclone" Davis, Charles Macune, Thomas Nugent, and Charles Jenkins became prominent figures in the state and national movement. John B. Rayner was one of the best-known African American leaders who became a prominent advocate for the Populists.

Prominent Democrats of the era who remained loyal to their party engaged in many spirited battles with Populists over the future and political control of the state. James S. Hogg would adopt many of the populist reforms in a successful career that led him to become one of the most famous governors in Texas history. Other prominent Democratic leaders who withstood the Populist challenge included George Clark, Charles Culberson, John H. Reagan, Alexander W. Terrell, and Joseph Weldon Bailey, and the behind-the-scenes master Colonel Edward M. House.

The Populists managed to gain control of several counties and elect members to the Texas Legislature in the 1890s. Though never able to win a statewide office, they pushed Texas Democrats to adopt many of their positions, including business regulations and the establishment of the Texas Railroad

Commission. Although the movement waned after national Democrats essentially merged with the Populists in William Jennings Bryan's unsuccessful 1896 presidential campaign, vestiges of the movement remained into the next century, when the Progressive Era would build on many of the populists' issues. The notion of populism and populist-style leaders would resonate for another century, into the modern era of politics.

THE PROGRESSIVE ERA

The Progressive Era of the early twentieth century built on nineteenth-century social and economic reform movements. Many of the changes sought during the 1890s began to take place even as the Populists as an organized political group disappeared into the history books. Farmers and rural residents were helped by railroad regulation, an expanding economy, and higher commodity prices. Urban residents benefited from a growing population and better communications, transportation, and public services. Women and religious groups took center stage in putting forward an agenda of prohibition and reform. Conversely, the state's minority population suffered many setbacks in spite of progressive victories. The state's progressive leadership systematically excluded African Americans and Mexican Americans from participation in politics and social life unless they could be rigidly controlled by the white majority. Segregation in Texas became entrenched and a defined pattern of life throughout the state until cracks began to appear in the New Deal and World War II eras.

Racial segregation and conflict intensified in the early twentieth century. Texas ranked third among all the states for lynching African Americans during this period. Race riots erupted in the larger cities of Dallas and Houston and in smaller cities in East Texas. Some progressives and religious organizations began to openly criticize the lawlessness and the lynchings. The reaction stemmed from concern in the growing urban business community and among religious leaders that the violence would be detrimental to the progressive image that civic leaders sought. The Association of Southern Women for the Prevention of Lynching, led by Jessie Daniel Ames of Georgetown, Texas, was founded during this era. Unfortunately, no elected official in Texas risked his or her political future on siding with reform advocates.

The *Dallas Morning News*, the *Houston Chronicle*, and the *San Antonio Express* published news coverage of the violence and editorials protesting lynching. Notably, advances in printing during this era allowed for photos to be inserted on the news pages. This change in technology helped propel the use of photographs in everyday life. Newspapers, magazines, and all types of printed material for mass distribution began to utilize photographs. As a result, by the early twentieth century, photography became a valuable resource for information and advertising and led to much more variety in visual images.

PROGRESSIVE VICTORIES: PROHIBITION, SUFFRAGE, AND EDUCATION

World War I and the resulting patriotic fervor that erupted in the nation were godsends to advocates of the prohibition of alcohol and women's suffrage. Prohibition supporters argued that alcohol was a waste of vital resources, a threat to American soldiers, and even a tool of the German kaiser. On April 14, 1917, the day the United States declared war on Germany, U.S. senator Morris Sheppard of Texas introduced the Eighteenth Amendment to Congress. Senator Sheppard said the war effort would be greatly improved "if the liquor traffic could be wiped out." At their fall convention, Texas Baptists restated their hostility to liquor and called for a ban on alcohol around military camps "to protect our soldier boys against evils more deadly than all the horrors and carnage of the battlefields." Senator Sheppard won his battle as Congress passed the amendment in December 1917 and it was sent to the states for ratification. Sheppard became nationally known as the "father of Prohibition."[1]

Likewise, suffrage advocates turned their rhetorical guns on newspapers and community and business leaders to press their cause. As part of their campaign, women's suffrage leaders enthusiastically volunteered for projects linked to the war effort. They worked on food conservation drives, war bond sales, and medical supply and clothing collections. Women's rights activists noted that the "alien enemy has paid his poll tax" while "our sons and brothers and husbands" were in the service and were effectively disfranchised. Minnie Fisher Cunningham, Jane McCallum, Annie Webb Blanton, and many other women activists gained fame and political experience in the suffrage movement.

The movement finally cleared a major hurdle when the special legislative session that voted for prohibition also approved a measure that allowed women the right to vote in primary elections. Women voters turned out in large numbers in the 1918 Democratic primary to reelect Governor William P. Hobby, now the male hero of the suffrage movement. Hobby withstood a strong challenge from former governor James Ferguson. The following year the legislature approved the constitutional amendment that granted women the right to vote. Annie Webb Blanton became the first woman elected to office when she became State Superintendent of Public Instruction in 1918.

World War I moved a majority of the state in favor of Prohibition and was a deciding factor in the ultimate victory of women's suffrage. Dry progressive Democrats became the dominant political force in Texas politics for many years to come. Alcohol remained a potent political issue for decades. After he became president, Lyndon Johnson noted that most Texas elections for his generation were usually decided by two simple issues: "All I heard was whether you were wet or dry, whether you were for the courthouse group or against them."[2] (The "courthouse group" refers to the elected county officials who had the capability to influence voters and to support selected candidates.)

TEXAS DURING WORLD WAR I AND
THE MEXICAN REVOLUTION

Isolationist sentiment remained strong in Texas but lessened significantly with the buildup to and onset of World War I. Germany's submarine warfare had created concern, but Texans were even more concerned with German attempts to encourage Mexico to renew hostilities with the United States. Germany was interested in keeping America out of the European war and became involved in the internal affairs of Mexico during that country's revolution (1910–1920). Violence along the Rio Grande and the political unrest brought about by the prolonged revolution became major contributing factors to U.S. entry into the war.

Photographs from the Mexican Revolution became a regular feature of the news publications of this era, but many border communities saw firsthand the violence and destruction that lasted nearly a decade. Attacks also occurred north of the Rio Grande, into South Texas, creating more unrest along the international border. The violence ultimately brought more U.S. troops to South Texas and the border as the revolution dragged on.

The prolonged military activity prepared the U.S. army for war; Texans gained valuable experience in working with large troop units with modern weapons. A large number of Texans volunteered for military service and entered the draft. Over 989,000 men registered and nearly 200,000 enlisted and saw service during the war. In addition, several hundred Texas women served as nurses during the war. One nurse and 5,170 men died while in service. Of these deaths, one-third actually occurred in the States, as a result of the influenza epidemic of 1918. Four Texans received the Medal of Honor for service in the war.

Perhaps the single most important Texan during World War I was Colonel Edward M. House. The consummate insider of his era, House served as the chief diplomat and political advisor to President Woodrow Wilson. In an administration with an impressive number of Texans, House stood the tallest, until a dispute with the president during the peace negotiations in Paris in 1919. Another prominent Texan was South Texas congressman John Nance Garner, who became Wilson's go-to representative in Congress to move the wartime budget and military expansion through the legislative process.

THE NEW WARTIME ECONOMY

The outbreak of World War I in Europe initially created economic havoc in Texas and the rest of the South. Cotton, the primary cash crop, dropped in price as the conflict disrupted international trade. However, by 1915, demand by the Allied forces for cotton, oil, and other agricultural and manufactured products reversed the trend. When the United States entered the war in 1917, Texas farmers and businesses benefited from the national mobilization effort.

Cotton prices rose from a low of seven cents per pound that year to thirty-five cents per pound in 1919. The Houston Ship Channel was enlarged and the "Bayou City" emerged as the largest inland seaport in the nation as a result of wartime traffic. Bank deposits rose and employment increased across the state from the stimulus provided by wartime activities.

The Texas oil industry, which had had a history of instability in the early 1900s following the Spindletop discovery, experienced a decline similar to that of cotton when the war began in Europe. After 1914, however, oil prices increased as exports flowed to England and France to fuel the Allied war machine. Many new strikes throughout the state increased production, while large refineries, pipelines, and other petroleum-related businesses were organized and expanded during the war years. The Texas Company (later known as Texaco), Gulf, Sun, Magnolia, and Humble Oil (later known as Exxon) all diversified as they saw their profits rise faster than a new gusher.

This diversification occurred because wartime demand for petroleum overcame certain legal concerns addressed in Texas antitrust laws. The state legislature allowed companies to combine production, refining, and marketing within a single firm, and this laid the groundwork for the growth of oil companies into major corporations. Federal troops responded to pleas from Texas oil executives to break a strike of over 10,000 unionized petroleum workers in November 1917. The strike dissolved as the need for an uninterrupted flow of oil was judged to be greater than concern over the fairness of the wages earned by workers in the oil fields. As a result of the demands created by the war, the oil industry grew to become the leading industry in the state. Along with this expansion, the industry also increased its political influence in both Austin and Washington, DC.

THE GOVERNORS FERGUSON

This was also the era of Miriam A. "Ma" Ferguson, the wife of Governor Jim "Pa" Ferguson, who gained fame as the first female governor of Texas. Jim Ferguson had risen to fame as a folksy governor who ultimately was impeached by the Texas Legislature for improper use of funds. His main offenses, according to many people, were his attacks on the University of Texas and his attempts to control the administration and faculty.

Together, the Fergusons were a dominant force in Texas politics for three decades. In 1924, when her husband's impeachment denied him a place on the ballot, Miriam Ferguson announced her candidacy. Promising Texas voters she would follow the advice and guidance of her husband, Ferguson campaigned under the slogan "Two governors for the price of one." She promised extensive reductions in state appropriations and opposed the Ku Klux Klan and Prohibition. She also took advantage of her husband's newspaper, the *Ferguson Forum*, to place strategic stories and photographs.

Miriam Ferguson easily won the election, becoming the first woman to be elected Texas governor and only the second woman governor inaugurated in the United States. Her term as governor was controversial and unsuccessful, as she and her husband were frequently accused of accepting bribes for granting pardons to convicted criminals in the Texas prison system, many of whom were incarcerated for prohibition violations. Following a bitter primary campaign, she lost to Attorney General Dan Moody.

In 1930, when her husband Jim was once again denied a place on the ballot, Miriam Ferguson unsuccessfully ran for governor. Then, in 1932, during the height of the Great Depression, she upset incumbent governor Ross Sterling as Texas voters demonstrated their unhappiness with the distressful economic circumstances. During that term, her attempts to introduce a state sales tax and corporate income tax were rejected by the state legislature. Miriam Ferguson retired from office in 1934, yet made one final unsuccessful attempt to become governor in 1940.

Thomas P. Ochiltree

Thomas P. Ochiltree, son of Texas jurist W. B. Ochiltree, came to Texas as a child in 1839. He served as a Texas Ranger and attained the rank of major in the Confederate army. Ochiltree served as a U.S. marshal for East Texas and was elected to Congress for one term in 1883. He later became a writer for the *New York News*. He died in 1902.

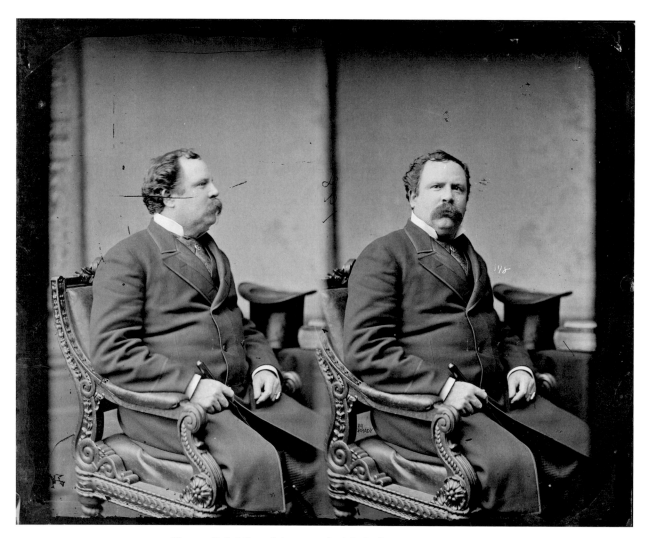

Thomas P. Ochiltree (1839–1902) while in Congress, circa 1883.

George Clark

George Clark, a Waco lawyer, was long active in the Texas Democratic Party. He served as campaign manager for two governors, Richard Coke and Sul Ross. Under Coke, Clark was acting secretary of state and then was appointed attorney general in 1874. Clark was a "dry" and led several campaigns to defeat anti-Prohibition initiatives in Texas. Running as the anti-Hogg candidate, he was defeated in 1893. He continued practicing law, representing railroads, and died in 1918.

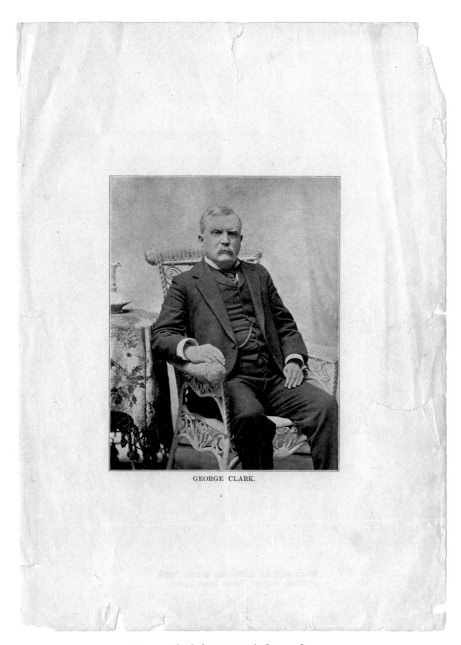

GEORGE CLARK.

George Clark (1841–1918), date unknown.

James S. Hogg

James S. (Jim) Hogg was born near Rusk in 1851. Orphaned at eleven, he and his brothers remained on the family plantation in East Texas. After serving as justice of the peace in Quitman, he began practicing law in 1874. He was elected county attorney of Wood County in 1878 and, in 1884, district attorney near Smith County. In 1886, Hogg was elected attorney general, and while in this office he attacked the railroad for various corrupt business practices. He supported the establishment of a commission to bring the railroads under state control.

In 1890, Hogg became the first native-born governor in Texas history. He was elected again in 1892, defeating the railroad-backed George Clark. Hogg supported the 1896 presidential campaign of William Jennings Bryan. He died in Houston in 1906.

Hogg seems to have been the first Texas governor who took full advantage of the popularization of photography. The Hogg images include family pictures, Hogg at his home, the governor in carriages, and even a photograph of Hogg and his ostriches—renowned for pulling the governor's buggy.

Portrait of "Hogg-acrats," date unknown.

Powerful Texans of their day: standing, left to right, Governor Francis Lubbock and Ambassador Alexander W. Terrell, and seated, left to right, John H. Reagan and Governor Jim Hogg (1851–1906), circa 1900.

Governor Hogg, third from right and holding an umbrella, with state officials at Camp Mabry in Austin, 1891.

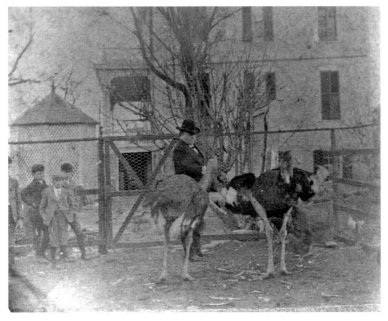

Governor Hogg with his ostriches, Jack and Jill, which he attached to a buggy to give rides to children. Date unknown.

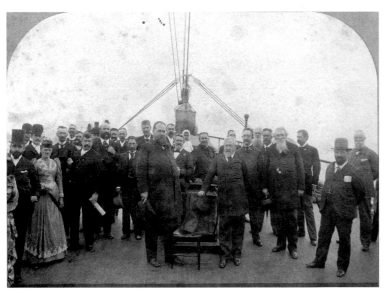

Governor Hogg (front, at left) and former president Benjamin Harrison (front, at right) at a dedication for the U.S.S. Lampasas *in Galveston, 1891. President Harrison was in Texas as part of a nationwide rail tour.*

William Jennings Bryan in Texas

William Jennings Bryan became a leading national figure in the 1890s as he adopted many reforms and programs espoused by the People's Party—the Populists. Bryan made three unsuccessful bids to win the White House as the Democratic presidential nominee. He maintained a close friendship with Governor James Hogg and enjoyed support from Hogg Democrats in Texas.

Presidential candidate William Jennings Bryan, left, and Jim Hogg, circa 1900.
Hogg supported Bryan during his 1896 and 1900 campaigns.

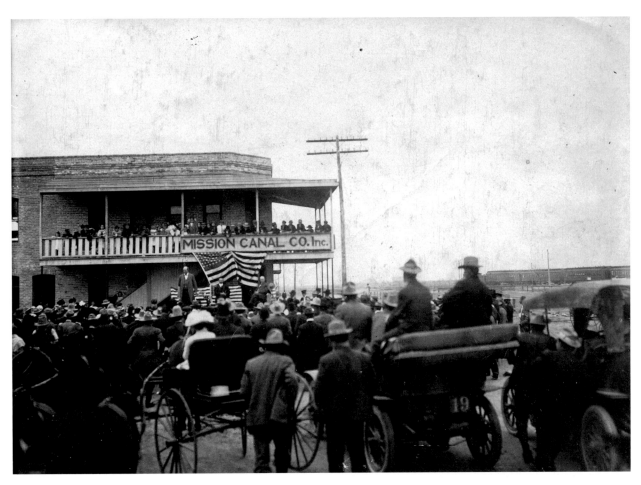

Democratic presidential candidate Bryan campaigning in South Texas in 1896.

On April 21, 1911, in the presence of some of Sam Houston's children, Bryan eulogized the general at the unveiling of the Sam Houston monument in Huntsville. In a lengthy speech, Bryan praised Houston as a leader, diplomat, orator, and legislator. Pictured, back row, left to right: Nettie Bringhurst (Houston's granddaughter), Mary W. Morrow (Houston's daughter), William Rogers Houston (Houston's son), Nettie Houston Bringhurst (Houston's daughter), Mrs. Franklin Williams, Franklin Williams (Houston's grandson), and William Jennings Bryan. Seated in the front are San Jacinto veterans Alfonso Steele and William Zuber.

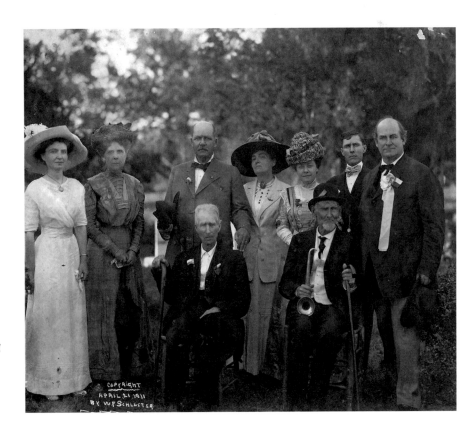

Horace Chilton

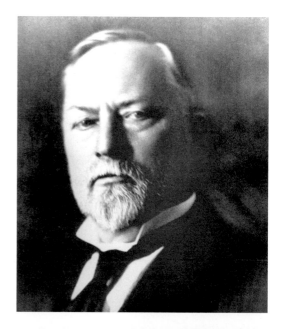

Horace Chilton was born in Smith County in 1853. A Democrat, he served in the U.S. Senate from 1891 to 1892 and from 1895 to 1901. Like William A. Blakley some fifty years later, he served as U.S. senator in both the Rusk and Houston senate successions. (Sam Houston and Thomas Jefferson Rusk were the first U.S. senators from Texas, so each succeeding senator has served as a replacement for either the Houston seat or the Rusk seat; Blakley and Chilton each served different terms as both.) Chilton was the first native Texan to serve in Congress.

Horace Chilton (1853–1932), circa 1892–1895.

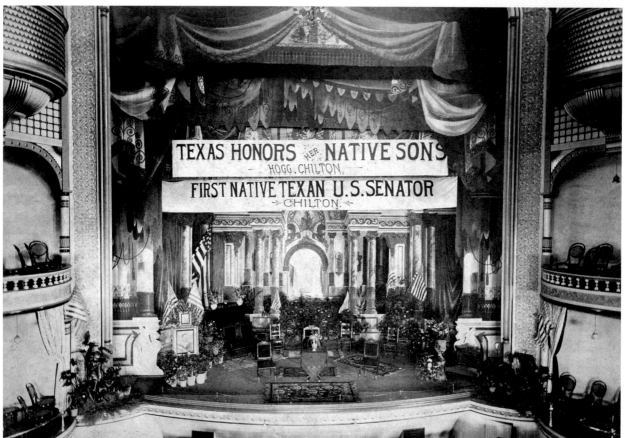

A stage decorated for a political event honoring Texas's first native sons to serve as governor (Jim Hogg) and U.S. senator (Horace Chilton), circa 1899.

Roger Q. Mills

Roger Q. Mills was born in 1832. A Democrat, he served in the House of Representatives, where he chaired the Ways and Means Committee and ran unsuccessfully for Speaker of the House in 1891, losing on the thirtieth ballot to Charles Crisp of Georgia. He then ran for and was elected to the U.S. Senate, serving from 1892 to 1899. He retired to Corsicana, where he died in 1911.

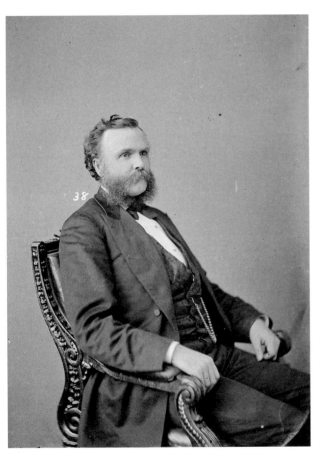

Roger Q. Mills (1832–1911), circa 1890.

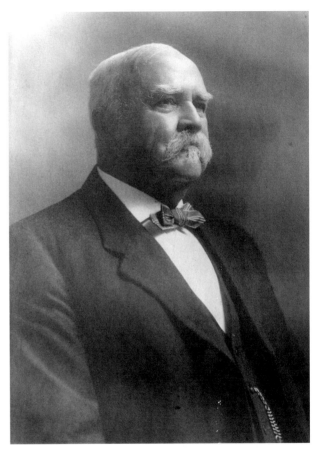

Mills as a U.S. senator, circa 1892.

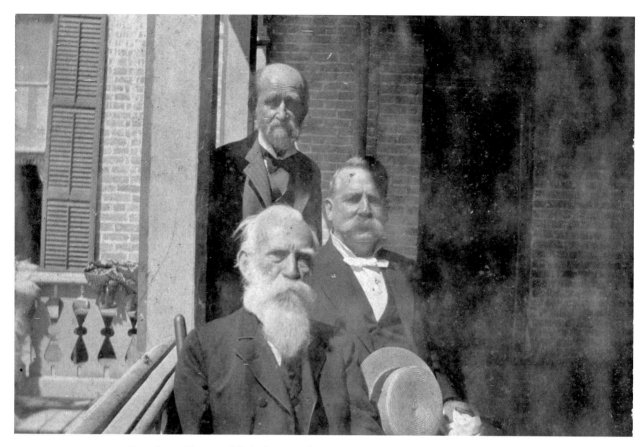

*Prominent Texans of their day: top, Guy Bryan; middle, Ambassador Alexander
W. Terrell; and bottom, Governor Francis Lubbock. Date unknown.*

Alexander W. Terrell

Alexander Watkins Terrell was born in Virginia in 1827 and
moved to Texas in the 1850s. As a member of the Texas
House and Senate, he opposed the railroad interests and
was closely allied with Governor Hogg. With Hogg's support, he was
named ambassador to Turkey in 1893. He died in 1912.

The Terrell Election Law required political candidates to be
nominated by political parties in direct primaries, rather than by
political conventions. The law also led to the elimination of many
of the state's minority voters in elections, as a result of various Jim
Crow laws, until federal election reforms were enacted in the 1960s.

*A. W. Terrell (1827–1912), left, with Texan businessman and
UT supporter George W. Brackenridge, 1901. Brackenridge had
the longest term ever as a regent of the University of Texas.*

Temple Houston

Temple Houston, the youngest of Sam Houston's children, was a lawyer and a politician. He served as a district attorney in the Texas Panhandle and was elected to the Texas Senate in 1885. In 1888, he made the dedication address at the opening of the new Texas Capitol. After leaving politics, he moved to Woodward, Oklahoma, and gained renown as a trial lawyer. He died in 1905.

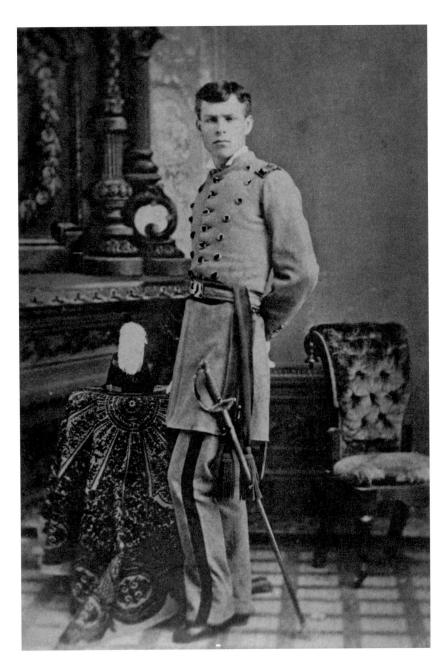

Temple Houston (1860–1905), in uniform, circa 1877.

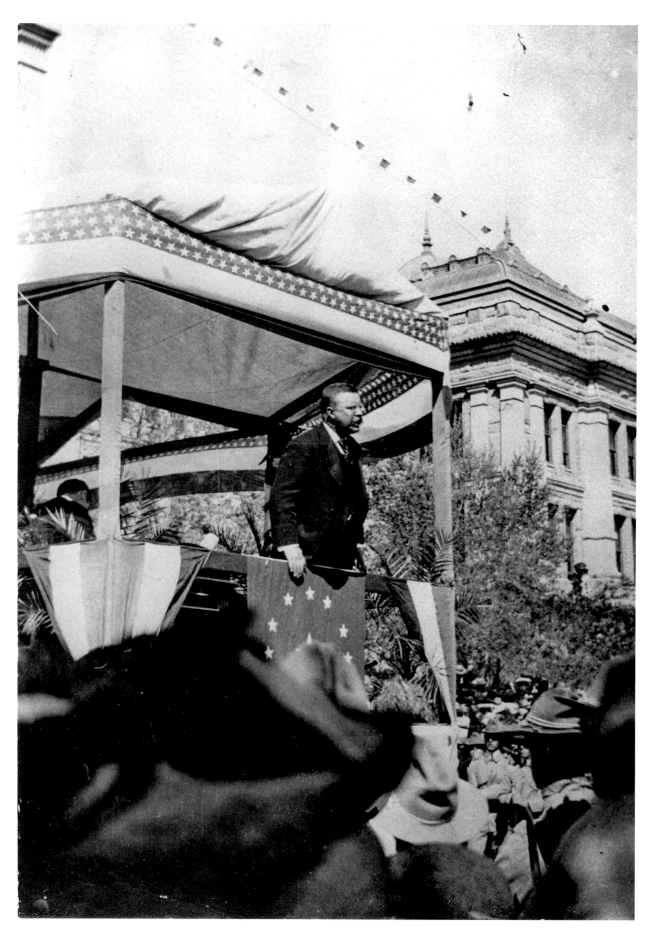

Theodore Roosevelt speaking at the Capitol in Austin, 1905.

President Theodore Roosevelt in Texas

Roosevelt had many close ties to Texas. He recruited volunteers for the Rough Riders in San Antonio at the Menger Hotel Bar. He also hunted in Texas with Burk Burnett and Quanah Parker. Although he never carried the state of Texas in his presidential elections, Roosevelt remained popular among many Texans.

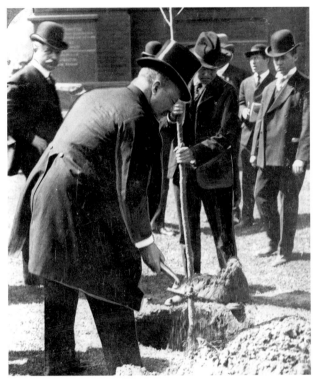

Roosevelt is pictured planting an oak tree at the Carnegie Library in Fort Worth, 1905.

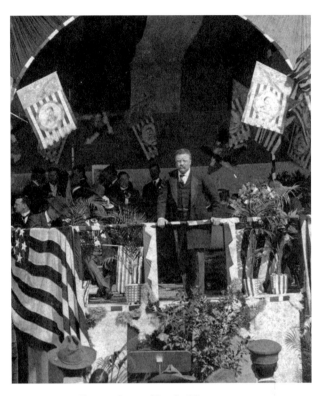

Roosevelt speaking in Waco, 1905.

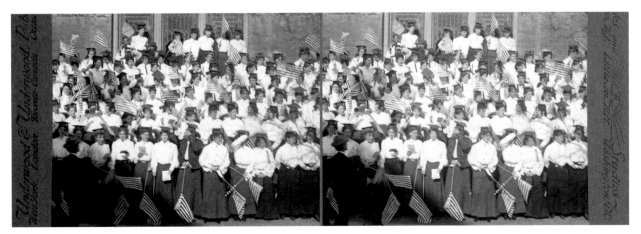

Schoolgirls waiting for Roosevelt's train in Sherman, Texas, in 1905.

Charles Culberson

The Alabama-born son of long-serving Texas congressman David Culberson, Charles Culberson was educated at the Virginia Military Institute and the University of Virginia. An anti-railroad man, he was elected Texas attorney general in 1890, putting him in a position to strongly defend Governor Hogg's Texas Railroad Commission. He was elected governor in 1894, 1896, and 1898. Culberson then was elected to the U.S. Senate, where he served until 1922. He died in 1925.

Charles Culberson (1855–1925), 1892.

Voting in Rural Texas

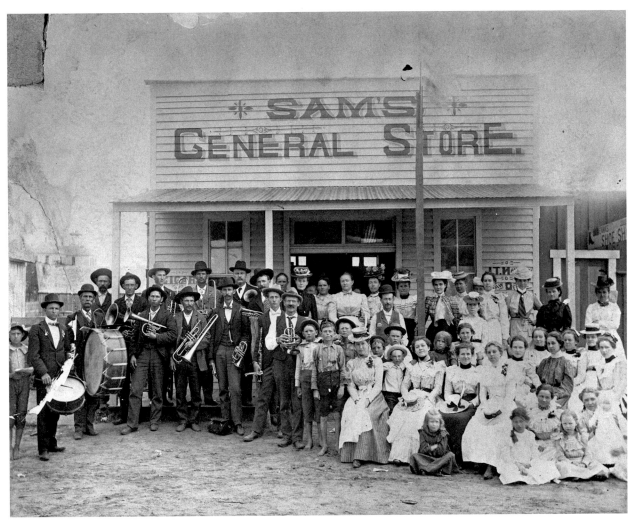

Election Day in Eastland, Texas, circa 1890s.

Joseph Weldon Bailey (1863–1929), in conversation with an unidentified man, date unknown. Bailey is the one facing the camera.

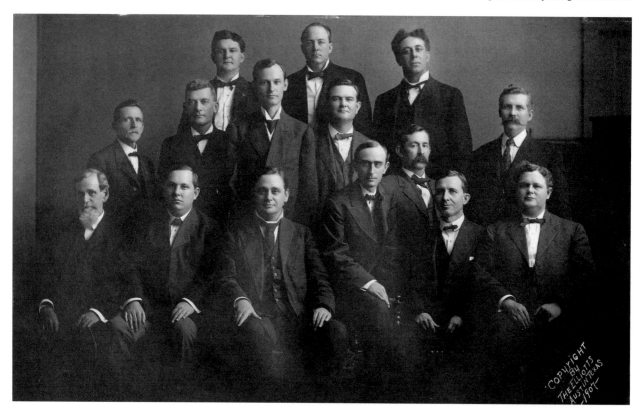

Bailey (third from left, in the front row) with the Texas legislative investigating committee, date unknown. The committee found no wrongdoing on Bailey's part regarding the Waters-Pierce matter. It was the second legislative investigation involving Bailey's legal representation of a firm (Waters-Pierce) allegedly connected to Standard Oil, which had been banished from Texas.

Joseph Weldon Bailey

Joseph Weldon Bailey was born in 1863 in Mississippi. A Democrat, he served in Congress and was a U.S. senator from 1901 to 1913. He was investigated and cleared by the Texas Legislature for his role as lawyer for the Waters-Pierce Oil Company, which was charged with antitrust violations. Bailey was considered a good orator and, while in Congress, served as minority leader of the Democrats. After returning to Texas, he was a successful lawyer. He died during a trial in Sherman in 1929.

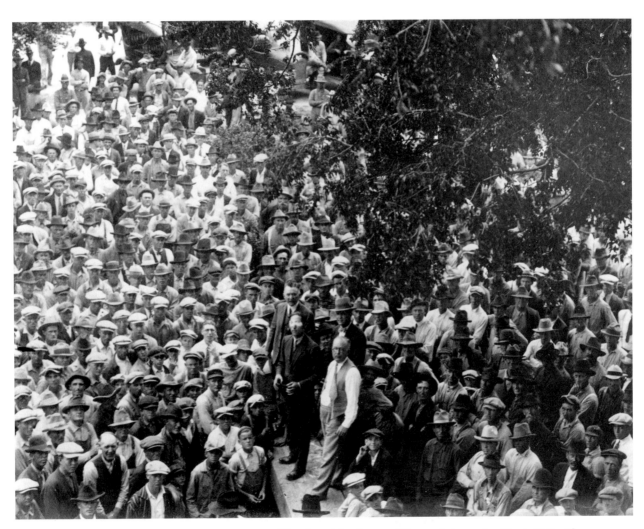

Bailey rally in Bonham, Texas, circa 1907. The photo is by the noted Texas photographer Erwin E. Smith.

Joseph D. Sayers (1841–1929), as a young man, date unknown.

Joseph D. Sayers

Joseph D. Sayers, who was born in Mississippi, moved to Bastrop in 1851, where he attended military school with Sam Houston's son. He practiced law until 1878 when he was elected lieutenant governor, after which he served several terms in Congress. Under the political guidance of kingmaker Colonel Edward M. House, Sayers was elected governor in 1898 and 1900. He died in 1929.

Governor Sayers addressing Confederate veterans group in 1903.

President McKinley in Texas

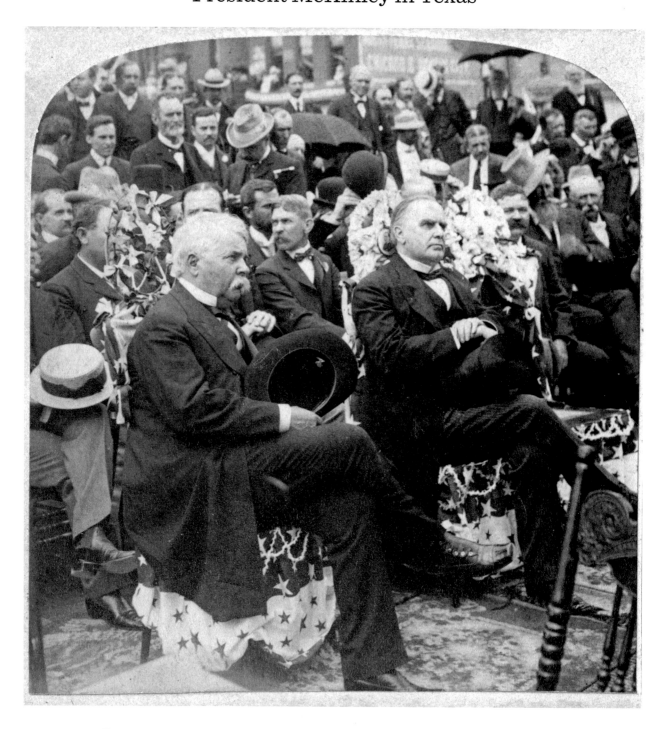

Governor Sayers with President McKinley at the Alamo, circa 1901. In his second term in office, McKinley was on an official visit to Texas, traveling from Houston to El Paso. He was assassinated later that year. Vice President Theodore Roosevelt then became president.

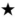

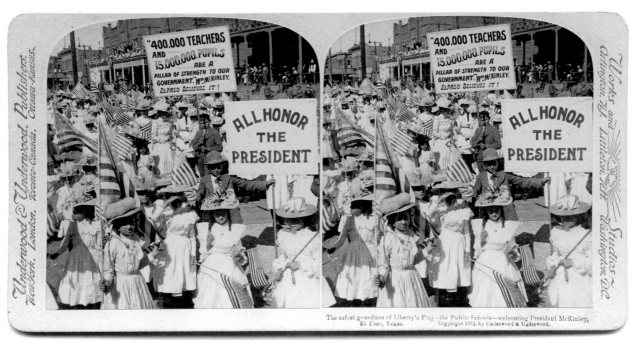

Texas teachers greeting President McKinley during a stop in El Paso, 1901.

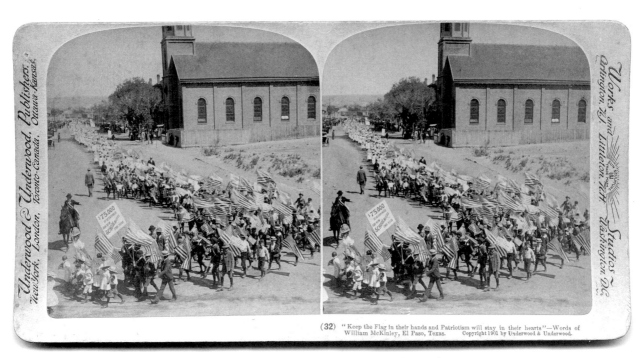

Schoolchildren marching to meet President McKinley in El Paso, 1901.

S. W. T. Lanham

amuel Willis Tucker Lanham was born in North Carolina. After the Civil War, he moved to Weatherford, Texas, where he opened a law practice. Appointed States Attorney by Reconstruction governor Edmund J. Davis, he prosecuted the Kiowa chiefs Santana and Big Tree for their part in the famous Warren Wagontrain Raid near Jacksboro.

Like governors Culberson and Sayers, Lanham's chief political advisor was Colonel Edward M. House and, with House's help, Lanham was elected to Congress in 1882 and governor in 1902 and 1904. He died in 1908. His son, Fritz Lanham, represented Fort Worth in Congress for over two decades.

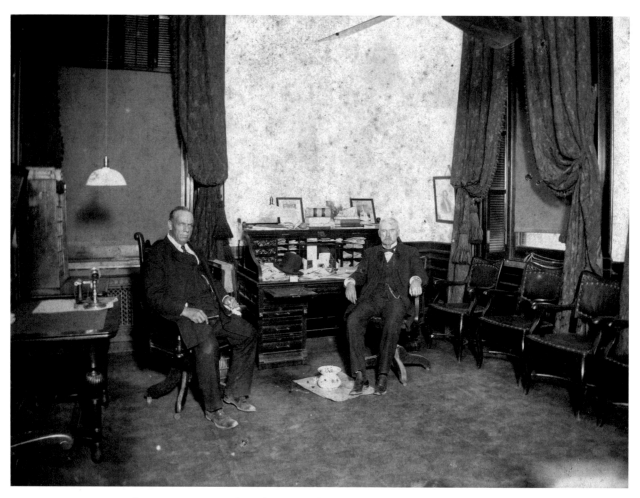

Governor S. W. T. Lanham (1846–1908), seated at the original governor's desk ordered when the Capitol was built, circa 1904. The other man is unidentified.

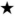

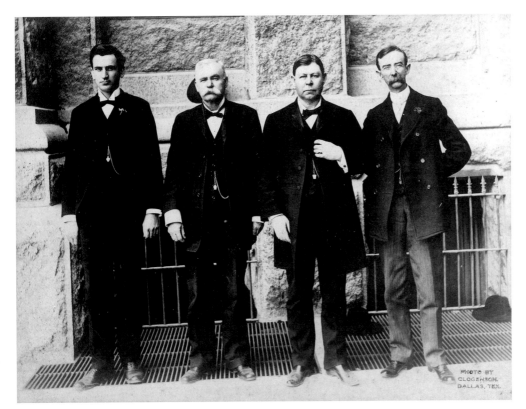

*Left to right:
Speaker Pat Neff,
Governor Lanham,
Lieutenant Governor
George Neal, and
an unknown man,
circa 1904.*

*Governor Lanham,
third from left in the
front row, visiting
a military camp,
circa 1904.*

President Taft in Texas

President Taft made trips to Texas as the Republican presidential nominee and while serving as president. In 1909, Taft met with Mexican president Porfirio Díaz in El Paso in the first-ever meeting between the chief executives of the United States and Mexico.

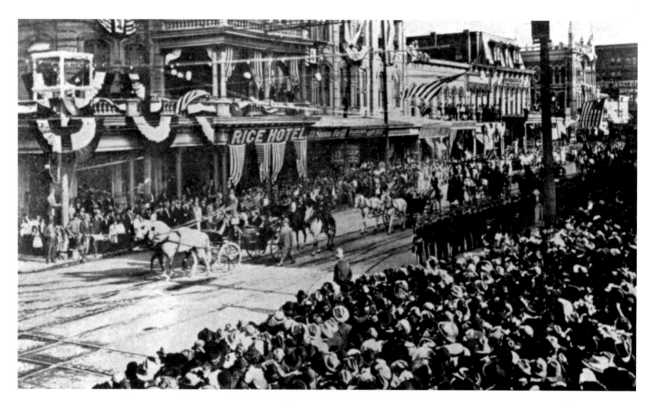

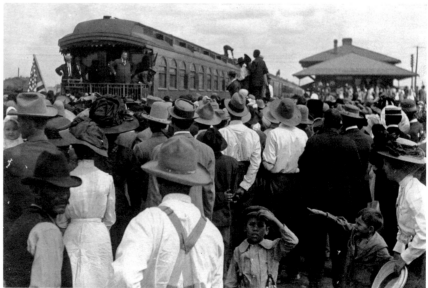

(above) President William Howard Taft in front of the Rice Hotel, Houston, in 1908.

(right) President Taft in Del Rio during a whistle stop, 1908.

Colonel Edward M. House

Colonel Edward M. House was born into a wealthy banking family in Houston in 1858 and was educated on the East Coast. Over his long career he became quite influential in both the political and economic realms in Texas, and later, beyond the state. House managed the successful reelection campaign of Governor Jim Hogg in 1892, then succeeded in getting Charles Culberson, Joseph D. Sayers, and S. W. T. Lanham all elected governor. Turning to the national scene, he was instrumental in the election of Woodrow Wilson in 1912 and became his closest adviser and confidant. After Wilson's death, House remained active in Democratic Party matters. He died in New York in 1938.

A formal portrait of Colonel Edward M. House (1858–1938), circa 1900.

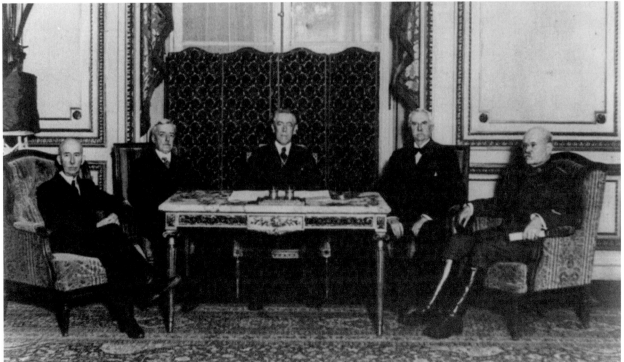

Colonel House at far left, with President Wilson, middle, in Paris in 1919, during the peace negotiations to end World War I.

Thomas Mitchell Campbell

Thomas Mitchell Campbell was the second native son elected governor of Texas. He was born near Rusk and was a childhood friend of Jim Hogg. Although he was a railroad lawyer, his two terms as governor in 1906 and 1908 were marked with such progressive legislation as antitrust laws and clean food acts. After serving as governor he returned to his legal practice. Campbell died in 1923.

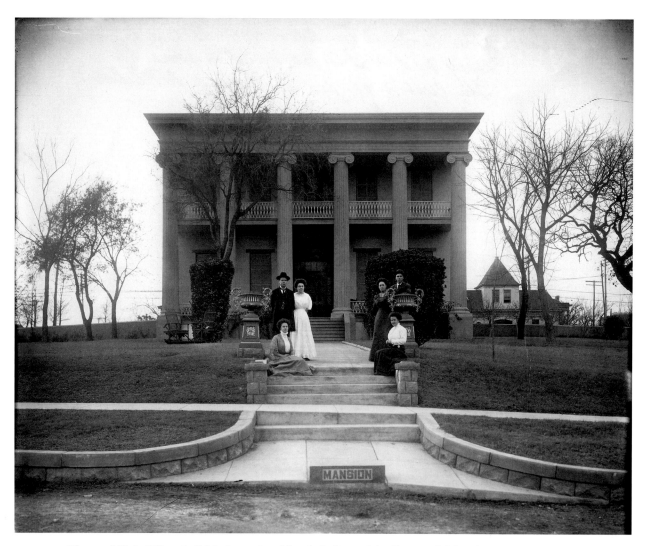

Thomas Mitchell Campbell (1856–1923) and family in front of the Governor's Mansion, circa 1906–1908.

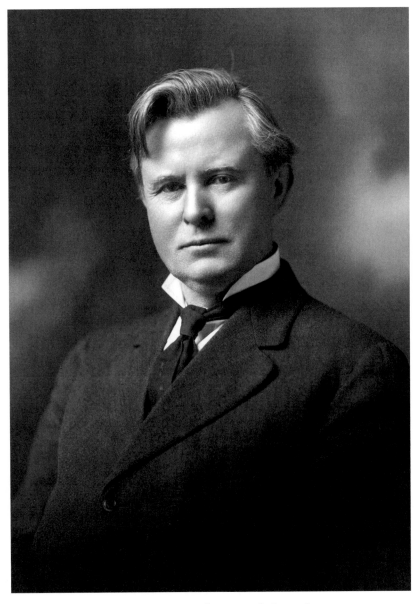

Martin McNulty Crane (1855–1943), date unknown.

Martin McNulty Crane

Martin McNulty Crane, born in West Virginia, moved to Cleburne, Texas, and in 1877 began a law practice. Shortly thereafter, he entered politics and was elected to the Texas House and Senate, then became lieutenant governor, and eventually, in 1894, attorney general. While in that office, he prosecuted and won the Waters-Pierce Oil Company case, the major antitrust case of its time. He also battled the Ku Klux Klan and, in 1917, served as special counsel in the impeachment of Governor Jim Ferguson. He died in 1943.

William F. Ramsey

Villiam F. Ramsey practiced law in Johnson County. He was appointed to the Court of Criminal Appeals in 1907 and the Texas Supreme Court in 1911. In 1912, he ran as a prohibitionist candidate for governor against Oscar Branch Colquitt and lost. Ramsey was the father-in-law of Supreme Court Justice Tom C. Clark and the grandfather of U.S. Attorney General Ramsey Clark.

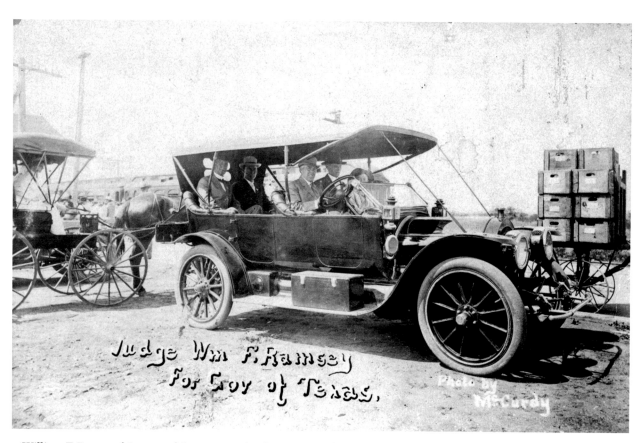

William F. Ramsey (1855–1922) in 1912, running for governor of Texas. Ramsey was probably in the back seat, on the right.

James H. "Cyclone" Davis

James H. "Cyclone" Davis was born in 1853. A Populist and noted orator, he was elected to Congress in 1914 for one term. Over the years, he ran for other positions, but never again held office. He died in 1940.

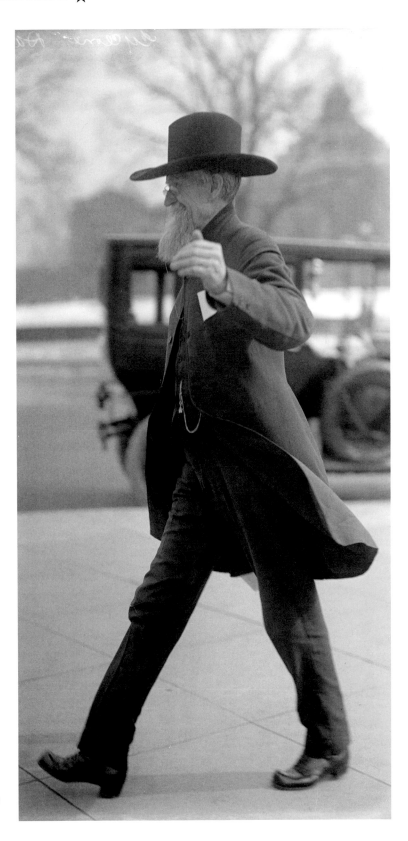

*James H. "Cyclone" Davis
(1853–1940), circa 1914.*

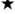

Oscar Branch Colquitt

Oscar Branch Colquitt, born in Georgia, came to Texas in 1878, where he first worked as a tenant farmer. Entering the field of journalism, he became friends with governors Hogg and Culberson and became a state senator in 1895. In 1910 Colquitt was elected governor and was reelected in 1912. As governor, he opposed Prohibition and continued to do so after leaving office. Presaging future governors, he complained bitterly about the federal government's failure to protect the borders during the Mexican Revolution. Colquitt was a Herbert Hoover supporter in 1928. He died in 1940.

(above) Governor Oscar Branch Colquitt (1861–1940), campaigning in Grand Saline, 1912.

(right) Watermelon for Colquitt supporters—and none for the supporters of Judge William F. Ramsey, his opponent, circa 1912.

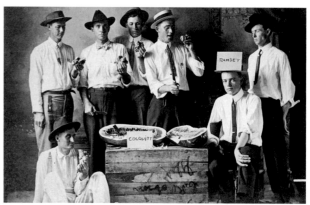

A boy sent this postcard showing his support for Colquitt for governor and Joseph Weldon Bailey for president, 1911.

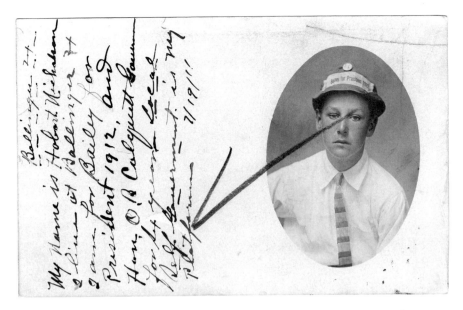

Governor Colquitt, in top hat, at the 1914 Houston Carnival.

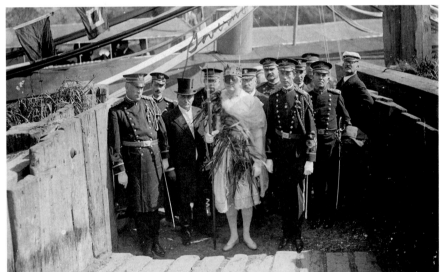

Texas Senate Chamber decorated for Governor Colquitt. The dates 1913 to 1915 cover his term of office.

The Governors Ferguson

James Edward (Jim) Ferguson and Miriam A. Wallace were both born in Bell County, he in 1871 and she in 1875. Ferguson became a farmer, then a lawyer and banker. In 1899, Ferguson and Wallace were married. He was elected the anti-Prohibition governor in 1914 and, during his first term, dealt with tenant farms, education, and troubles on the Mexican border.

Reelected in 1916, Ferguson soon butted heads with the University of Texas over faculty issues and finances. Later, financial misdeeds of the governor's were discovered and, in 1917, he was impeached and convicted. Not allowed to run for office again, he persuaded his wife Miriam to try for the job in 1924, telling voters they would get "two governors for the price of one." (Popularly, they were known as "Ma" and "Pa" Ferguson.) Miriam Ferguson defeated both Ku Klux Klan and Prohibition candidates to win the office that year, and though losing reelection bids in 1928 and 1930, she succeeded in winning again in 1932. Fergusonism had lasted twenty years.

Jim Ferguson died in 1944 and Miriam Wallace Ferguson died in 1961.

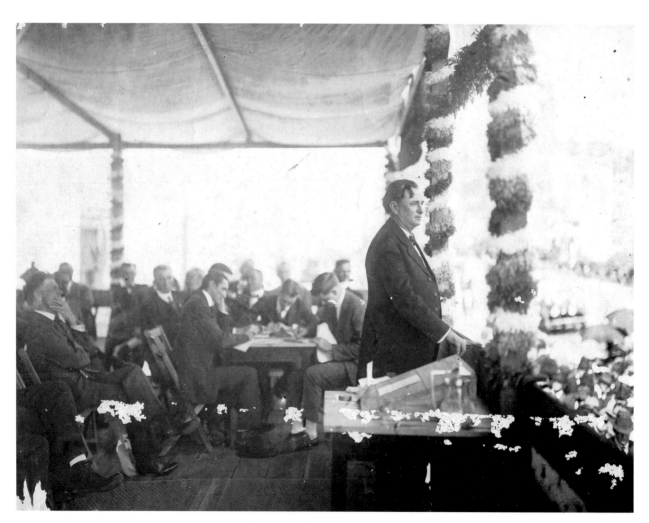

Jim Ferguson (1871–1944), making a speech, date unknown.

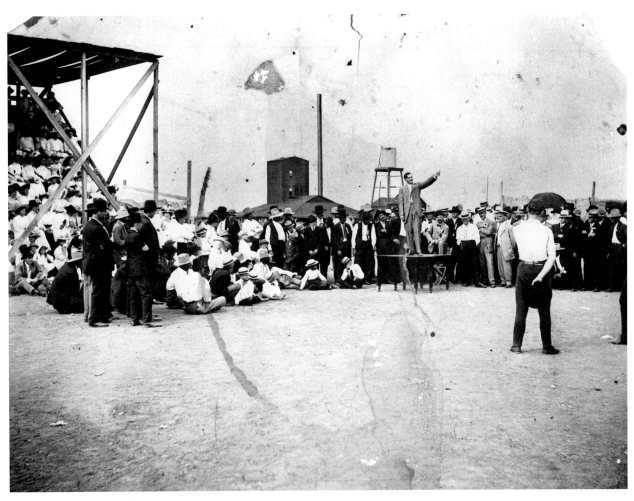

"Pa" Ferguson supporter Method Pazdral from West, Texas, campaigned for Ferguson at a baseball park in Granger in 1914.

Governor Jim Ferguson, watching from the Capitol windows, observes an anti-Ferguson, pro–University of Texas parade, circa 1916.

University of Texas supporters staged an anti-Ferguson protest regarding the governor's treatment of UT faculty issues, circa 1916. In the protest, Governor Ferguson's administration is compared to kaiserism, as World War I was ongoing.

Miriam Ferguson (1875–1961) and her chickens—she always portrayed herself as a homebody. The date of the photo is unknown.

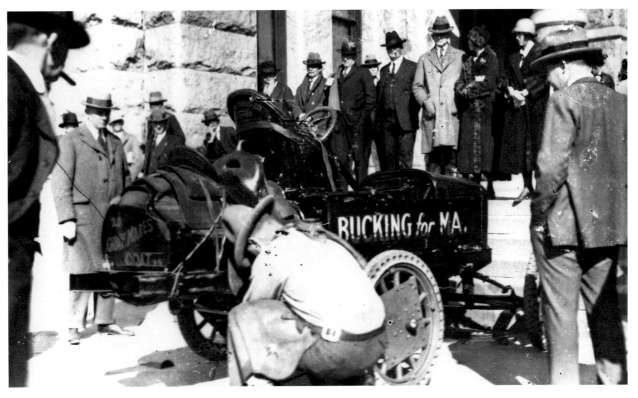

"Bucking for Ma" in front of the Texas Capitol, circa 1924.

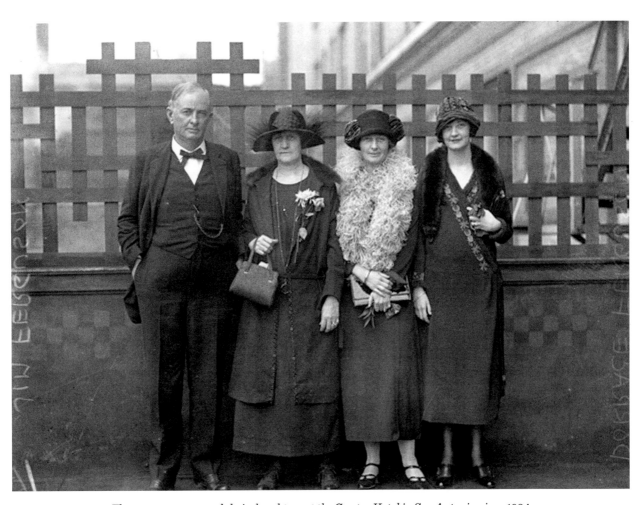

The two governors and their daughters at the Gunter Hotel in San Antonio, circa 1924.

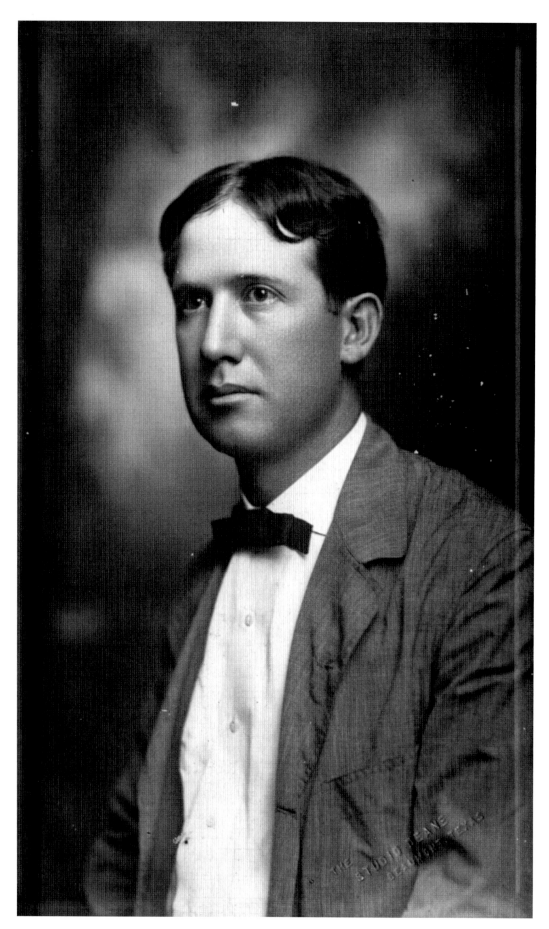

William P. Hobby (1878–1964) as a young man, date unknown.

William P. Hobby

William P. Hobby was born in 1878 into a politically active family; his father served in the Texas Senate and his uncle in the Texas House. Later his son would serve as lieutenant governor; his wife, Oveta Culp Hobby, would serve as the first secretary of the Department of Health, Education, and Welfare; and his grandson would run for state comptroller. Running against Prohibition, Hobby was elected lieutenant governor in 1914 and 1916. In 1917, he ascended to the governor's job upon the impeachment of Jim Ferguson. The next year, he was elected on his own. After retiring from politics, Hobby purchased and operated the *Houston Post*. He died in 1964.

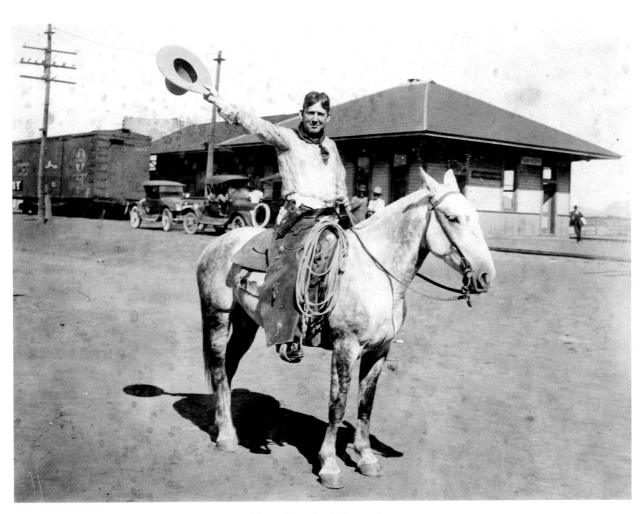

Hobby on horseback, date unknown.

Voting in Urban Texas

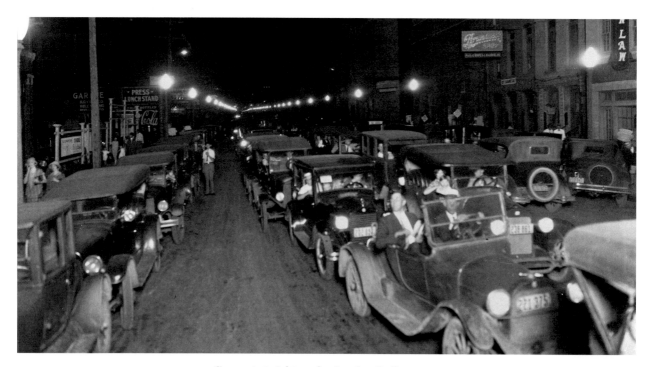

Cars out at night on election day, Dallas, 1925.

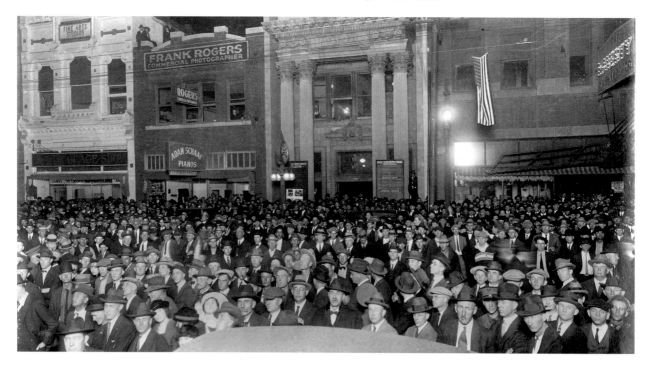

On the night of a city election, Dallas, circa 1930s.

Albert Sidney Burleson

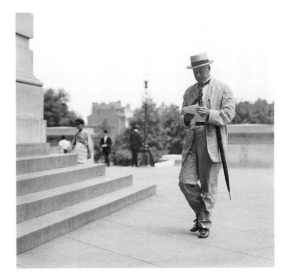

Albert Sidney Burleson was born in 1863 in San Marcos into a famous family. His grandfather, Edward Burleson Sr., had been vice president of the Republic of Texas, and his father, Edward Burleson Jr., had been a Texas Ranger and a delegate to the 1876 Constitutional Convention. Albert Sidney Burleson was a lawyer and was elected to Congress in 1899. He served until 1913 when President Wilson appointed him U.S. postmaster general. He served until 1921. Nicknamed "the Cardinal," he was a talented infighter and his federal office increased his power in Texas. Burleson died in 1937.

Albert Sidney Burleson (1863–1937), 1911.

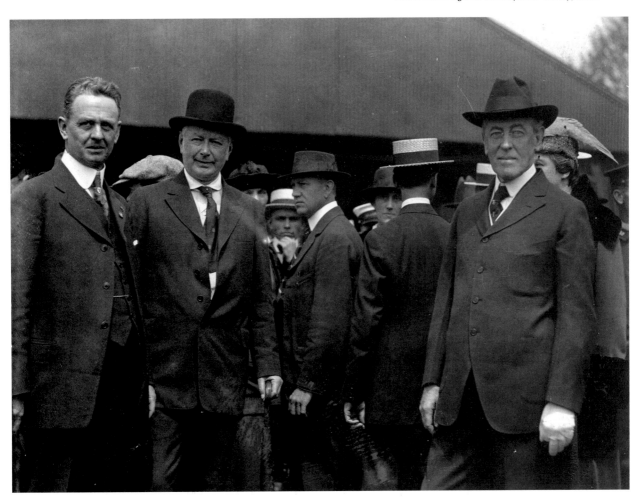

Postmaster General Burleson, second from left, and President Woodrow Wilson, far right. The photo is circa 1913.

Earle B. Mayfield

Earle B. Mayfield was born in 1881 in Overton, Texas. He served in the Texas Senate from 1907 to 1913, then made a run at the U.S. Senate in 1922 with the alleged help of the Ku Klux Klan. Though he became known as the Klan candidate, he still won the Democratic primary runoff against Jim Ferguson. Mayfield went on to to serve as senator until 1929, when he was defeated by Tom Connally. He retired to Tyler and died in 1964.

Earle B. Mayfield (1881–1964) circa 1923.

John Morris Sheppard

John Morris Sheppard, who went by the name Morris, was born in 1875. A Democrat, he spent ten years in the U.S. House of Representatives. In 1913, he won the Senate seat recently held by Joseph Weldon Bailey. He served in the Senate until his death in 1941. His strong Prohibition beliefs led to passage of the Eighteenth Amendment to the Constitution in 1920. Sheppard became known as "the father of Prohibition."

Morris Sheppard (1875–1941), circa 1914.

Senator Sheppard, in 1919, with 7'6" cowboy Ralph E. Madsen from Nebraska.

Annie Webb Blanton

nnie Webb Blanton was born in Houston in 1870. She taught public school and became active in the Texas State Teacher Association. A suffragette, Blanton ran for state school superintendent in 1918 and succeeded, becoming the first woman to be elected to a statewide office. After an unsuccessful run for Congress, where her brother, Tom Blanton, served several terms, she taught at the University of Texas. Blanton died in 1945.

Annie Webb Blanton (1870–1945), seated behind her desk with two unidentified women, 1941.

Jane Y. McCallum

Jane Yelvington was born to a Wilson County sheriff and his wife in 1877. After marrying Arthur McCallum, she moved to Austin, where she became renowned in the women's suffrage movement. After women's suffrage became law, McCallum formed the Joint Legislative Council, a coalition of women's organizations, and was helpful in electing Dan Moody governor. She was appointed Texas secretary of state by both Moody and Governor Ross Sterling. She died in 1957.

Jane Y. McCallum (1877–1957), date unknown.

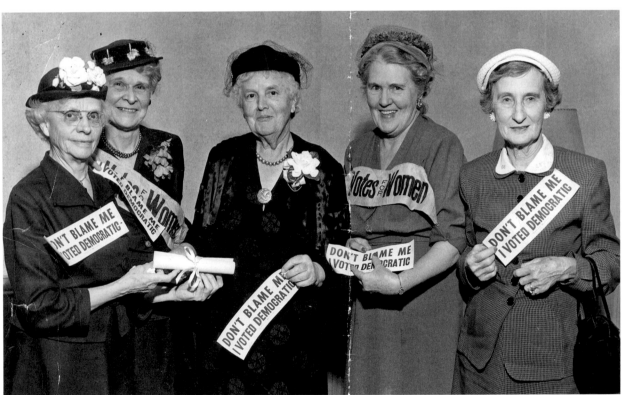

Suffragette veterans, including Jane McCallum, second from left, show support for the Democratic Party in Texas, circa 1952–1956.

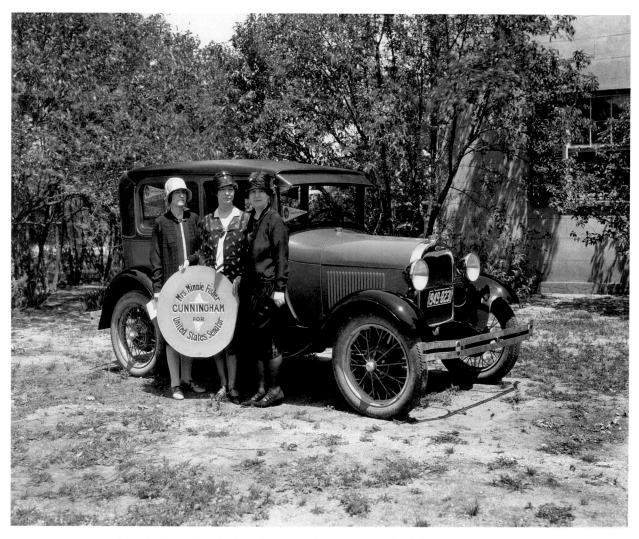

Minnie Fisher Cunningham (1889–1964) campaigning for the U.S. Senate in 1928.

Minnie Fisher Cunningham

Born in 1889, Minnie Fisher was introduced to politics at a young age by her father, a member of the Texas Legislature in the 1850s. After marrying Bill Cunningham, she moved to Galveston, where she became a leader of the women's suffrage movement. After the passage of the suffrage law, Cunningham formed the League of Women Voters and, in 1928, ran for the U.S. Senate against the Klan-supported candidate, Earle B. Mayfield. She lost, but tossed her support to the eventual winner, Tom Connally. In 1944 she ran for governor and finished second in the Democratic primary out of a large field of candidates. She retired a few years later and died in 1964.

President Harding in Texas

President Harding served in the early years of the Roaring Twenties; he enjoyed vacations in Texas while he campaigned.

(right) Warren G. Harding campaigning in South Texas, November 1920.

(below) Harding is shown, in white shoes and broad-brimmed hat, fishing on the Texas Gulf Coast, November 1920.

Pat Neff

Pat Neff was born in McLennan County in 1871. He was educated at Baylor and began his legal career in 1897. In 1900 he was elected to the Texas House of Representatives and became Speaker in 1903. In 1905 he resumed his legal practice, serving as a prosecutor, and in 1920 ran for governor and was elected. He was reelected in 1922. Later Neff served as chairman of the Texas Railroad Commission and as president of Baylor. He died in 1952.

Pat Neff (1871–1952) at Stuart Brothers Ranch, date unknown.

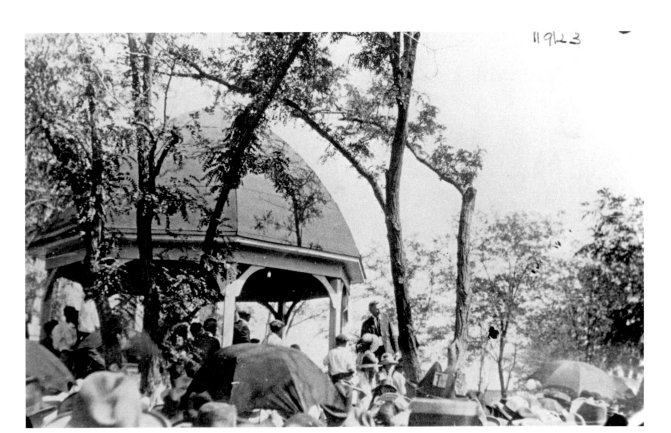

11923

Pat Neff speaking in Lubbock, 1923. Neff signed the legislation creating Texas Tech University.

Governor Neff delivering a speech supporting state parks in Gonzales, 1924.

Neff, left, and W. Lee O'Daniel on horseback, probably during an O'Daniel inaugural event, date unknown.

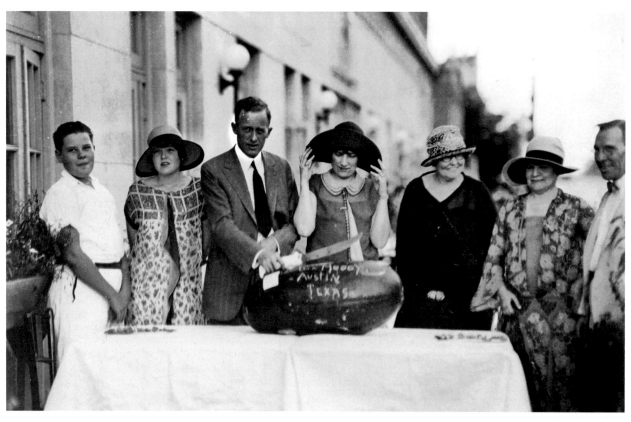

Dan Moody (1893–1966), cutting into a watermelon in Austin, date unknown.

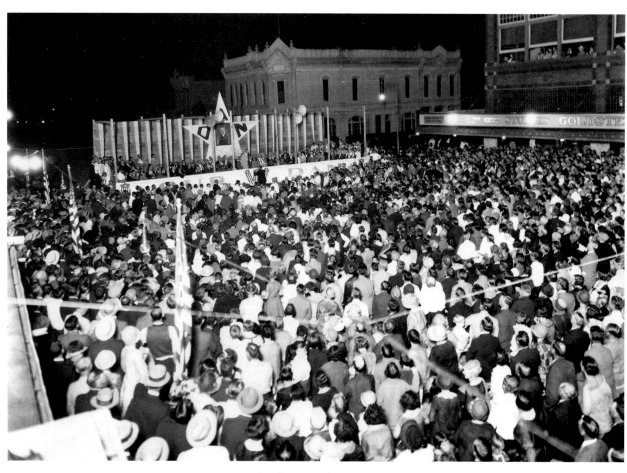

Moody rally in Taylor, circa 1928.

Dan Moody

D an Moody was born in Texas in 1893. He became a prosecuting attorney and received widespread fame for his convictions of four Klansmen for a local assault. He was elected Texas attorney general in 1924. In 1926 he took on the Ferguson machine, winning the governorship and holding it for two terms. He unsuccessfully challenged Senator O'Daniel for his seat in 1942 and later opposed Roosevelt's fourth term as president. Moody died in 1966.

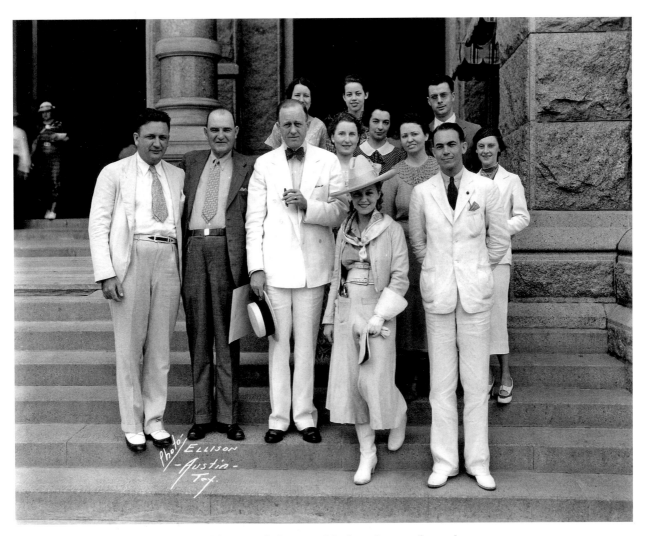

In front of the Capitol, Governor Moody and guests, date unknown.
The governor is in the middle, wearing a white suit and bow tie.

Ross S. Sterling

oss S. Sterling was born near Anahuac in 1875. Early in his life he was involved in several businesses: he ran a feed store, worked in the lumber business, and became a banker. Around 1910, he started buying oil leases and eventually formed the company that became Humble Oil. After serving on the Texas Highway Commission, Sterling ran for governor. He won, and was immediately faced with the Great Depression and oil industry wars. In 1932, he was defeated for reelection by Miriam Ferguson, bringing the Fergusons back to power one last time. He later encouraged a young Dolph Briscoe Jr. to enter politics. Sterling died in 1949.

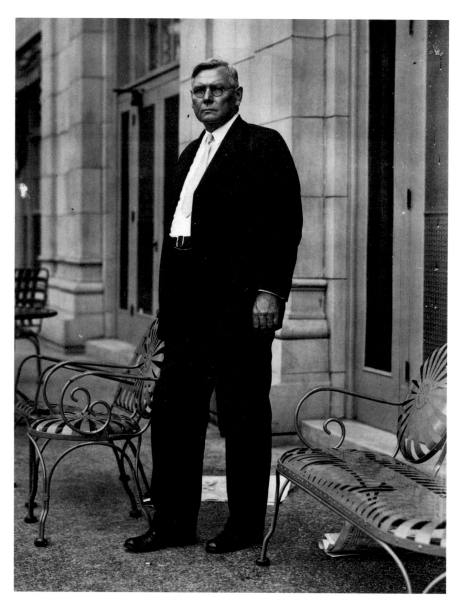

Ross Sterling (1875–1949), circa 1930–1932.

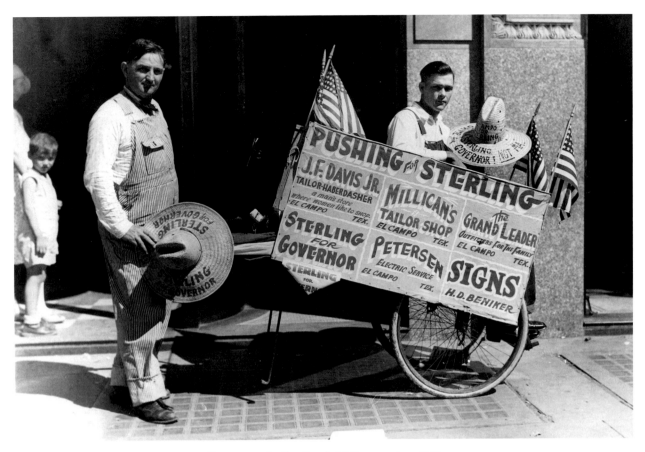

Supporters for Sterling in El Campo, circa 1930.

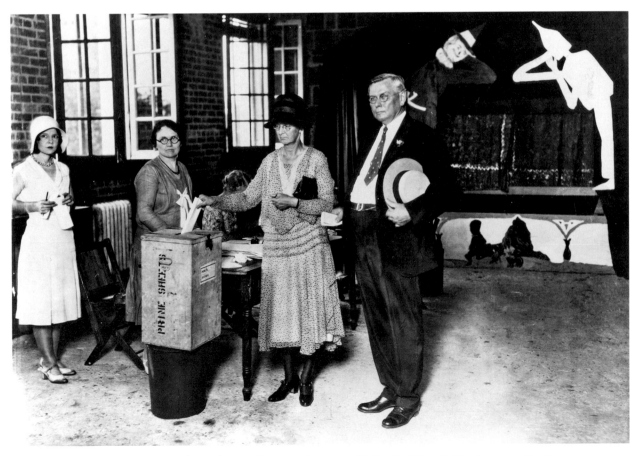

Governor Sterling and his wife, Maud, voting, circa 1932. Notice the Wizard of Oz *figures on the stage.*

TEXAS
in the
GREAT DEPRESSION
and
WORLD WAR II

THE CRASH OF 1929

At the onset of the Great Depression, many people in Texas and throughout America refused to believe that hard times were ahead. Recessions and economic downturns had always been parts of American life. However, following the initial market crash on October 29, 1929, the stock market lost over 40 percent of its value in only a few weeks and the economic shock waves began to be felt across the nation. Yet even President Herbert Hoover, who had just taken office following a smashing victory in 1928, believed that the American economy was sound, the market would rebound, and good times were just around the corner.

But hard times did indeed arrive and became rooted in Texas and throughout the nation. Record unemployment, bank and business closures, extreme weather conditions, and many other difficulties damaged both the economy and the American psyche. As late as the spring of 1931, predictions were still being made that the Depression was to be short-lived. The Fort Worth *Star-Telegram* reported, "In America, we don't know what hard times are.

Certainly these times are not hard, except for the utterly improvident, the idle, and the shiftless—and all times are hard on them." Still, in spite of the optimistic rhetoric in the press and from political leaders, most Americans understood that the Depression was a real economic disaster.

THE NEW DEAL IN TEXAS

With the election of President Franklin Roosevelt and Vice President John Nance Garner in 1932, Americans chose a new, activist leader to save the nation. Texas governor James Allred chose to work closely with the Roosevelt administration and Congress to confront the effects of the Depression in Texas. With the help of a number of influential Texans in Congress and the Roosevelt administration, over $100 million poured into federal programs that provided jobs and loans and that funded buildings, highways, and dams in the state.

Next to President Roosevelt, Vice President Garner of Uvalde became the single most influential leader in the early New Deal years. Garner's political knowledge combined with the respect afforded to him by his colleagues in the House of Representatives and the Senate were invaluable to Roosevelt. And Garner's whiskey drinking and poker playing with his congressional colleagues helped lubricate the legislative process for the New Deal in its early years. Because Garner knew the strengths and weaknesses of both houses he was able to push bills through or bury them. A master at working individual senators on the floor, he was the "wise old man of Congress." On most evenings after a legislative session Garner would convene his "Board of Education," where he held court over bourbon and branch.

The influence of the Texas congressional delegation and especially Garner's protégé Sam Rayburn of Bonham, Texas, provided vital support to the New Deal programs. From 1933 to 1938 no fewer than eight Texans held regular committee chairmanships and chaired two special committees. Rayburn learned invaluable lessons at Garner's "Board of Education" sessions that propelled him into becoming House majority leader in 1937 and Speaker of the House in 1939. Rayburn also continued the sessions and helped tutor his own protégé—Congressman Lyndon B. Johnson.[1]

The relationship between Garner and Roosevelt began to unravel after the landslide victory of 1936. Tensions arose over Garner's criticism of expanding the New Deal, Roosevelt's ill-fated court-packing plan, and the president's opposition to many of Garner's friends in the Senate and the House in the 1938 elections. Garner opposed Roosevelt's effort to seek a third term and unsuccessfully sought the Democratic presidential nomination himself in 1940. He left Washington in 1941 with a vow never to return to the nation's capital, a place where he had served for nearly forty years.

A crucial appointment made by President Roosevelt was the selection of Jesse H. Jones of Houston to head the Reconstruction Finance Corporation (RFC). The RFC used federal money to provide low-interest loans to the nation's banks and businesses that had been hardest hit by the Depression, attempting to stem the tide of bank failures and business closures. Ultimately the RFC loaned over $10 billion to banks, railroads, construction programs, and private businesses. All of this money was repaid, with interest, which made the RFC one of the most successful New Deal agencies. Jones became known as one of the most powerful men in Washington.

Other well-known Texas business leaders recognized new opportunities to end hardship in their communities. Fort Worth publisher Amon Carter Sr., a close friend of Jesse Jones, became a prominent booster for Texas in Washington, DC. In some Washington circles, the Lone Star State became known as the "star loan state."

One well-known federal agency, the Civilian Conservation Corps (CCC), enrolled over 10,000 men from the ages of 17 to 28 in forty-two different camps across the state of Texas, paying each $30 per month. (Over 100,000 Texans joined the CCC to work in camps across the nation.) The Public Works Administration (PWA) provided millions of dollars for building public buildings, schools, post offices, hospitals, coliseums, and dams. The Works Progress Administration (WPA) provided workers for these projects and also provided funds for the visual arts, literature, writing, and music. These contributions are fervently reflected in many images from this era.

Lyndon B. Johnson, then only twenty-seven years old, became state director of the National Youth Administration (NYA). Johnson employed over ten thousand students a month in part-time and full-time jobs to help in offices, roadside parks, highway construction, campgrounds, and public schools. Unlike the leaders of the other New Deal programs, Johnson helped place about nineteen thousand young African American men and women in the NYA, making it the only program in the South to enroll minorities.

In fact, in other New Deal programs in Texas and the rest of the South, cooperation with the federal government depended on non-interference with segregation and the preservation of the existing political and social order. During the 1930s, northern newspapers and political leaders, beset by their own problems, leveled little criticism at the segregated South. Roosevelt and his New Deal administrators instead attempted to focus on preserving political support and earning healthy press coverage.

THE TEXAS CENTENNIAL

The centennial of Texas's independence in 1936 provided an opportunity to significantly improve the state's economy and change its image. Even as

economic conditions worsened throughout the state in the 1930s, the idea of an extended celebration of Texas's past gained momentum. Leaders wanted not just a grand party but also a celebration that would provide real improvements, jobs, and dollars for the state economy. Thus a concerted campaign began for the use of not just local funds but also state and federal dollars to fund the many events and projects.

One shining example of this fundraising occurred at Fair Park in Dallas. The state contributed over $1 million to Fair Park while the federal government contributed $1.5 million and funded more than fifty Dallas murals as part of the Public Works of Art Project. The Texas Hall of State, a million-dollar building to honor Texas heroes, became the centerpiece of the permanent buildings. The park site included museums and exhibition buildings for petroleum, communications, agriculture, transportation, and industry. Next door in Fort Worth, Amon Carter Sr.'s promotions attracted a somewhat different clientele. The "Frontier Follies" at the Casa Mañana (financed through generous RFC loans and federal funds) featured Wild West shows, chorus lines, Sally Rand's bubble dance, risqué performances, and ample supplies of liquor. As Carter assured his friend Jesse Jones, "Nothing like it has ever been shown in America." Everyone seemed to enjoy the shows and forget their troubles. And it seemed that America discovered Texas and its political leaders in the process.

At the dedication of the Texas Centennial Exposition in Dallas on June 7, as the *Dallas Morning News* reported, the festivities opened "before the largest crowd ever gathered in the Southwest." An estimated 250,000 people attended, "making it the greatest occasion in the history of Dallas and the most notable event in Texas since Sam Houston and his men changed the course of the New World at San Jacinto." Extensive coverage over radio stations and in the state's newspapers heightened enthusiasm for the great event. Texas governor James Allred introduced Secretary of Commerce Daniel Roper. As he inserted a gold key to unlock the ceremonial gate, Roper proclaimed, "Texas welcomes the world."[2]

A host of state and national dignitaries attended centennial events around Texas and reaped a harvest of favorable publicity. President Roosevelt, Vice President Garner, Jesse Jones, Sam Rayburn, James Allred, Amon Carter Sr., Lyndon Johnson, and many other notable figures appear in the historic photos of this era. The Texas Centennial Exposition closed in November 1936 with more than six million people having attended the six-month-long celebration. Along with the oft-photographed politicians and beauty queens, over 350,000 schoolchildren from Texas and other states took part. The festivities laid the foundations for a growing tourist trade and provided economic relief in the form of thousands of jobs and substantial improvements in many communities around the state. Many structures from the event are still present

and viable today. The celebrations also brought relief from the ongoing economic depression and lifted the spirits of many of the state's citizens.

TEXAS IN WORLD WAR II

With the outbreak of World War II in December 1941, Texas eventually provided nearly 750,000 troops for the war effort, including 12,000 women. Over 80,000 African American men served in segregated units in the armed forces. Only a year into the war, in December 1942, Secretary of the Navy Frank Knox stated that Texas was contributing a larger percentage of men to the fighting forces than any other state. Over 23,000 Texans were killed during the war.

Beyond manpower, Texas was also instrumental in providing facilities for training and manufacturing. The army had fifteen training posts in Texas while the Third Army and the Fourth Army established headquarters there. Many Americans came to Texas for training in army and aviation units. In San Antonio, Fort Sam Houston served as the headquarters of the Third Army and trained troops from throughout the nation. Randolph Field, Kelly Field, and Brooks Field were all expanded for air training. Fort Worth became home to the national headquarters of the American Air Force Training Command. Aircraft manufacturing plants in the Dallas–Fort Worth area produced thousands of aircraft and Texas ports were home to dozens of shipyards.

Many Texans were recognized for their valor in the war. Audie Murphy of Farmersville became the most decorated soldier of World War II. In all, thirty Texans received the Medal of Honor, including five Mexican Americans. Six Texans received the navy's Medal of Honor, including Doris Miller, the African American sailor who shot down four Japanese aircraft at Pearl Harbor. Commander Samuel D. Dealey was the most decorated man in the navy and was killed during the war. James Earl Rudder served with distinction as commander of the Second Ranger Battalion during D-Day.

Other prominent Texans who contributed significantly to the war effort were Dwight Eisenhower, who was born in Denison; Fleet Admiral Chester W. Nimitz, who was the commander-in-chief of the Pacific Fleet; and Oveta Culp Hobby, wife of former governor William Hobby and the director of the Women's Army Corps.

MARTIN DIES JR.: PREDECESSOR TO JOE McCARTHY AND McCARTHYISM

Congressman Martin Dies Jr. of Texas, first elected in 1930, represented the Piney Woods of Southeast Texas. An ardent opponent of Franklin Roosevelt and the New Deal, Dies believed that any government attempts to abolish poverty and unemployment amounted to a "dictatorship." Dies was strongly

supported by lumber baron John Henry Kirby of East Texas. He became best known as the chairman of the House Un-American Activities Committee, an office that he held from 1938 through the end of World War II. Following the death of Huey Long in 1935, the administration was still fearful, in the years preceding the war, of an extremist leader rising up whose demagoguery would take hold of the nation—and Dies fit the mold.

Dies's favorite theme was the alleged widespread communist penetration of the federal government. At various times the Dies committee estimated that more than one thousand communists worked in the federal government and that some high officials in the Interior Department were members of communist front groups. Dies also accused many Democrats who were supporting New Deal programs and Roosevelt of being friendly to communists, and helped defeat a number of these members.

In the special senate election of 1941, Dies accused candidate Lyndon Johnson of being duped by a Nazi agent and accused the Texas attorney general of placing communists on the ballot. Throughout his career, Dies urged attacks against those who disagreed with him and his views. He slandered his opponents and other innocent individuals by accusing them of subversion, fascist leanings, or communist sympathies. The House Un-American Activities Committee, rather than focusing on activities aimed at the government from foreign countries in World War II, worked as a wrecking crew to attack individuals and organizations through slogans, half-truths, and outright lies and slander. The congressman and his committee laid the groundwork for Joe McCarthy and his techniques in the 1950s.

NEW OPPORTUNITIES CREATED BY WORLD WAR II

World War II marked a sharp reversal in the course of American history, renewing hope where the Depression had brought despair. The Depression had left in its wake a population decline, devastated communities, and shattered dreams; the war brought population growth, resurgent communities, and rising expectations. The war was, of course, a multifaceted event that had different results for different groups of people, depending on their geographic locations and socioeconomic status before, during, and after the war.

What was distinctive for one group, Mexican Americans, was that, for the first time, they—both men and women—were working and serving in the armed forces as equals with whites. When the military called for recruits, Mexican Americans responded in great numbers and went on to serve with distinction. Some 350,000 Mexican Americans served in the armed services and won seventeen Medals of Honor. The war also brought industrial expansion, further aggravating the labor shortage caused by growth of the armed

forces. Mexican Americans thus managed to gain entry to jobs and industries that had been virtually closed to them in the past.

Enlistment in the armed forces during World War II also created new opportunities for women in Texas. As part of the massive war effort, they became an essential part of the work force. Women worked in almost every conceivable job as men left employment to join the armed services. This included positions in factories, in agriculture raising produce and cattle, in aeronautics testing and flying airplanes, and in many other war-related industries.

The era of the Great Depression through World War II had a profound influence on the people, culture, and institutions of Texas, and the personalities and events of the era are well documented in the photographic history of this period. Many of the images have real resonance today. In many ways, the major issues of the present day—social and economic justice, expanded educational opportunities, the role of government and personal responsibility, and the development of a more diversified economy and culture—were being captured and defined during this critical era.

Andrew Jackson Houston

Andrew Jackson Houston, Sam Houston's second son, was once caught locking the Texas Senate doors so that the senators could only be rescued by yelling out the Capitol windows for help. He attended military school and once ran for governor as a Prohibitionist. In 1941, at age 87, he was appointed a U.S. senator by W. Lee O'Daniel, but he died several weeks later.

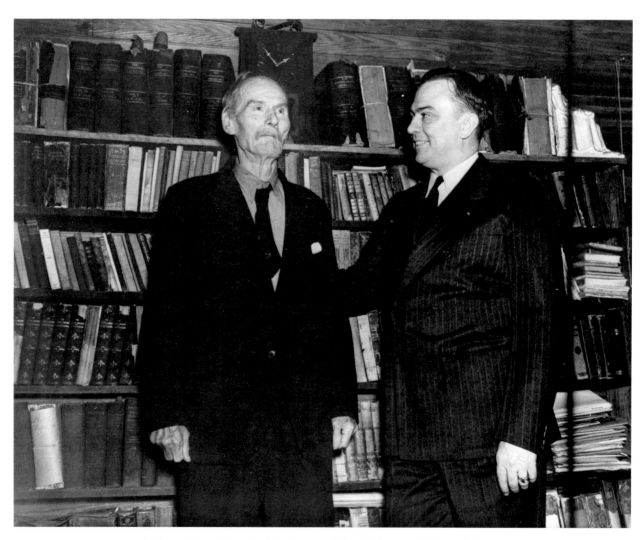

Andrew Jackson Houston (1854–1941), left, and Governor O'Daniel in 1941.

Adina De Zavala

Adina De Zavala was the granddaughter of founding father Lorenzo De Zavala. She was born in 1861 and was a teacher and historical preservationist who, along with Clara Driscoll, was instrumental in saving the Alamo from demolition.

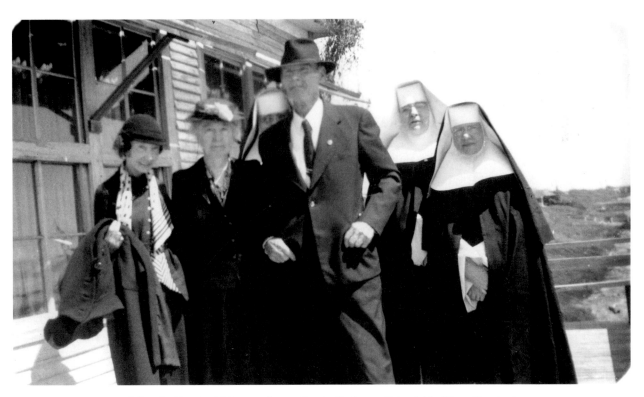

Adina De Zavala (1861–1955), standing to the immediate right of Sam Houston's son Andrew Jackson Houston in La Porte, Texas, May 1941.

John Nance Garner

John Nance "Cactus Jack" Garner, from Uvalde, was born in 1868. He entered politics at an early age, serving first in the Texas House. Elected to Congress in 1902, he became Speaker of the House in 1931. In 1932 and 1936 he was Franklin Roosevelt's vice president, but by the late 1930s he and Roosevelt had fallen out over several matters, including whether Roosevelt should run for a third term; in fact, Garner competed against the president in the primaries for the 1940 nomination. After losing, Garner left Washington and promised never to cross the Potomac again, and he stayed faithful to his promise. But as the "Sage of the Southwest," Garner hosted a number of birthday parties in his native Texas that were well-attended by influential political figures. President Kennedy's last phone call, on November 22, 1963, was a call to wish Garner a happy birthday. Garner died in 1967.

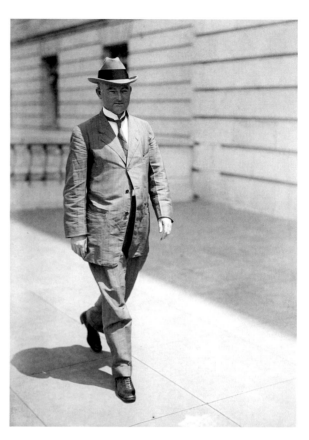

Early photo of Congressman John Nance Garner (1868–1967), 1913.

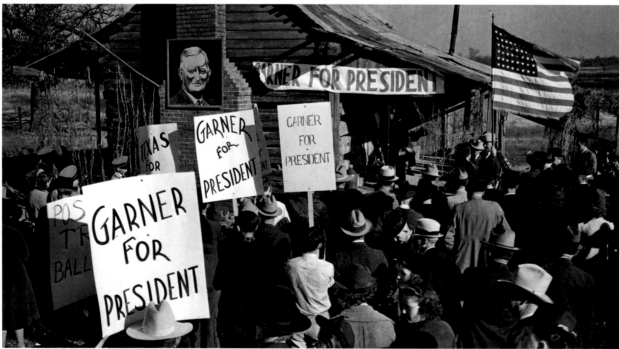

The headquarters of Garner for President, circa 1939.

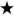

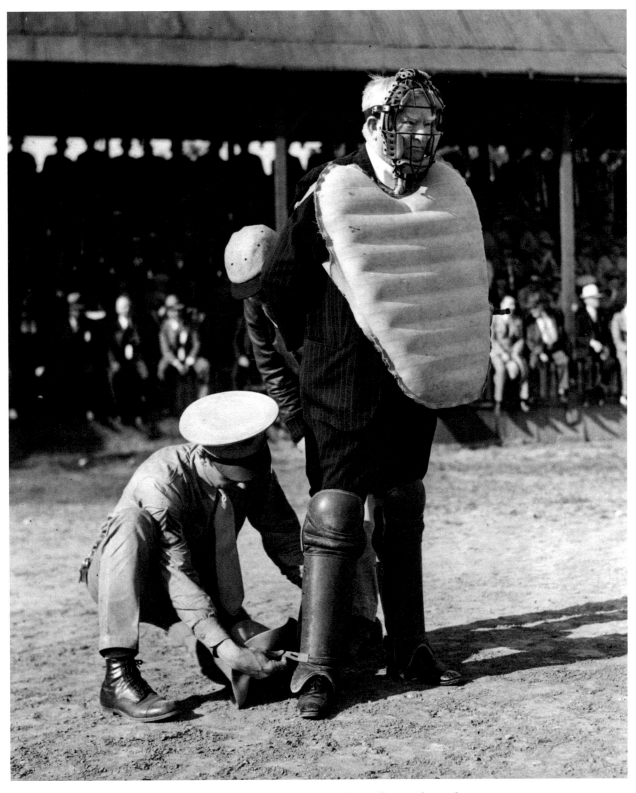

The vice president being suited up for a baseball game, date unknown.

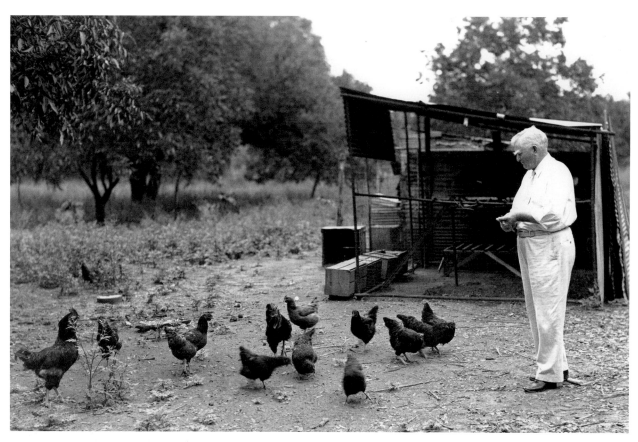

Vice President Garner "herding chickens," date unknown.

Garner enjoying a ripe watermelon, date unknown.

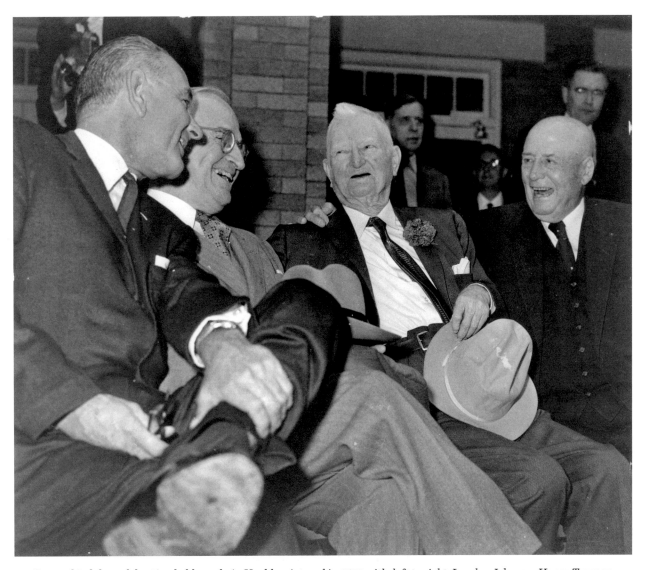

Garner birthday celebration held yearly in Uvalde, pictured in 1959 with, left to right, Lyndon Johnson, Harry Truman, Garner, and Sam Rayburn. Governor Dolph Briscoe Jr. is in the background, behind Rayburn.

Sam Rayburn

Sam Rayburn was born in 1882 in Tennessee. A few years later his family moved to East Texas, where he later attended college at what is now Texas A&M Commerce. In 1906, he was elected to the Texas Legislature, where he served as Speaker in 1909. He won a seat in the U.S. Congress in 1913, serving until his death in 1961. Known affectionately as "Mr. Sam," he served as Speaker of the House from 1940–1947, 1949–1953, and 1955–1961, making him the longest-serving Speaker in U.S. history. His funeral in Bonham was attended by presidents Kennedy, Eisenhower, and Truman, and then–Vice President Johnson.

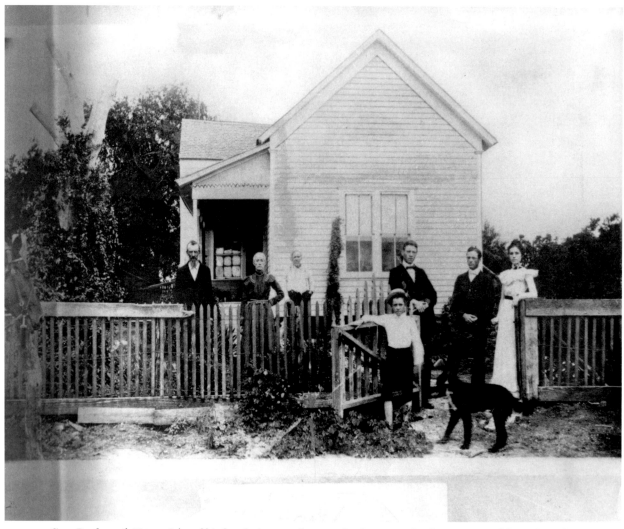

Sam Rayburn (1882–1961) and his family in an early portrait, circa 1902. Rayburn is second from the right.

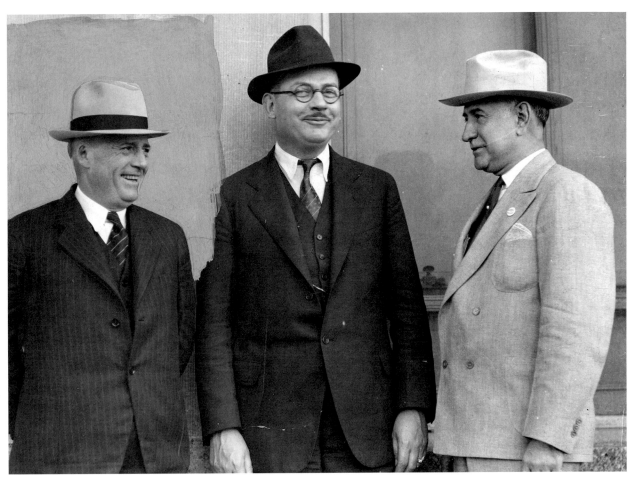

Congressman Rayburn, left, with Texas Lieutenant Governor Walter Woodul, middle, and Fort Worth publisher Amon Carter Sr., May 1932.

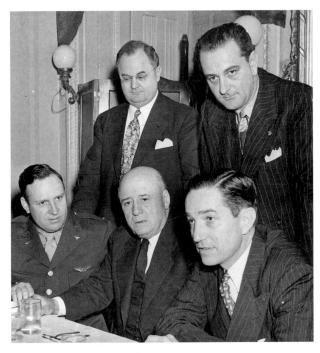

Sam Rayburn, seated in the middle, with cowboy star Gene Autry (in uniform); Herman Jones, later a Travis County district judge; and, standing, Congressman Wright Patman (left) and Lyndon Johnson, circa 1940s.

Speaker Rayburn with a bag of sweet Texas onions, July 1948.

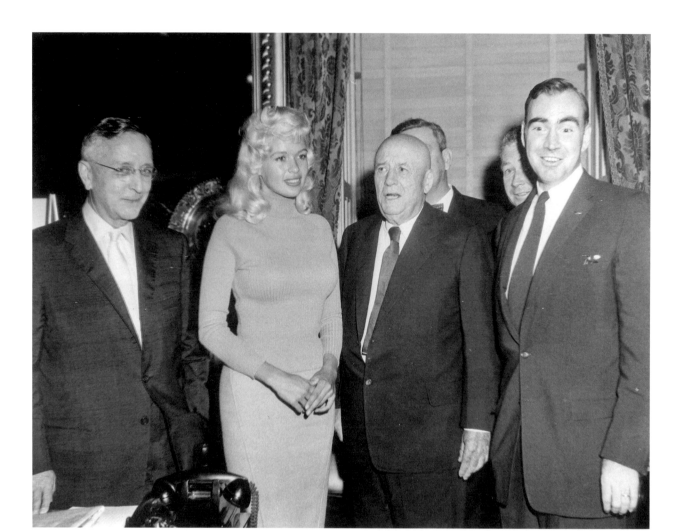

A reception for Dallas actress Jayne Mansfield with, left to right, Clark Thompson,
Speaker Sam Rayburn, and Congressman Jim Wright. The date is unknown.

Speaker Rayburn, at microphone, campaigning in Mabank, Texas, 1948.

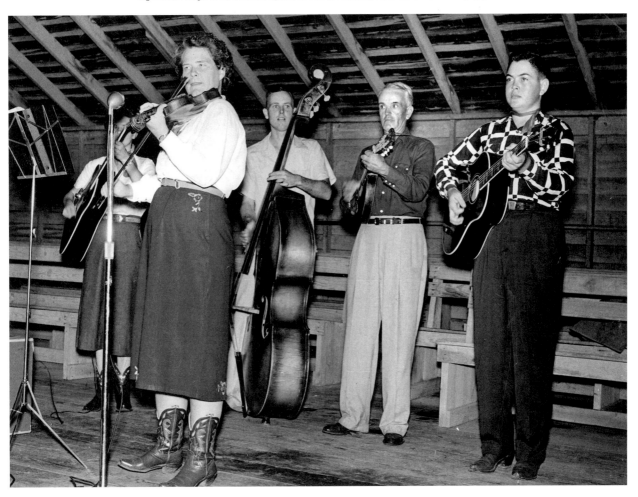

Country band playing during Rayburn campaign in Leonard (in his East Texas district), 1952.

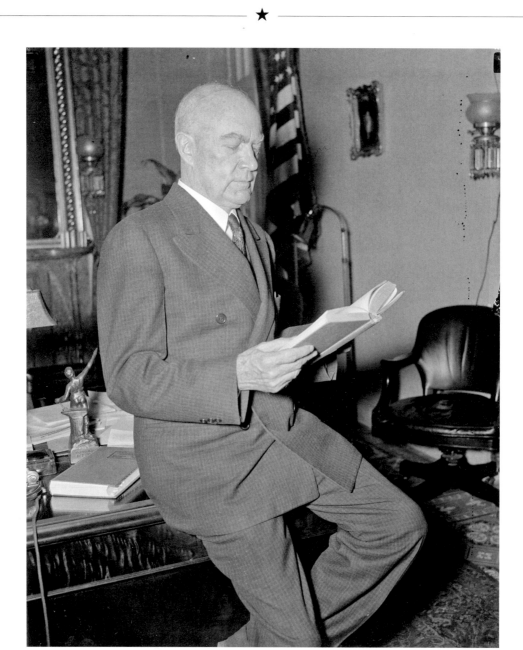

Hatton Sumners (1875–1962), 1938.

Hatton Sumners

Hatton Sumners was born in 1875 in Tennessee. A Democrat, he served as Dallas county attorney, then was elected to Congress in 1912. Moving from an at-large position to the 5th District, he served until 1947. One of the longest-serving Texans in Washington, he was chairman of the House Judiciary Committee and was probably kept off the Supreme Court due to his opposition to President Roosevelt's court-packing scheme in the 1930s. Sumners died in 1962.

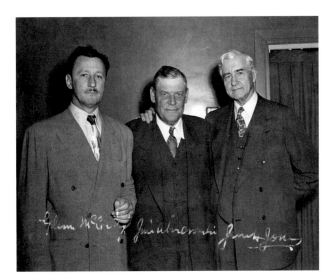

Jesse H. Jones

Jesse H. Jones was born in Tennessee in 1874. His family moved to Texas in the 1880s and by the 1890s he was getting established in Houston. Eventually he became successful in lumber, banking, and real estate, and in 1908 bought part of the *Houston Chronicle*. Early in the Depression, Jones was appointed by President Hoover to run the Reconstruction Finance Corporation. Jones was reappointed by President Roosevelt and served in that capacity until 1939. After other appointments, he became Secretary of Commerce in 1940. Despite his competent tenure, he split with Roosevelt over political issues and returned to Texas in 1945. He died in 1956.

Jesse H. Jones (1874–1956), at right, with wildcatter Glen McCarthy (left) and Houston oil man Jim Abercrombie, circa late 1940s. McCarthy, the king of the wildcatters, was the inspiration for the character Jett Rink in Giant. *Abercrombie founded Cameron Iron Works in Houston.*

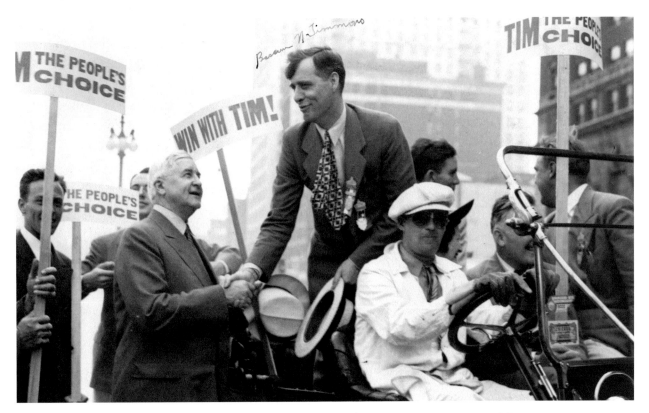

Jones at a Bascom Timmons campaign parade. Timmons, a long-time newspaperman and Garner supporter, decided, partly as a joke, to run for vice president in 1940 when John Nance Garner left the Roosevelt ticket.

Wright Patman

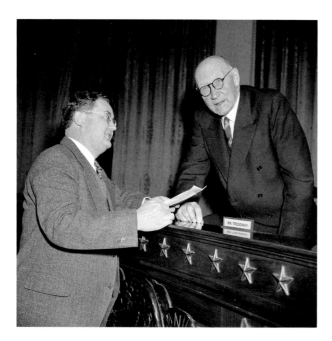

Wright Patman, a Democrat, was born in Cass County in 1893. After attending Cumberland Law School, he practiced law in East Texas. He was elected to Congress in 1928 and served until his death in 1976. Another long-tenured Texan, he served as the powerful chairman of the Banking and Currency Committee for over ten years.

Wright Patman (1893–1976), left, with Ways and Means chairman Robert Doughton, 1939.

Wright Patman and President Johnson, December 1967.

William Robert Poage

Democrat William Robert (Bob) Poage was born in Waco in 1899. After graduating from Baylor, he practiced law in Waco until 1936, when he was elected to Congress. He served until 1979. Poage chaired the Agriculture Committee in the House from 1967 to 1974. He died in 1987.

Bob Poage (1899–1987), circa 1930s.

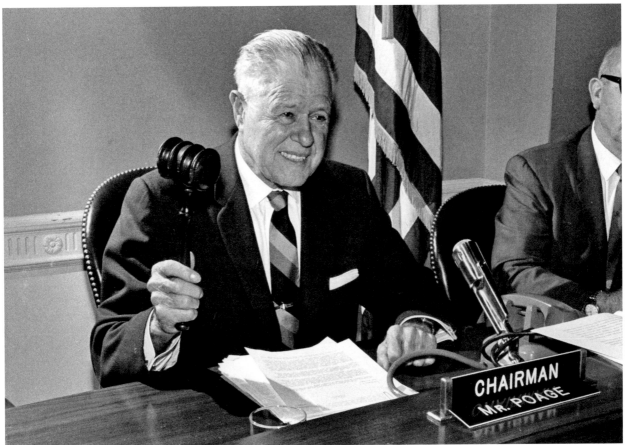

Chairman Poage, circa 1960s.

Martin Dies Jr.

Martin Dies Jr. was a Democrat from Southeast Texas who served in Congress from 1931 to 1945 and from 1953 to 1959. He was best known for his chairmanship of the House Un-American Activities Committee. As in the 1950s investigations conducted by Senator Joe McCarthy, Dies focused on real and imagined Hollywood ties to the Communist Party. In his enthusiasm, he included child star Shirley Temple as one among many Communist sympathizers. His political clout waned when it became obvious that his hearings were aimed more at attacking the New Deal than about protecting the nation during World War II. Dies died in 1972.

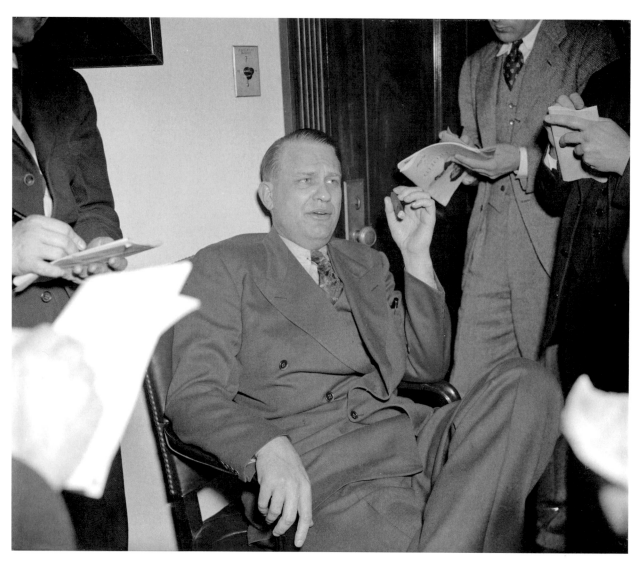

Martin Dies Jr. (1900–1972), 1941.

Albert Thomas (1898–1966), date unknown. The Harris & Ewing Collection in the Library of Congress has a number of photos of congressmen engaged in normal, everyday activities, such as shaving.

Albert Thomas

Albert Thomas was born in 1898 in Nacogdoches. A Democrat, he served as Nacogdoches county attorney and district attorney before being elected to Congress in 1936, serving until his death in 1966. His wife, Lera Thomas, served out his unexpired term as the first Texas woman in Congress.

Maury Maverick

aury Maverick, a Democrat from San Antonio and a descendant of an illustrious pioneer family, was a congressman from San Antonio from 1935 through 1938. He served as San Antonio's mayor from 1939 to 1941 and was the chairman of the Small War Plants Corporation during World War II. Maverick died in 1954.

Maury Maverick (1895–1954), 1937.

Nat Patton

Nat Patton was elected to Congress in 1935 and served four terms, after a career that included stints in the Texas House of Representatives and Texas Senate. He also served as county judge of Houston County. Patton practiced law until his death in 1957.

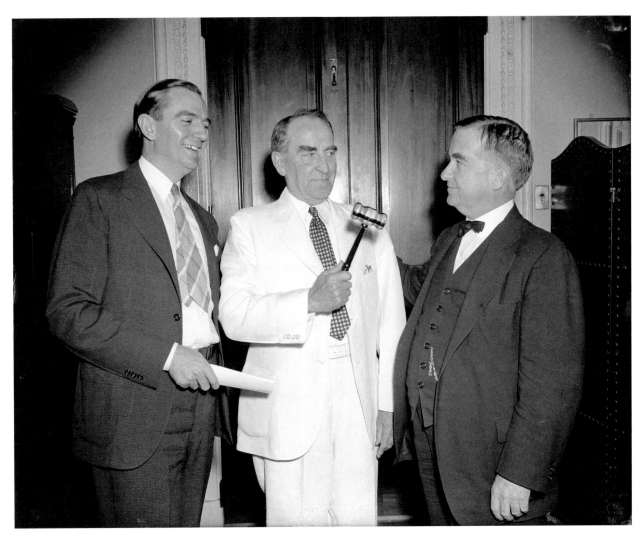

Nat Patton (1884–1957), right, and Albert Thomas, left, give a gavel that was made by Davy Crockett's grandson to Speaker William Bankhead, 1938.

Tom Connally

Tom Connally was born in 1877 near Waco. A Democrat, he served in the U.S. House from 1917 to 1928 and the U.S. Senate from 1929 to 1953. He was the powerful chairman of the Senate Foreign Relations office for six years and was active in the creation of NATO and the UN. Connally served until 1953 and died ten years later.

Connally and an amazing standing trophy fish, date unknown.

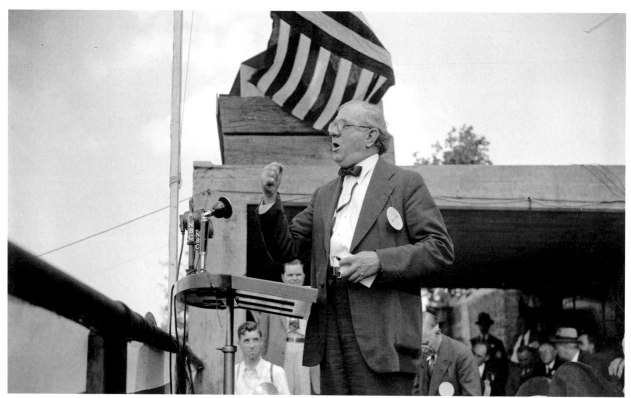

Tom Connally (1877–1963) giving a speech, 1938.

Charley Lockhart

The diminutive Charley Lockhart was born in Dallas in 1876. He served as county treasurer in Scurry County before being elected Texas state treasurer in 1930. He resigned in 1941 and was replaced by his deputy treasurer Jesse James, who was succeeded by Warren G. Harding (no relation to the president of the same name).

State treasurer Charley Lockhart (1876–1954) and son, May 1933.

Governor James V. Allred (1899–1959), left, with big band leader Paul Whiteman, September 1936.

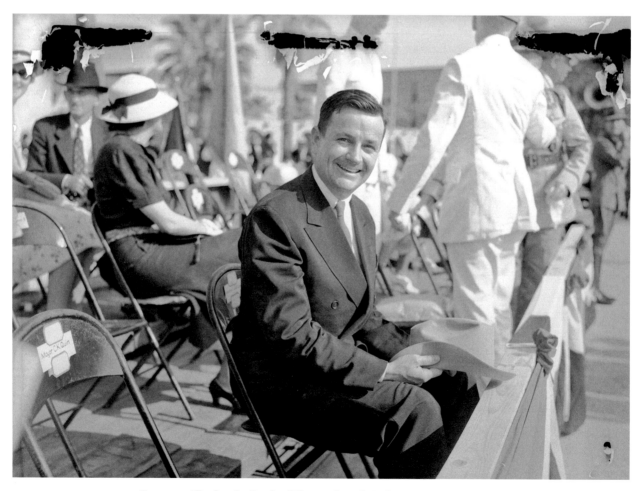

Governor Allred at the Battle of Flowers Parade in San Antonio, circa 1936.

James V. Allred

James V. Allred was born in 1899, one of five brothers, all of whom became lawyers. He attended Cumberland Law School in Tennessee, a popular choice for many budding Texas lawyers in the early part of the twentieth century, and later lived in Wichita Falls. Allred was anti-Klan and, in 1930, was elected attorney general. He was elected governor in 1934 and reelected in 1936, the Texas centennial year. As governor during the years of the Great Depression, Allred cooperated with the Roosevelt administration and the influential Texas congressional delegation on initiatives including recovery programs, expanded aid to education, and establishment of the teacher retirement system. Allred was twice appointed to the federal bench. He died in 1959.

Governor Allred and Lyndon Johnson in the Texas Capitol, circa 1936.

Governor Allred speaking to the National Negro Business League in Houston, circa 1936. The league was established in 1900 by Booker T. Washington and was made up of bankers and businessmen in the black community. This is a rare photo of a white politician addressing a black group during Jim Crow days.

The Texas Centennial

A Texas Centennial parade float in Dallas, 1936.

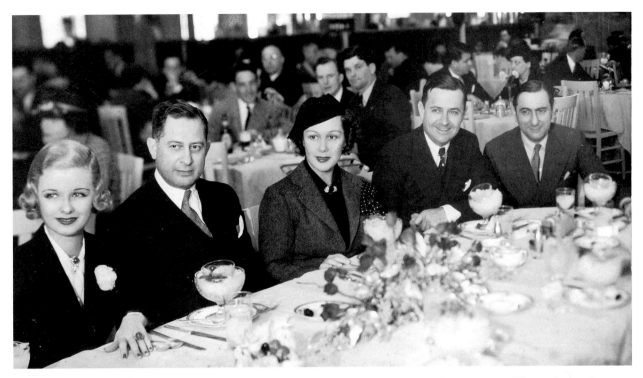

Governor Allred, second from right, at a celebratory Texas Centennial dinner at the Paramount Theater in Austin.

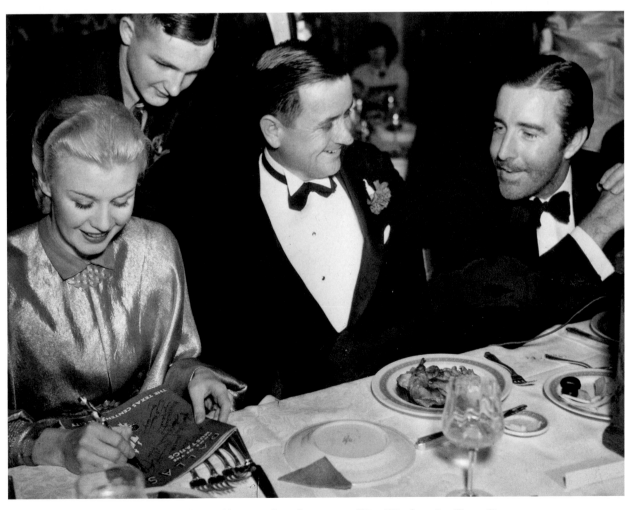

*Governor Allred seated between famed actress and Fort Worth native Ginger Rogers
and actor John Boles from Greenville at another Texas Centennial event.*

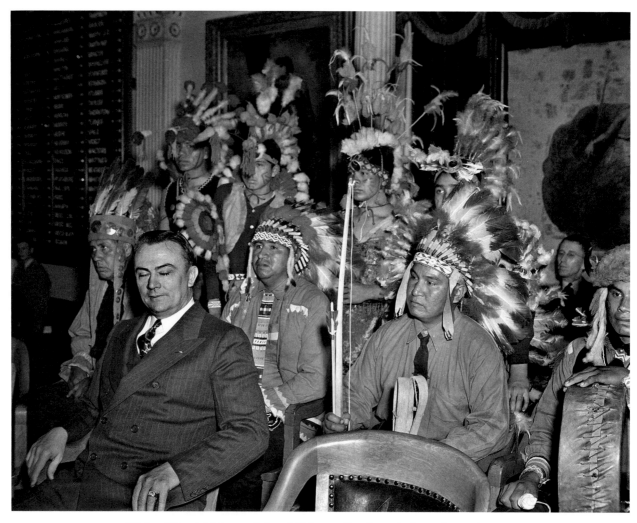

W. Lee O'Daniel (1890–1969) and Alabama-Coushatta Indians, date unknown.

O'Daniel flour sack dress worn by Mrs.
E. A. Sealey at O'Daniel inaugural, 1939.

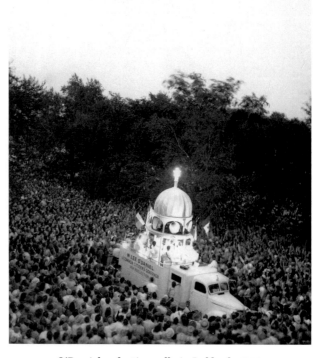

O'Daniel reelection rally in Lubbock, 1940.

W. Lee O'Daniel

Wilbert Lee "Pappy" O'Daniel was born in Ohio in 1890 and was educated in a Kansas business school. After several years in the flour business, he went to work for Burris Mills in Fort Worth, where he became general manager. As an advertising gimmick, he created the Light Crust Doughboys, a hillbilly band led by Bob Wills. O'Daniel then created a popular radio program and parlayed that popularity into his election as governor in 1938 and again in 1940. He ran his campaign on the virtues of hillbilly music, flour, and the Ten Commandments. After his lack of success as governor (he reneged on most campaign promises), he nonetheless remained a popular figure. In 1941 O'Daniel defeated Lyndon Johnson in a special election for the U.S. Senate, where he remained until 1948. His comeback attempts to become governor in 1956 and 1958 failed, however. He returned to Dallas, where he died in 1969.

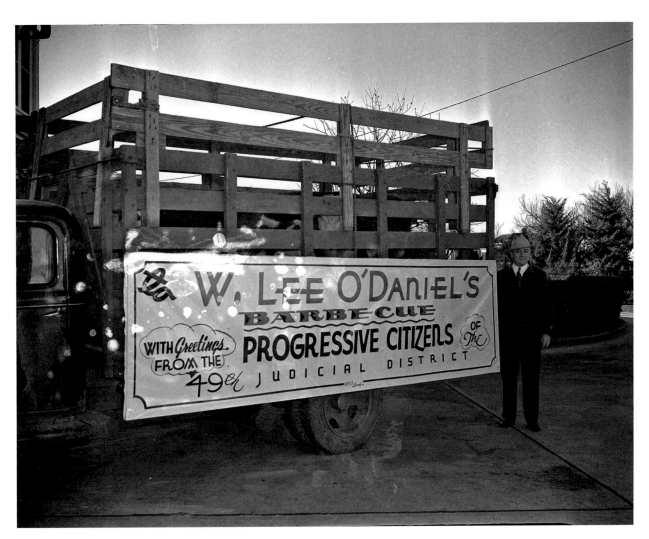

O'Daniel inaugural barbecue in January 1941.

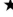

President Franklin Roosevelt in Texas

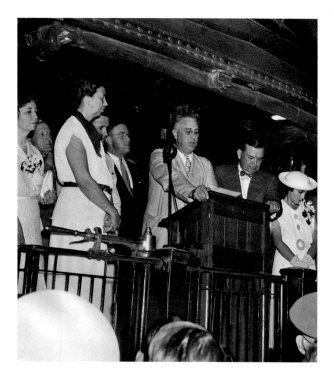

President Roosevelt was popular with Texans and made many trips to Texas, including during the Texas Centennial in 1936. Influential Texans in the Roosevelt administration included Vice President John Nance Garner and Secretary of Commerce Jesse H. Jones. Roosevelt's son, Elliott, lived in Fort Worth for a time, where he was a radio executive. Sam Rayburn became an important ally of Roosevelt's, especially when the Texan became House Speaker in 1940.

Franklin and Eleanor Roosevelt in Austin, June 11, 1936.

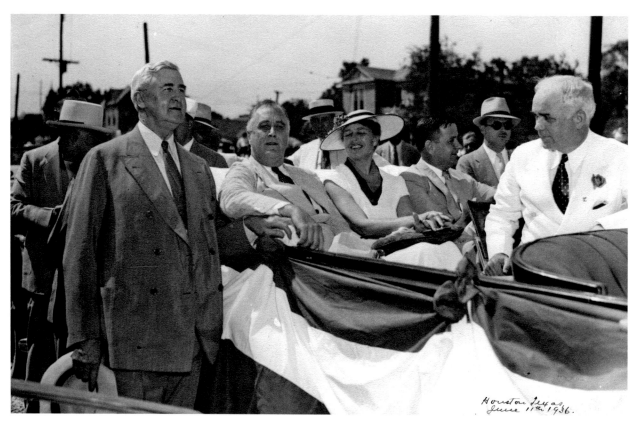

Jesse Jones, left, with Franklin and Eleanor Roosevelt and James Allred in Houston, June 11, 1936.

Ernest O. Thompson

Ernest O. Thompson, a World War I colonel and mayor of Amarillo, ran for governor in 1938, losing to W. Lee O'Daniel. He also served on the Texas Railroad Commission during the 1930s, a period of unrest in the East Texas oil fields.

Pro-Thompson voter in July 1938.

MODERN
TEXAS

The term "modern Texas" may at times seem like an oxymoron—especially when Texas politics and elected officials are placed under the microscope. Despite all the growth, urbanization, diversification, and social change that took place in the second half of the twentieth century, we might sometimes wonder if the Capitol in Austin is covered by an invisible dome that withstands the effects of time and progress. A parade of entertaining, beguiling, and often unbelievable characters passed through Texas political history during this era. Photography and news coverage highlighted the grandeur along with the sometimes outlandish behavior of our erstwhile public officials. Political careers rose like rockets and went down in flames like meteors—and, thankfully, much of this was documented in photos and on film.

Many men and a growing number of women from Texas gained not just state but national attention. From the 1940s until the 1986 Texas sesquicentennial, as the state increased in wealth and political influence, many new leaders emerged on the scene. These new faces appeared during the era's struggles over civil rights, women's equality, public education, health and services, taxation, transportation, agriculture, business, the environment, and natural resources.

The older generation of Texas's traditionally ruling Democrats gave way in this era. As Lyndon Johnson, Sam Rayburn, John Connally, and Ralph Yarborough moved off the stage, others took their place with varying degrees of success and failure. Notably, this included not just a new generation of Democrats but also an increasing number of Republicans. As the state became more diverse, many individuals involved in non-traditional areas of Texas business, such as the aerospace industry and technology, also became influential. And along the way, the Texas media shaped policies and perceptions of officeholders and the political process.

POST–WORLD WAR II POLITICS

In one of the more intriguing gubernatorial campaigns after World War II, Beauford Jester defeated former University of Texas president Homer Rainey by nearly a two-to-one margin, 700,000 votes to 355,000 votes. Jester, a native Texan whose father was a strong follower of Jim Hogg, served in World War I and became wealthy as an oil industry lawyer; his first statewide office was Texas Railroad Commissioner. Jester's election revealed, not for the first time, that the University of Texas had become a lightning rod in Texas politics. Disputes between gubernatorial appointees and the administration reflected larger questions relating to academic freedom, public support for higher education, and the role of the university in a state transitioning from a rural, agricultural economy to an urban, more diverse business economy. In one very public fight, distinguished historian J. Frank Dobie was denied an extended leave of absence by the university and subsequently left for the University of Oklahoma (pouring salt in the wounds of many UT supporters). In reality, Dobie was fired for his support of Rainey; in addition, Dobie openly favored admitting African Americans to the university.

In 1948, President Harry Truman ran for reelection as the underdog against Republican Senator Tom Dewey. Texas leaders like Governor Jester and conservative Texas Democrats were reluctant to support Truman because of his positions on civil rights, such as advocating an anti-lynching law and abolishing the poll tax. Jester, other Texas leaders, and some national Democrats attempted to persuade Dwight Eisenhower to announce as a Democrat and run against Truman. When they were unsuccessful, Jester decided to stay with Truman and the national Democratic Party, while a number of Texas Regulars, an anti-Roosevelt faction that emerged in the early 1940s, left to support the Dixiecrat candidate, Strom Thurmond of South Carolina. Former Vice President John Nance Garner, House Speaker Sam Rayburn, and other stalwarts remained loyal to Truman. President Truman went on to win an upset victory over Dewey. Truman carried Texas with 1.3 million votes, compared to Dewey's 304,000 and Thurmond's 114,000.

The election year of 1948 also became known for another race—the U.S.

Senate race to succeed W. Lee O'Daniel, between Coke Stevenson, a popular, conservative former governor of Texas, and Lyndon Johnson. In one of the more colorful and tumultuous elections in state history, "Landslide Lyndon" eventually won the Democratic primary by the narrowest of margins. (What many forget is that Johnson was on the losing side of a similarly close race in 1941, the special election to succeed venerable U.S. senator Morris Sheppard. In that race, Johnson led Governor W. Lee "Pappy" O'Daniel; however, Johnson lost the election a few days later after a number of questionable returns came in from East Texas, favoring O'Daniel. In that race, Johnson learned lessons about vote counts and holding back returns controlled by favorable supporters.) Johnson spent untold sums of money on the 1948 race and became the first Texas politician to campaign by helicopter—the "Johnson City Windmill." The campaign drew national attention. When the polls closed, Stevenson was leading by a narrow margin. But then returns from South Texas came in to push Johnson into the lead by eighty-seven votes. For nearly a week, late reports from both sides trickled in as the race seesawed back and forth. Many counties in East Texas and South Texas were still under the control of political bosses who could manipulate vote totals to favor their chosen candidate. The contested race went to the Texas Democratic Party State Executive Committee, where Johnson was ruled the winner by a one-vote margin. After a number of legal maneuvers by Stevenson's team to invalidate Johnson's nomination, U.S. Supreme Court Judge Hugo Black ultimately ruled in favor of Johnson's position and his name was officially placed on the 1948 general election ballot. Johnson won the November election and survived a challenge before being seated in the Senate. Johnson later correctly assessed the bizarre events of the year, saying, "Nearly anything can happen in a Texas election—and most of it did this year."[1]

THE 1950s AND THE CIVIL RIGHTS STRUGGLES

When the Supreme Court ruled in the 1954 landmark case of *Brown v. Board of Education of Topeka* that Jim Crow–segregated public schools were illegal, most Southern political and business leaders united in opposition to the ruling. South Carolina senator Strom Thurmond first introduced the "Declaration of Constitutional Principles," which became known as the "Southern Manifesto." When the Southern Manifesto made its way through Congress, 101 Dixie congressmen and senators signed on, with Richard Russell of Georgia, a respected and skillful leader of the opponents of federal civil rights legislation, leading the charge. The manifesto denounced integration, called the Brown case a "clear abuse of judicial power," and urged southerners to "resist forced integration by any means." Polls in 1956 and 1957 indicated that over 80 percent of southern whites opposed integration. And for those who believe that Texas was more racially tolerant, a 1956 statewide referendum

on exempting white children from "compulsory attendance at schools with Negroes" won passage in the state with 78 percent of the popular vote. A similar percentage favored "interposition," a states rights theory of "sovereignty" that permitted states and local governments to resist federal interference with schools and other public facilities.

With public opinion and the Texas press in an uproar over the Supreme Court's Brown decision, most Texas political leaders feared taking a public stance in favor of the decision. Ralph Yarborough became one of the first to accept the challenge. Yarborough came into office in a special election in 1957 after previously losing three very close gubernatorial campaigns with only a plurality of votes. He realized he would be nothing more than a historical footnote if he lost the 1958 primary election. But more than anything, he wanted to change Texas and the South from being viewed as a region of little more than short-staple cotton, turnip greens, hookworms, and "colored only" and "white only" signs.

Speaker Sam Rayburn was another politician who, though a longtime supporter of segregation, decided to support the Brown decision. Rayburn said, "If you had been on that Court, you would have voted exactly as they voted—if you were an honest man." But even with Rayburn's support, civil rights legislation faced an uncertain future in a House and Senate still controlled by Southern segregationists.

Yarborough had already distanced himself from Senator Richard Russell and his Southern colleagues because of his refusal to sign the Southern Manifesto. Then, he went against the grain again when he signed on to the Civil Rights Act of 1957. Senator Russell described the bill as "the reimposition of post–Civil War Reconstruction" that would "force a comingling of white and Negro children in the state-supported public schools of the South." Yarborough knew there would be political costs charged to his account back home. Yet he also sensed that the time had come to challenge the foundations of the southern social and economic system—the entire culture of segregation and all of its questionable beliefs and actions.

Yarborough, Sam Rayburn, Jack Brooks, Jim Wright, Lyndon Johnson, and a small number of other Southern representatives helped pass the Civil Rights Act in the summer of 1957, the first bill of its kind since the Reconstruction era. As a result, a lot of people, including the major daily press outlets, predicted a quick exit for Yarborough in the 1958 primary election. But Yarborough faced the issue head on—even in East Texas, the most highly segregated region of the state. There, he told his audiences, "I'm in favor of the United States Constitution; I'm in favor of the flag; I'm in favor of mother, God, and country. I'm in favor of everybody's right to vote. How many people in the audience are not in favor of everybody having the right to vote?" And he went from town to town and courthouse square to coffee shop with this message. The 1957 bill never really increased minority voting, nor did it have any

measurable impact on segregation. But as corny as it sounds today, it took a lot of courage to go into the courthouse squares of East Texas and take on the issue in front of friends, neighbors, and opponents. Ralph Yarborough handily won reelection in 1958 and remained in the U.S. Senate until his loss to former congressman Lloyd Bentsen Jr. in the 1970 Democratic primary election.

THE 1960s

By the 1960s the state of Texas was becoming more urban and industrialized. Ranching and farming remained important to the state's economy, but the number of people living on farms continued its steep decline. Texas cities attracted more people, especially younger families. The booming oil industry spurred development throughout the state. Business expansion, better educational opportunities, and a vibrant social and cultural life attracted many people from within and beyond the borders of Texas. Along with this growing population came a new group of political leaders who would influence state and national politics for many years.

The 1960 presidential ticket of John F. Kennedy and running mate Lyndon Johnson brought more attention to Texas. Although he had failed in his bid to gain the presidential nomination, Johnson provided regional balance to the ticket and helped Kennedy win the closely contested election. In preparing for the campaign, President Kennedy had known Texas would be a pivotal state with its twenty-four electoral votes. Furthermore, many Texans provided key political and financial support to the Kennedy/Johnson ticket. Kennedy had come under fire in some quarters because of his support for civil rights and his domestic agenda. Divisions in the Democratic Party along with a growing Republican movement illustrated the changing demographics of the state; Texas had Republican senator John Tower serving alongside liberal senator Ralph Yarborough. Following his victory in the 1961 special election to replace Senator Johnson, Tower had become the first Republican elected statewide since Reconstruction. Tower's victory marked the beginning of the modern resurgence of the Republican Party in Texas.

President Kennedy's assassination in Dallas on November 22, 1963, had a dramatic influence on Texas and the nation. Vice President Lyndon Johnson assumed the presidency and steadily guided the nation through the traumatic aftermath of the assassination. The wounding of Texas governor John Connally, who was riding in the car with Kennedy, brought national attention and sympathy to the state's chief executive. Connally, a former aide to Johnson and secretary of the navy under President Kennedy, had become Texas governor after a hard-fought election in 1962, narrowly defeating Democrat Don Yarborough (no relation to Ralph Yarborough, though he undoubtedly benefited from the name recognition). Connally remained an influential and successful governor until his decision to not run for a fourth term in 1968.

The 1960s produced a number of popular and successful political leaders. The passage of President Johnson's civil rights and voting rights laws opened the door to new leadership from the state's minority population. Barbara Jordan of Houston was the first African American woman to be elected to the Texas state senate in 1967. She later won election to the U.S. Congress and gained a national reputation for her role in the House Judiciary Committee's impeachment proceedings for President Richard Nixon. Also in 1967, Curtis Graves of Houston and Joe Lockridge of Dallas became the first African American members of the state legislature. Other accomplished minority politicians who emerged in this era included Henry B. González of San Antonio, Mickey Leland of Houston, Paul Moreno of El Paso, Gonzalo Barrientos of Austin, Carlos Truan of Corpus Christi, Craig Washington of Houston, Al Luna of Houston, Eddie Cavazos of Corpus Christi, and Eddie Bernice Johnson of Dallas. Overall, legislative and congressional redistricting combined with concerted strong efforts in the Mexican American and African American communities resulted in an increase in minority elected officials.

SHARPSTOWN

Texas voters witnessed an unprecedented turnover in political offices from the political fallout that became known simply as "Sharpstown." In 1971 and 1972, a series of charges alleging fraud were leveled against both active and former state officials. In the resulting scandal that played out in the press and the courts, many of the state's most prominent leaders witnessed the end of their political careers. Governor Preston Smith would lose his bid for reelection. Texas House Speaker Gus Mutscher and two of his associates were indicted and convicted. Lieutenant Governor Ben Barnes, thought by many to be the next governor and the possible successor to Johnson in the White House, lost his gubernatorial bid. Half of the members of the Texas legislature chose not to run or were voted out of office. Using the scandal as a springboard, a handful of Democrats and Republicans formed a coalition known as the "Dirty Thirty" to initiate reform and a stronger presence in the legislature.[2] Texas Democrats of the John Connally/Lyndon Johnson/Ralph Yarborough era were making way for younger lawmakers who increasingly came from the ranks of African Americans, Mexican Americans, women, and Republicans.[3] Representative Frances "Sissy" Farenthold of Corpus Christi rode the Sharpstown wave to gain a runoff with rancher and former state representative Dolph Briscoe Jr. in the 1972 Democratic gubernatorial primary. Briscoe became governor and ushered in many reforms for more open government. Even though she lost that race, Farenthold gained national attention at the 1972 Democratic National Convention when she had her name placed into nomination for vice president. She made one more unsuccessful run for governor, then became the first chair of the National Women's Political Caucus.

Other leaders who gained statewide office in the wake of the Sharpstown reforms made significant contributions to the state's history. Bill Hobby Jr., the son of the former governor and publisher of the *Houston Post*, won election as lieutenant governor in 1972 and served in the position until 1991. Known for his quiet leadership and extensive knowledge of state government, Hobby presided over major legislative initiatives in the areas of education, health services, budget reform, and ethics. Former state representative and secretary of state Bob Bullock exerted tremendous influence over state government. Elected as state comptroller in 1973, Bullock revolutionized state government through the use of newer technologies, economic forecasts, professional organization, and modernization of the tax system. Although known for being blunt and aggressive, Bullock also became renowned for his ability to attract highly competent professionals who provided efficiency and leadership in many different agencies and state political offices. Bullock served as comptroller until 1991, when he won election as lieutenant governor after Bill Hobby Jr. announced his retirement.

WOMEN IN TEXAS POLITICS

Barbara Jordan and Frances Farenthold were among many prominent Texas women involved in politics for generations. Texas women began taking an active role in politics during the populist and progressive movements of the late nineteenth and early twentieth centuries. Women were at the forefront of the temperance movement for years before the Eighteenth Amendment ushered in the age of prohibition in the 1920s. The long battle for women's suffrage culminated with the passage of the Nineteenth Amendment in 1920. The Great Depression of the 1930s, followed by World War II, also created a stimulus for women to take a bigger role in business, civic, and political affairs.

Minnie Fisher Cunningham was one of the crusading Texas women who fought for suffrage and worked to influence the next generation of women to pursue politics and public service. She and Frankie Randolph were two of the influential founders of the *Texas Observer* in the 1950s.

In the late 1960s, Anita Martinez of Dallas became the first Mexican American woman to win a city council seat in Texas. Wilhemina Delco was the first African American, male or female, to be elected to the school board in Austin. Betty Andujar and Kay Bailey both won seats in the legislature as Republicans in the 1970s, and Irma Rangel of Kingsville became the first Mexican American woman in the legislature in 1972. In 1984 Lena Guerrero became the second female Hispanic member elected to the Texas Legislature. In 1991 Governor Ann Richards appointed her as the first minority woman on the Texas Railroad Commission, a position previously only held by white males. She later resigned due to misstatements regarding her University of Texas college degree. Another notable Texas legislator was attorney Sarah

Weddington. She gained national recognition when she argued and won the landmark Supreme Court case *Roe v. Wade* in 1973.

THE RISE OF THE REPUBLICAN PARTY

For more than a century, the traditional power structure in Texas had been strongly, consistently based in the Democratic Party. But as a result of the changes of the 1960s and 1970s, liberals had gained power within the party and had drawn to it activist reformers and minority voters in general. Most of the women and minorities entering politics in the 1970s did so as Democrats. More conservative Texans—including many concerned with the rapid rate of societal and political change they saw the activists advocating—converted to the Republican Party. Bruce Alger of Dallas became the first Republican in Congress in 1955. Robert Price of Pampa, Jim Collins of Grand Prairie, and George H. W. Bush of Houston won election to Congress as Republicans in the 1960s. By the 1970s Republicans had made noteworthy inroads into state government, with seventeen Republicans elected to the House and three to the Senate. Notable members included Tom Craddick, Anita Hill, Ray Hutchison, and Walter Mengden (and the two Republican women mentioned earlier, Betty Andujar and Kay Bailey). In the state elections of 1978, for the first time since Reconstruction, a Republican—Dallas oilman William Clements Jr.—was elected governor of the state. His victory, albeit by a narrow margin, surprised his opponent, Attorney General John Hill.

THE 1970s AND 1980s

With its growth in population and the influence of national politics, Texas slowly moved to become a two-party state. Though Bill Clements was defeated by Democrat Mark White in the election of 1982, their positions were reversed four years later when Clements ousted White to win the job back.

Minorities and women continued to make inroads. In 1981, Democrat Henry Cisneros was elected mayor of San Antonio; not since the administration of Juan Seguín a hundred and forty years earlier had a Hispanic headed the city government. That same year, El Paso native Sandra Day O'Connor was appointed to the United States Supreme Court by the Republican administration of Ronald Reagan, the first woman in this role. In 1982, Democrat Ann Richards rose from Travis County Commissioner to win election as Texas state treasurer. Richards became the first woman elected to statewide office since Miriam "Ma" Ferguson served as governor from 1933 to 1935.

In Congress, the Texas delegation maintained a significant presence throughout the 1970s and 1980s. Many protégés of former longtime U.S. House Speaker Sam Rayburn preserved the Texas influence through their seniority and their committee chairmanships. Jim Wright of Fort Worth rose

to become majority leader in 1977 and then House Speaker in 1986. Notable Texas congressmen of the era included Jack Brooks of Beaumont, J. J. "Jake" Pickle of Austin, Charlie Wilson of Lufkin, Ray Roberts of McKinney, Kika de la Garza of Mission, Ralph Hall of Rockwall, Jack Hightower of Vernon, Bob Eckhardt of Houston, Bob Poage of Waco, Olin E. Teague of College Station, George Mahon of Lubbock, and Bob Casey of Houston. Prominent Republican members of Congress of this era included Phil Gramm of College Station, Bill Archer of Houston, Jack Fields of Humble, Tom Loeffler of San Antonio, and Ron Paul of Lake Jackson.

THE 1990s TO THE PRESENT

From the 1990s through the first decade and a half of the twenty-first century, changes in Texas occurred faster than a wildfire with a tailwind. Coupled with population growth and economic expansion, the state's population became much more diverse. Business, technology, research, education, sports, cultural life, and politics all reflected these dramatic changes.

Many Texas political leaders expanded beyond the Lone Star State to become notable players in national politics—for better or for worse, depending on one's political persuasion. The list of these influential individuals is long, and those on the list will certainly require significant historical consideration in the future. George H. W. Bush served as president for one term, 1989–1993. President Bill Clinton appointed Texas senator Lloyd Bentsen Jr. as Treasury Secretary in the 1990s. Kay Bailey Hutchison succeeded Bentsen as senator and became one of the most influential members of that body during her tenure in office. George W. Bush served as Texas governor during the 1990s and won a controversial presidential election in 2000; he served for two terms as president, then returned home to Texas in 2009.

In addition, the roster of influential senators and members of Congress during this era included John Cornyn, Eddie Bernice Johnson, Charles A. Gonzalez, Frank Tejeda, Sylvester Reyes, Joe Barton, Kay Granger, Tom DeLay, Chet Edwards, Charles Stenholm, and Ralph Hall.

When Governor George W. Bush took the oath of office as the forty-third president in 2001, Lieutenant Governor Rick Perry succeeded him as governor. Until his announcement in 2014 that he would not run again for the office, Governor Perry set the record for the longest tenure as governor since Texas joined the Union in 1845. He will also be noted in history as one of the longest-serving governors in the nation.

As we survey the historical images of these Texas public leaders from the state's beginnings to its present, we are reminded that our past holds an entertaining, informative, and sometimes controversial role in making Texas politics the subject of continuing national interest. The topic is as popular as pecan pie and a visit to the Alamo, so we should always plan to keep coming back.

Coke Stevenson (1888–1975), with Rosie the Riveter, circa 1940s.

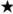

Three former Texas House Speakers in 1942: Coke Stevenson, left, was governor of Texas; Sam Rayburn, middle, was Speaker of the U.S. House; and Robert Ewing Thomason was a federal judge in El Paso.

Coke Stevenson

Coke Stevenson was born in Mason County in 1888. His family settled in Junction, where he became a successful banker, businessman, rancher, and lawyer. In 1928, he was elected to the Texas House and served until 1939, with two terms as Speaker. In 1938, he was elected lieutenant governor and, in 1941, replaced W. Lee O'Daniel as governor. He is the only man to have served as Speaker of the House, lieutenant governor, and governor. In 1948, he lost the election for U.S. Senate to Lyndon Johnson; in this famous race to succeed O'Daniel, "Landslide Lyndon" defeated the governor by only 87 votes. The election featured questionable votes and vote counts on both sides. Stevenson later retired to Junction and died in 1975.

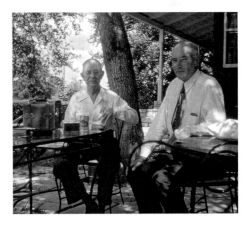

Stevenson, right, visiting with former Texas House Speaker Emmett Morse in Austin, circa 1950s.

Beauford Jester (1893–1949) square dancing with Department of Public Safety employees in Austin, circa 1947.

Beauford Jester

Beauford Jester, the son of Lieutenant Governor George T. Jester, was born in Corsicana in 1893. He practiced law there until he was appointed to the Texas Railroad Commission in 1942 and was elected commissioner in 1942. He served on the UT Board of Regents and, in 1946, was elected governor in a race against former UT president Homer Rainey. He was reelected in 1948 but died while in office in 1949, becoming the only governor to do so.

Governor Beauford Jester (1893–1949) with Phillip Morris cigarette product spokesman Johnny the Bellboy and an unidentified boy in 1948.

Governor Jester, left, and actor Zachary Scott, center, 1948. The other man is unidentified.

Lyndon B. Johnson

Lyndon Baines Johnson was born near Johnson City in 1908. After graduating from what is now Texas State University in San Marcos, he taught school in Cotulla and Houston. He was elected to Congress in 1937 and ran in a special election for the U.S. Senate in 1941, only to lose to W. Lee O'Daniel. In 1948, he succeeded in being elected to the Senate, where he ruled as the powerful majority leader, working closely with his mentor Speaker of the House Sam Rayburn. In 1960, Johnson was chosen by John F. Kennedy to be his vice presidential candidate. Assuming the presidency upon the death of Kennedy in 1963, he was elected to his own term in 1964. As president, Johnson forged the many programs that composed the Great Society and passed the first civil rights and voting rights measures since Reconstruction. Declining to run again in 1968, he returned to his Hill Country ranch, where he died in 1973.

Photo of Lyndon Baines Johnson (1908–1973) taken in a Harvey House camera booth and found among Sam Rayburn's papers, date unknown.

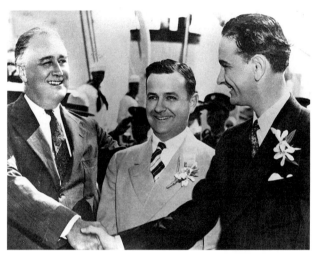

Campaign photo of Johnson with Franklin Roosevelt and Governor Allred, 1937.

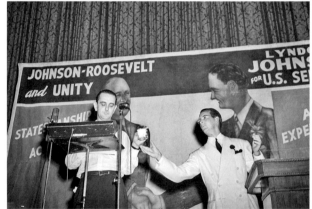

Johnson campaign in San Antonio, 1941. The photo being used as a backdrop now only shows LBJ and FDR; Allred has been removed.

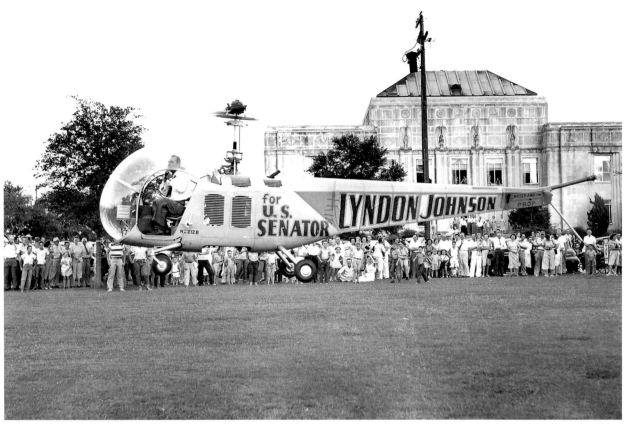

Helicopter dubbed the "Flying Windmill" in Port Arthur, Texas, during Johnson's 1948 campaign for the U.S. Senate.

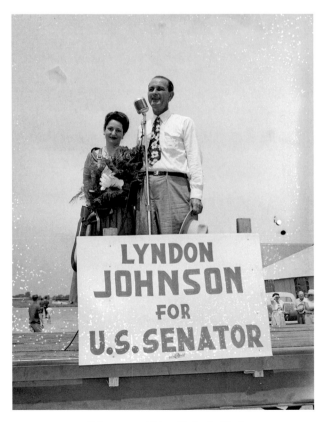

Johnson and his wife Lady Bird campaigning in Dallas in 1948.

Johnson campaigning in Dallas, 1948.

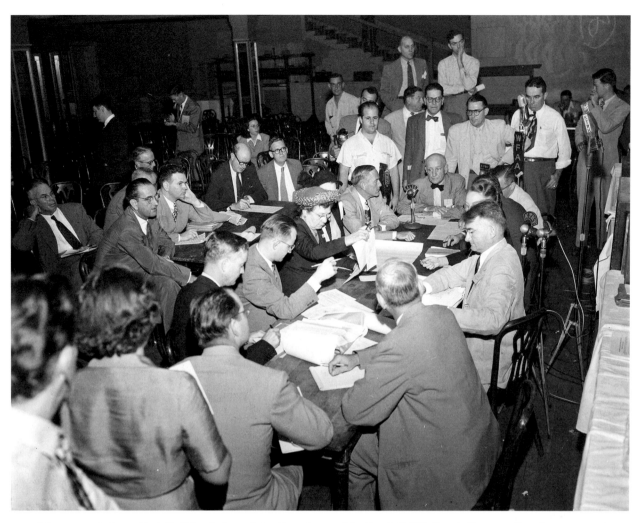

Johnson, seated near the left of the photo, watches the vote count for the 1948 U.S. Senate Democratic primary race at Fort Worth's Blackstone Hotel. Johnson won the primary runoff by eighty-seven votes, overcoming a large lead by his opponent, Governor Coke Stevenson, thanks in part to "found" votes from Jim Wells County. The Texas Democratic Executive Committee voted to uphold the victory by a majority of one (29 to 28). Johnson became known as "Landslide Lyndon," a nickname that took on new meaning when he won the 1964 presidential election by a large margin.

Johnson with the Hardin-Simmons University drill team and Harley Sadler, a producer of circus and tent shows throughout West Texas, circa 1950s.

Johnson after being named "Texas's Favorite Son" at the 1956 State Democratic Convention in Dallas.

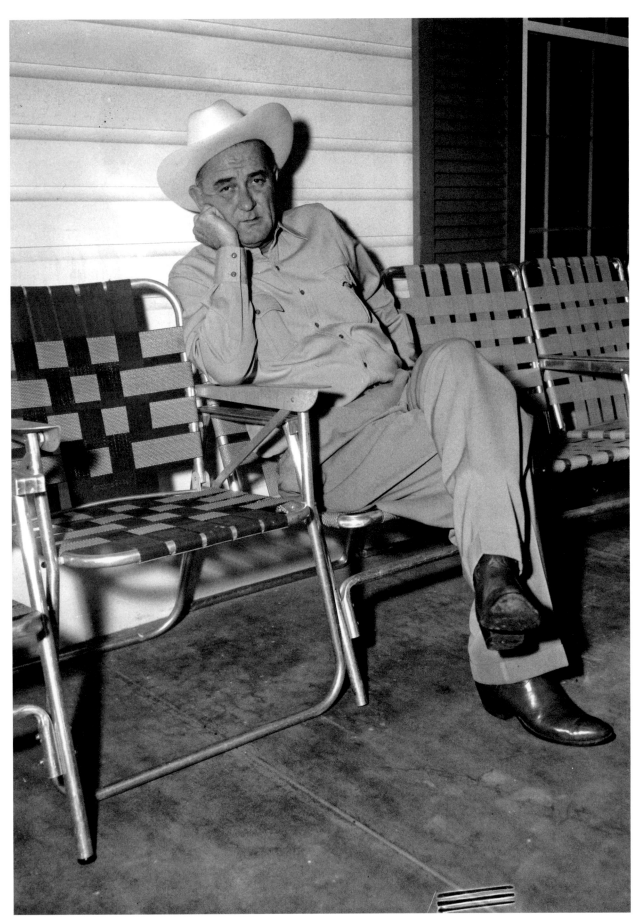

Johnson in a thoughtful moment, date unknown but probably late 1950s.

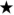

Justice Clark playing horseshoes with fellow Texan Speaker of the House Sam Rayburn, date unknown.

Thomas C. Clark

Thomas C. (Tom) Clark was born in Dallas in 1899 and practiced law there after receiving his law degree from UT Austin. He joined the Justice Department in the 1930s and was appointed U.S. attorney general by President Truman in 1945.

In 1949, Truman appointed him to the U.S. Supreme Court, making him the only Texan among the justices. He served until 1967 when he resigned to avoid conflicts of interest with his son, Ramsey Clark, who had been appointed U.S. attorney general. He died in 1977.

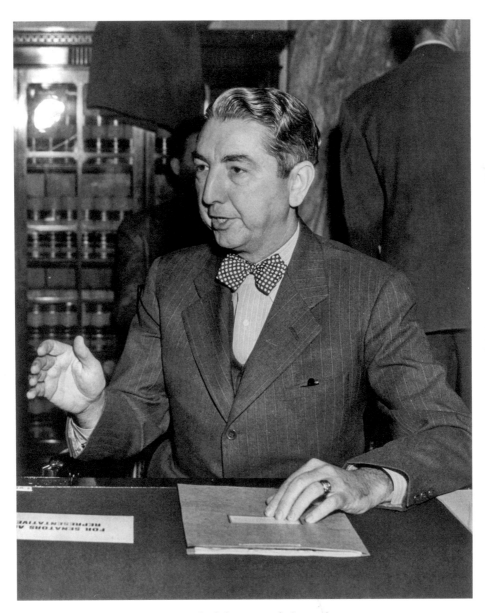

Thomas C. Clark (1899–1977), date unknown.

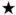

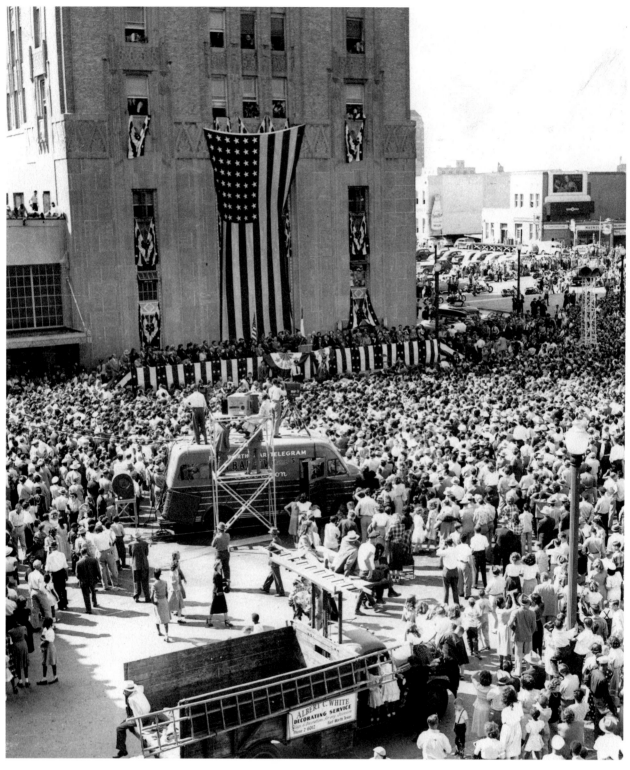

Harry Truman in Fort Worth on September 27, 1948 (the day the author was born in a nearby hospital). It was the first live television broadcast in Texas, as WBAP covered the event.

President Truman in Texas

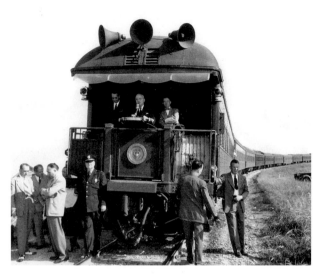

As a senator from Missouri, Harry Truman built lasting friendships in Washington with John Nance Garner and Sam Rayburn. In April 1945, Truman was in Rayburn's Capitol office when he received the phone call that President Roosevelt had died. Campaigning for reelection in 1948, President Truman trailed Republican nominee Tom Dewey in the polls. Truman credited his whistle-stop tour visit to John Nance Garner in Uvalde, Texas, as the turning point in his successful reelection to the presidency.

Truman campaign train outside Waco, 1948.

From left to right, Democratic state chairman Raymond Buck, Truman, Fort Worth publisher Amon Carter Sr., and Governor Beauford Jester at T&P Station in Fort Worth, September 27, 1948.

Robert Ewing Thomason

R obert Ewing Thomason moved from East Texas to El Paso in 1911 where he established a law practice with Tom Lea. He was elected to the Texas legislature in 1917 and became Speaker in 1919. Thomason ran unsuccessfully for governor in 1930, then was elected El Paso's mayor in 1927. He represented El Paso in Congress from 1931 to 1947, after which he was appointed federal judge for the Western District of Texas. He died in 1973.

These Texas Congressional delegates gathered to support the creation of a Big Bend national park in August 1937. Congressman Robert Ewing Thomason (1879–1973), on the far left, is taking contributions from, left to right, Wright Patman, Milton West, Martin Dies Jr., Lyndon Johnson, Clyde Garrett, Fritz Lanham, and Bob Poage.

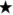

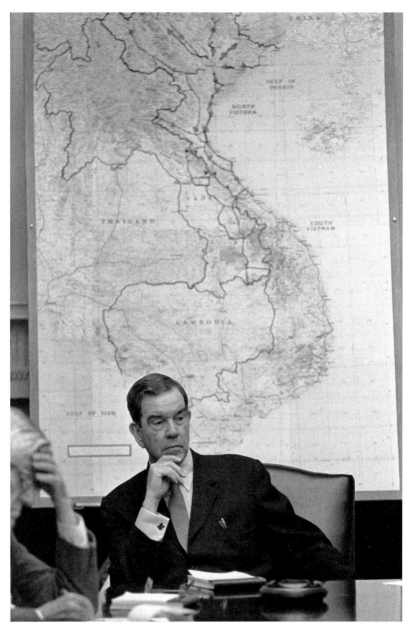

George Mahon (1900–1985) in the Cabinet Room of the White House, June 1966.

George Mahon

George Mahon was born in Louisiana in 1900. His family moved to Mitchell County where, after passing the bar, he served as county attorney and district attorney. A Democrat, he was elected to Congress in 1934 and served until 1979. He was the senior member of Congress upon his retirement and had served as chairman of the House Appropriations Committee for many years. Mahon died in 1985.

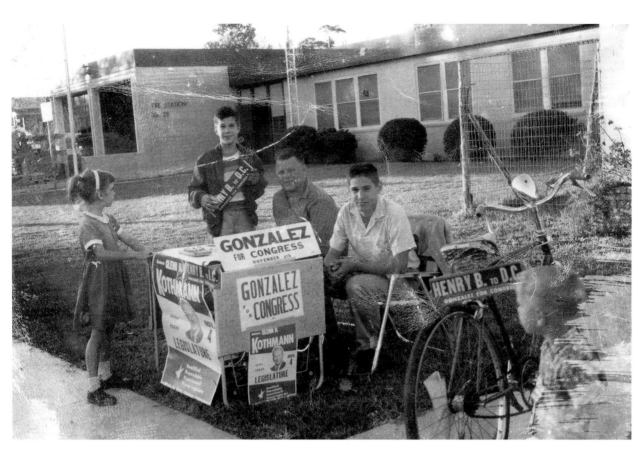

These San Antonio supporters were campaigning in 1958 for González and Glenn Kothmann,
both of whom represented Bexar County in the state legislature.

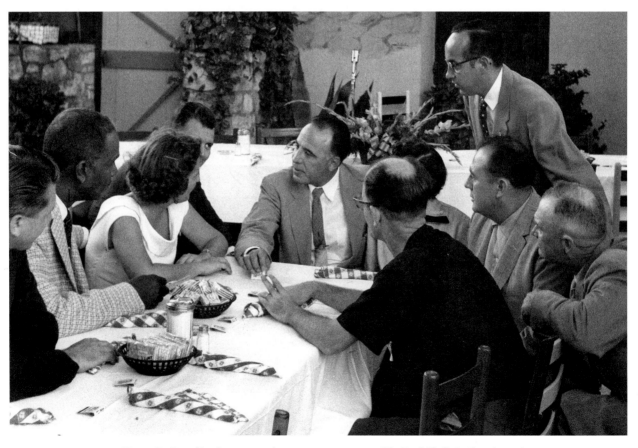

Henry B. González (1916–2000) at a restaurant, possibly Earl Abel's in San Antonio
where he often met with voters and constituents, date unknown.

Henry B. González

enry B. González was born in 1916 in San Antonio. A Democrat and a lawyer, he was elected to the state senate for three terms beginning in 1957, the first Hispanic in over one hundred years to serve there. After unsuccessful runs for governor and U.S. senator, he was elected to Congress in 1961 and served until 1998, chairing the House Banking and Currency Committee. His son Charlie González won the election to succeed his father. Henry B. González died in 2000.

Henry B. González with his son Henry B. González III, greeting future president George H. W. Bush, date unknown.

Will Wilson Sr.

Will Wilson Sr. was born in Dallas in 1912. He was elected district attorney in that city in 1946, serving until 1950, when he was elected associate justice of the Texas Supreme Court. He then served as Texas attorney general from 1957 to 1963, during which time he famously shut down many of the gambling operations in Galveston County. Wilson ran unsuccessfully for governor and the U.S. Senate in the early 1960s and later served as head of the criminal justice division of the U.S. Department of Justice. He died in 2005. One of his children, Will Wilson Jr., served as a Travis County district judge.

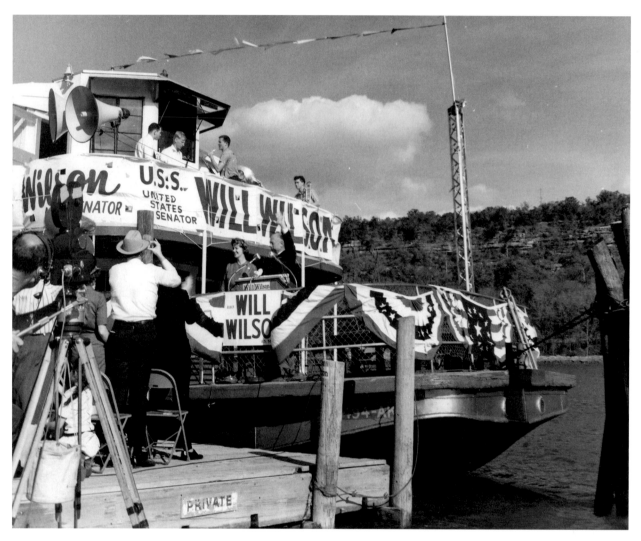

Will Wilson campaign boat, circa 1961.

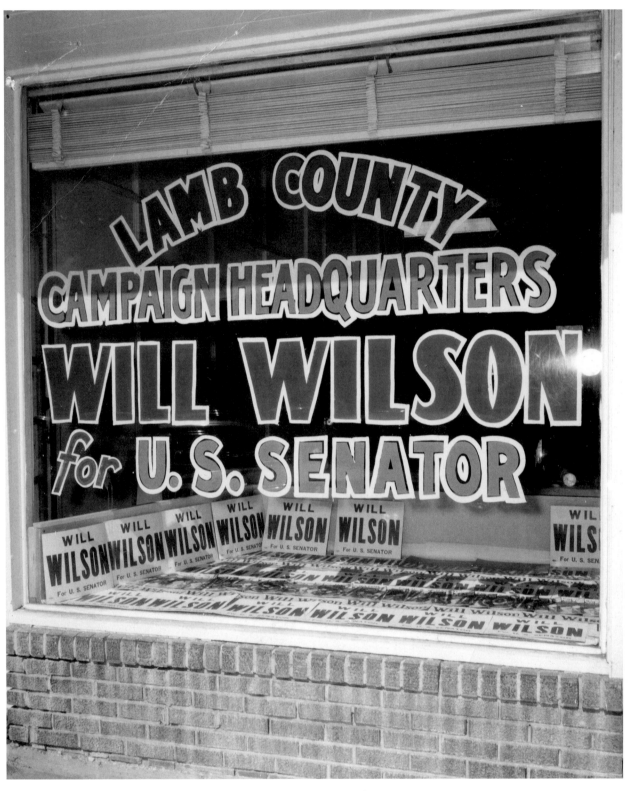

Wilson campaign headquarters in Lamb County, circa 1961.

Allan Shivers

Allan Shivers was born in Lufkin in 1907 and grew up in East Texas. At age twenty-five, he was elected to the Texas Senate, becoming lieutenant governor in 1946 and 1948. Then, in 1949, he became governor upon Beauford Jester's death. He was reelected three more times, but not without strong opposition from fellow Democrat Ralph Yarborough. In 1952, Shivers supported Republican Dwight Eisenhower for president, largely due to Eisenhower's support of Texas's claims to the tidelands. In 1973, he was appointed to the UT Board of Regents. Shivers died in 1985.

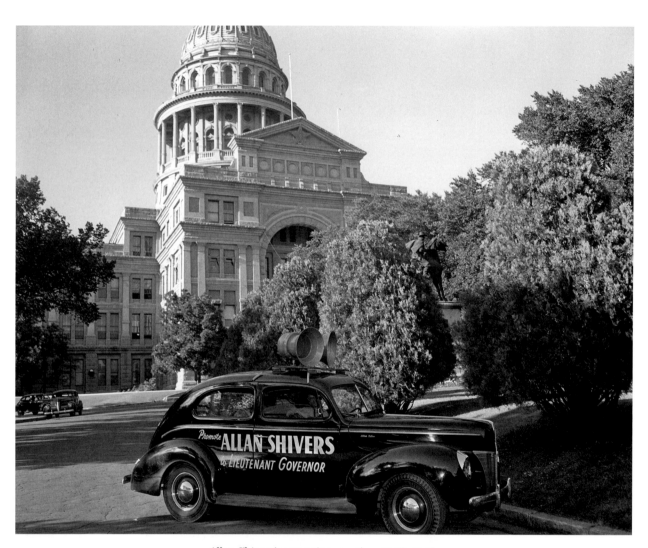

Allan Shivers's campaign car, circa 1946–1948.

*Allan Shivers (1907–1985)
in the Peanut Festival in
Floresville, 1953.*

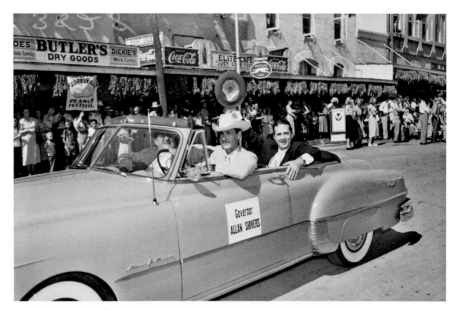

*Shivers at Wooldridge Park,
Austin, circa 1954, in a
Russell Lee photograph.*

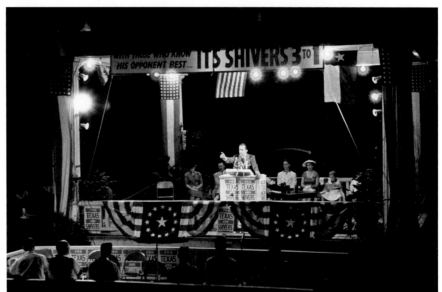

*Campaign luncheon for
Shivers in Austin, circa
1952–1956. Lyndon Johnson is
speaking. Seated to Shivers's
right is former governor
Miriam Ferguson.*

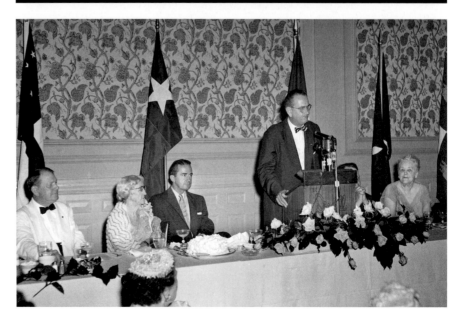

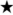

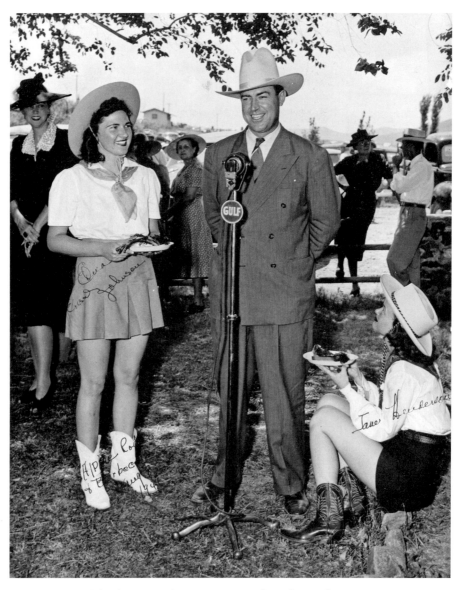

Bascom Giles (1900–1993) campaigning at the rodeo in Alpine, circa 1940s.

Bascom Giles

Bascom Giles was born in Travis County in 1900. He began working in the Texas General Land Office in 1919 as a draftsman and rose through the ranks until taking a job with the Texas Tax Board in 1930. In 1938, he was elected commissioner of the General Land Office. By the end of his eight terms, he was involved in the Veteran's Land Board scandal. Friends of Giles were accused of selling tracts of property at inflated prices to the Land Board (of which Giles was chairman), after which the board would sell to veterans who often did not even realize they were purchasing property. Giles was convicted and served nearly six years in prison. He died in 1993.

Jerry Sadler

Jerry Sadler was born in Anderson County in 1907. After being elected to the Railroad Commission in 1938, he resigned to serve in the army during World War II. From 1955 to 1961, he served in the Texas House. Sadler was elected land commissioner in 1961, but was defeated for reelection in 1970 and died in 1982. Always colorful, he earned the nickname "Jerry the Pirate" after engaging in a fistfight with a San Antonio reporter and another fight with a Texas senator over the rights to a Spanish galleon found off the Texas coast in the 1960s.

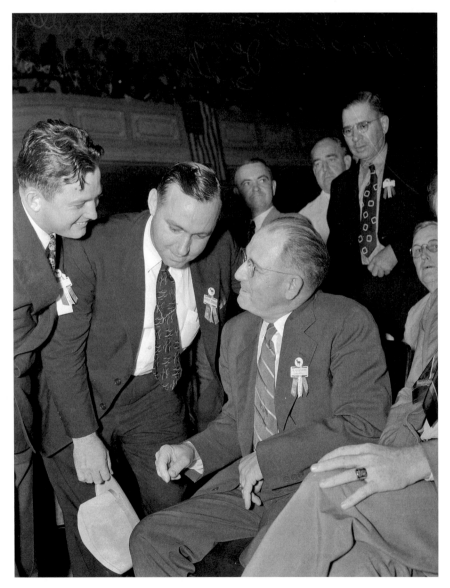

Jerry Sadler (1907–1982) at the 1938 State Democratic Convention in Beaumont. Sadler (leaning over in the middle of the photograph) was visiting with Lindley Beckworth and M. M. Marshall, delegates to the convention.

Photographs by Russell Lee

Russell Lee became renowned as a Works Progress Administration photographer during the Depression. He later photographed many Texas political people and events, including many of Ralph Yarborough's campaigns. In June 1954, he covered a political rally in the small Travis County community of Elroy. His images show a direct connection between politicians and their supporters—the citizens who would decide the coming elections.

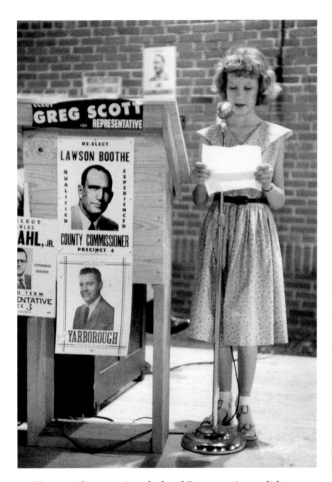

Young girl supporting the local Democratic candidates.

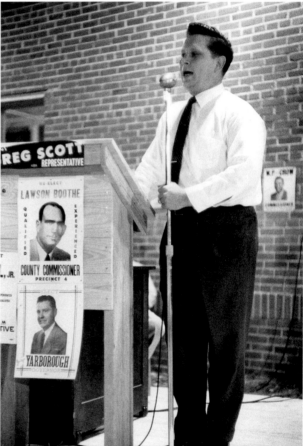

Senator Johnnie B. Rogers speaking on behalf of the lieutenant governor.

District attorney candidate, left, working the crowd.

Women listening at the rally.

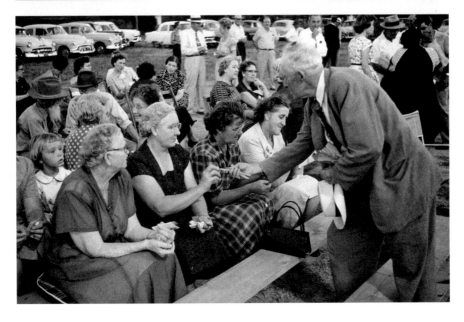

Justice of the peace candidate passing out emery boards.

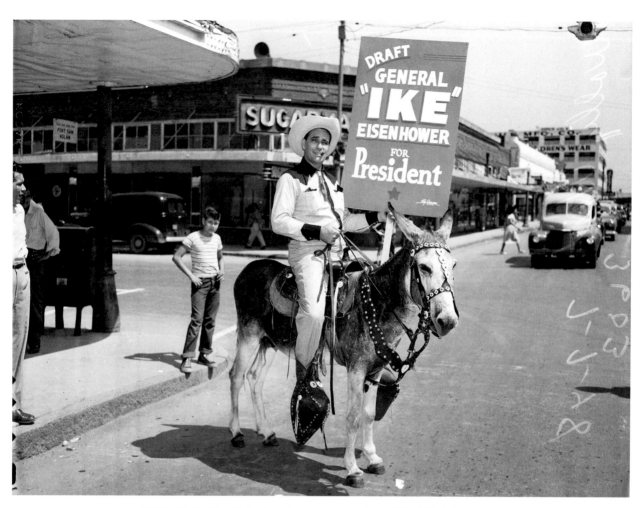

Wally West of San Antonio rides a pony carrying a "Draft Ike" sign, 1948.

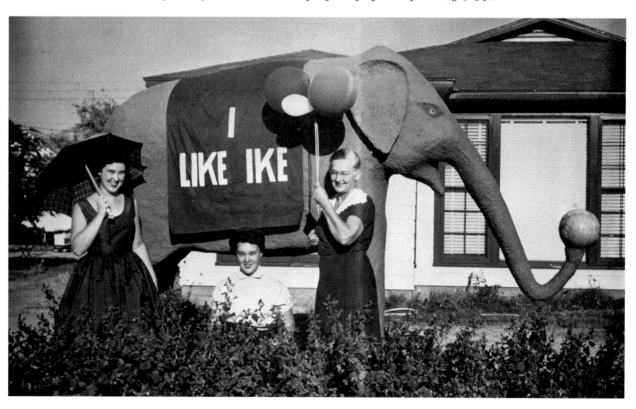

Eisenhower supporters in Abilene, date unknown.

President Eisenhower in Texas

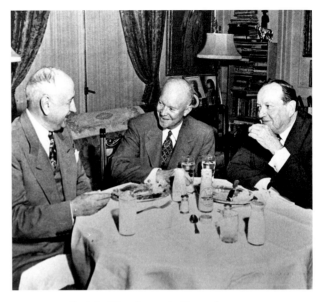

The first native-born Texan to become president (he was born in Denison), Dwight Eisenhower carried the state's electoral votes in the 1952 and 1956 presidential elections—the first Republican to do so. Prominent Texans in the Eisenhower administration included Oveta Culp Hobby as the first secretary of Health, Education, and Welfare. As president, Eisenhower frequently cooperated and worked with Speaker Sam Rayburn and Senate majority leader Lyndon Johnson. He supported Texas in the tidelands controversy and championed the Texas oil and gas industry.

Dwight Eisenhower in November 1950 with Texas businessmen Amon Carter Sr., left, and Sid Richardson, right.

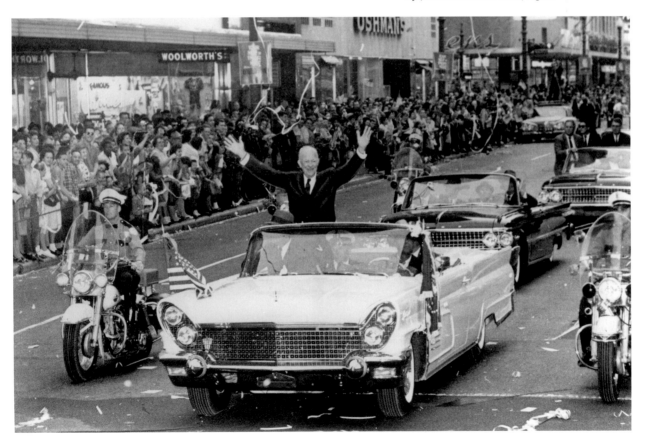

Eisenhower campaigning in Houston, circa mid-1950s.

Price Daniel

Price Daniel was born in Dayton, Texas, in 1910. He began working as a newspaperman, then became a lawyer after graduating from Baylor Law School. He was elected to the Texas House in 1938 and served as Speaker in 1941. Daniel was elected attorney general in 1946 and fought the federal government on the Texas tidelands sovereignty issue both in that capacity and as a U.S. senator, a position to which he was elected in 1952. Eventually, Texas was successful in maintaining sovereignty to 10.2 miles out into the Gulf of Mexico largely because of Daniel's efforts. Daniel was elected governor in 1956, serving three terms. He was then appointed to the Texas Supreme Court in 1971, serving until 1979. Daniel died in 1988. His wife, Jean, was a direct descendant of Sam Houston and his son Price Daniel Jr. served as Speaker of the Texas House in 1973.

Governor Daniel, left, discussing a bill with state representatives A. R. "Babe" Schwartz, middle, and Harold Barefoot Sanders Jr., circa 1950s.

Governor Price Daniel (1910–1988) and actress Sandra Dee (in the fur), date unknown. The other woman in the photo is unidentified.

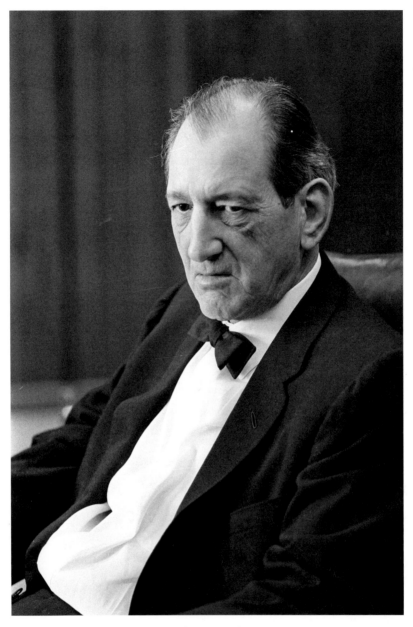

William Blakley (1898–1976), date unknown.

William Blakley

William A. "Dollar Bill" Blakley was born in 1898. A Democrat and businessman/lawyer from Dallas, he was appointed to the U.S. Senate by Governor Allan Shivers and served from January to April 1957. This seat, in the Rusk succession, was won by Ralph Yarborough in a special election. In 1961, Blakely was again appointed, this time by Governor Price Daniel, and served from January 3 to June 14 in the Houston succession. The seat was then won by John Tower.

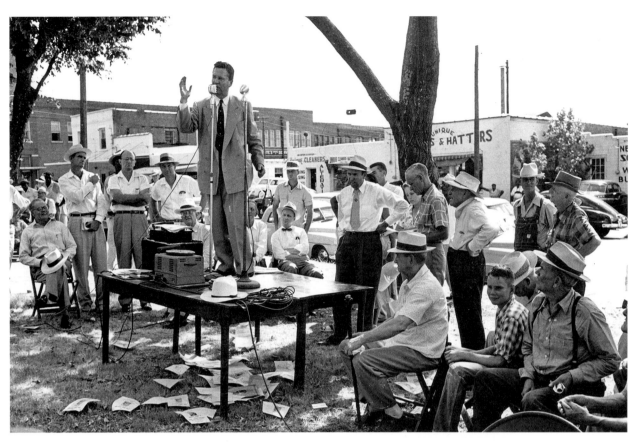

Ralph Yarborough (1903–1996) engaging in a specialty of his, a "stump speech"
in a Texas courthouse square, circa 1950s. The photograph is by Russell Lee.

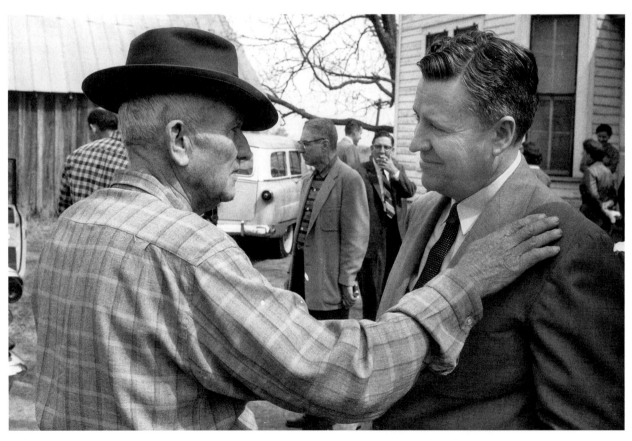

Yarborough campaigning in East Texas, 1954, in a Russell Lee photograph.

Ralph Yarborough

Ralph Yarborough was born in 1903 in Chandler, Texas. A Democrat, he was elected to the U.S. Senate in a special election in 1957. He won reelection twice, serving until 1971 (defeating George H. W. Bush for the seat in 1964). Yarborough was the only U.S. senator from the South who voted for all the major civil rights bills in the 1960s. He sponsored legislation to create the Padre Island National Seashore and many environmental initiatives during his terms in the Senate. Yarborough's campaigns were often photographed by the famous WPA photographer Russell Lee. He lost several gubernatorial races to Allan Shivers and was defeated by Lloyd Bentsen Jr. in the Democratic primary for the Senate seat in 1970. He died in Austin in 1996.

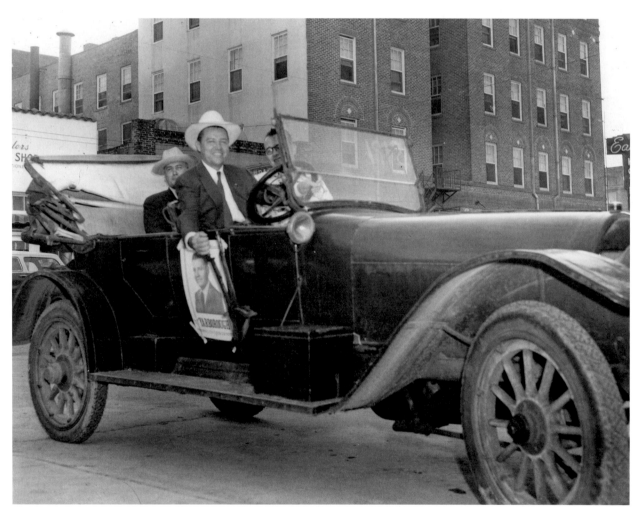

Yarborough campaigning the old-fashioned way, circa 1958.

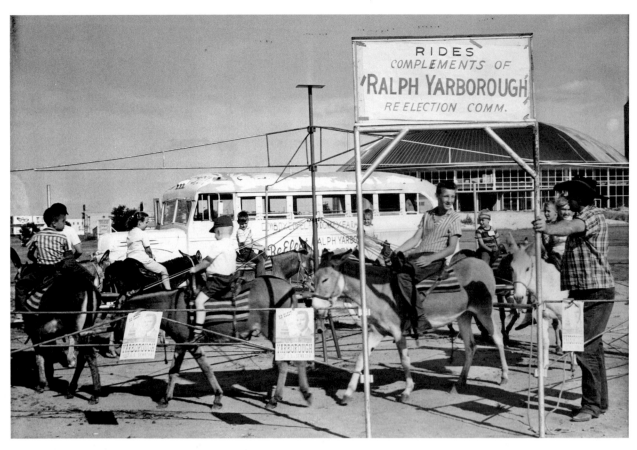

Pony rides compliments of the Ralph Yarborough Reelection Committee, circa 1960s.

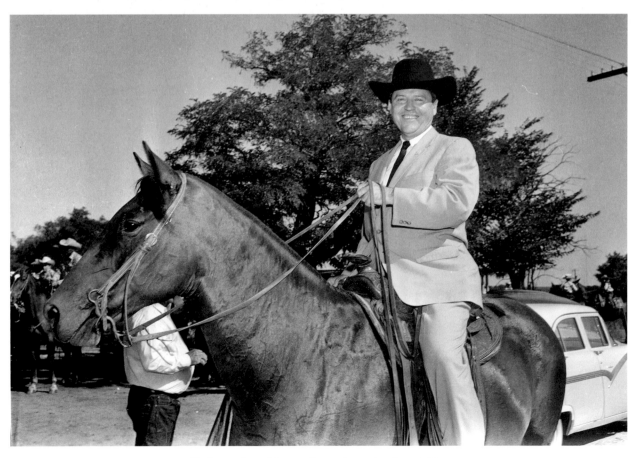

Yarborough working on the cowboy vote, circa 1960s.

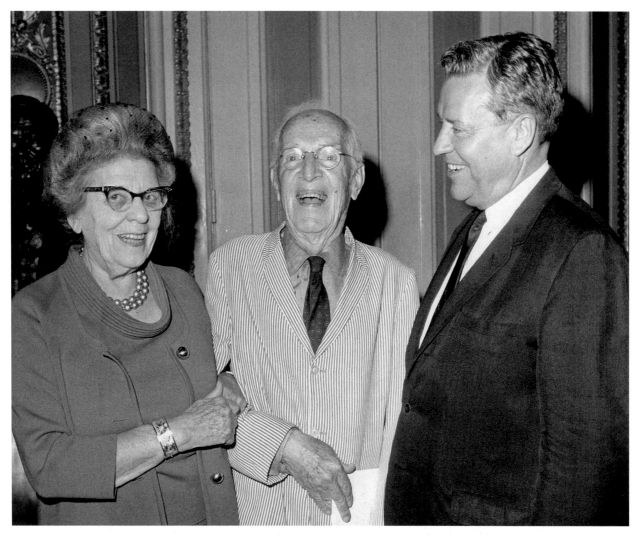

Yarborough with author Upton Sinclair and Sinclair's wife, Mary Elizabeth Willis, July 1965.

Arlon B. "Cyclone" Davis

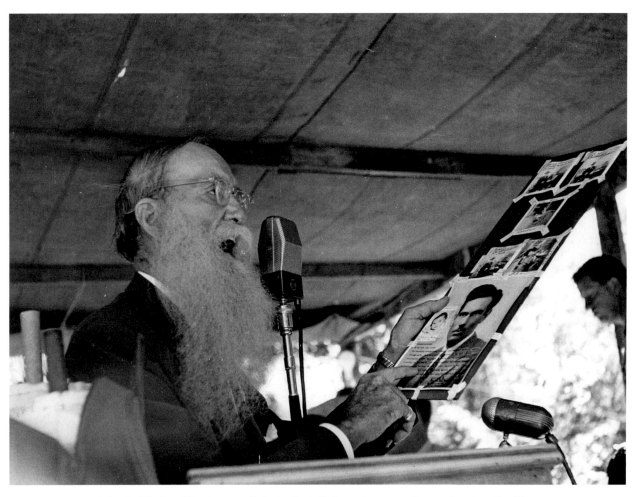

Arlon B. "Cyclone" Davis at a political rally in Belton, circa 1954, "campaign shouting like a Southern diplomat" (with apologies to Chuck Berry). Davis, like his father before him, was a top orator out of deep East Texas. Both men ran for office several times but rarely won.

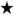

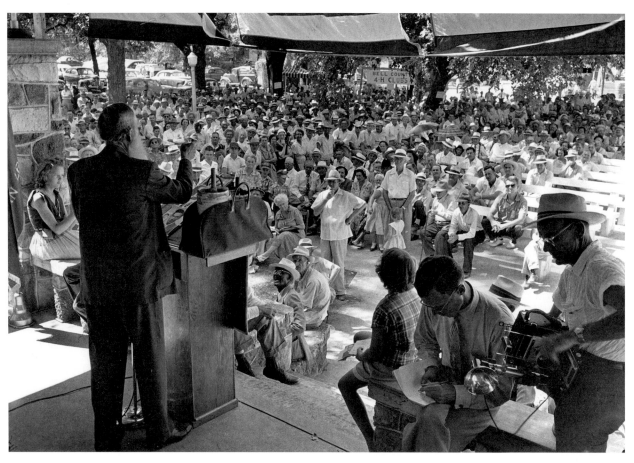

Cyclone Davis at a Belton rally, 1950s.

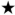

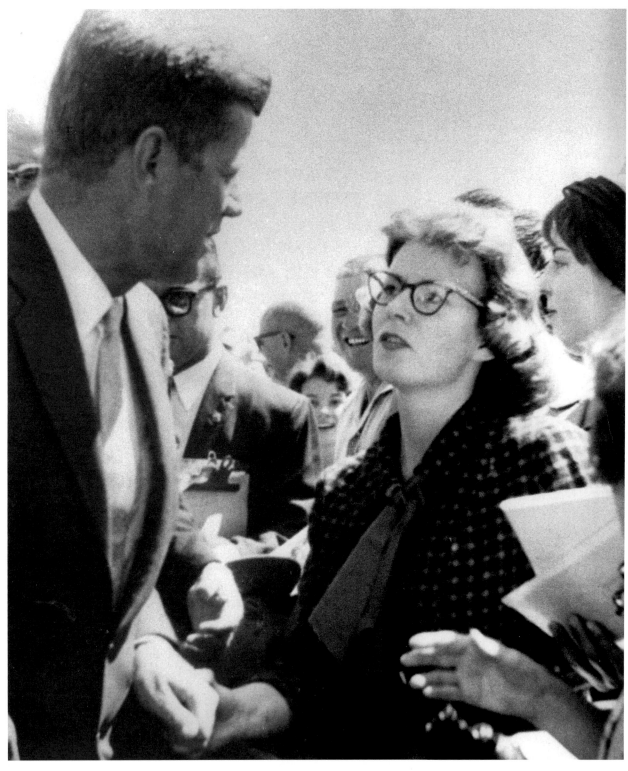

*John F. Kennedy campaigning in 1960 in Lubbock, shaking hands
with Carolene English, later a senior staffer for Bob Bullock.*

President Kennedy in Texas

After defeating Johnson in the 1960 Democratic primary, John F. Kennedy selected him as his running mate. Kennedy campaigned extensively in Texas in 1960 and paid close attention to Speaker Rayburn and the Texas congressional delegation. As president, Kennedy appointed John B. Connally Secretary of the Navy. The ill-fated trip to Dallas, Texas, in November 1963 resulted in the assassination of John F. Kennedy and the wounding of Governor Connally.

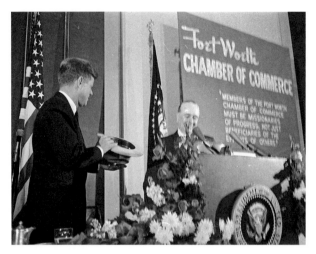

Attorney Raymond Buck gives a hat from local hatmaker Peters Brothers to President Kennedy at a breakfast reception in Fort Worth on the morning of November 22, 1963.

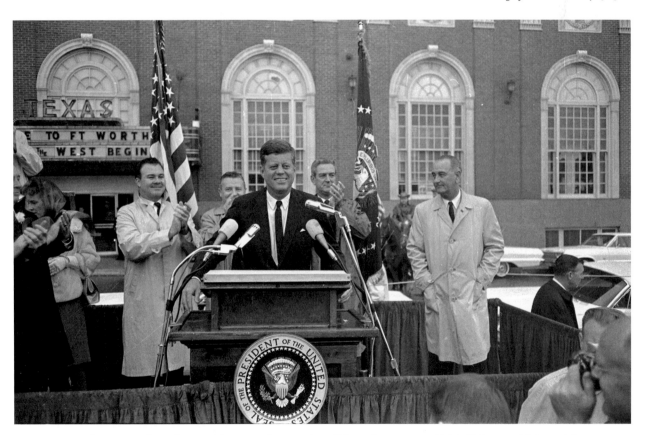

President Kennedy at the Hotel Texas on the morning of November 22, 1963. Behind him stand, left to right, State Senator Don Kinnard, Senator Ralph Yarborough, Governor Connally, and Vice President Johnson.

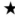

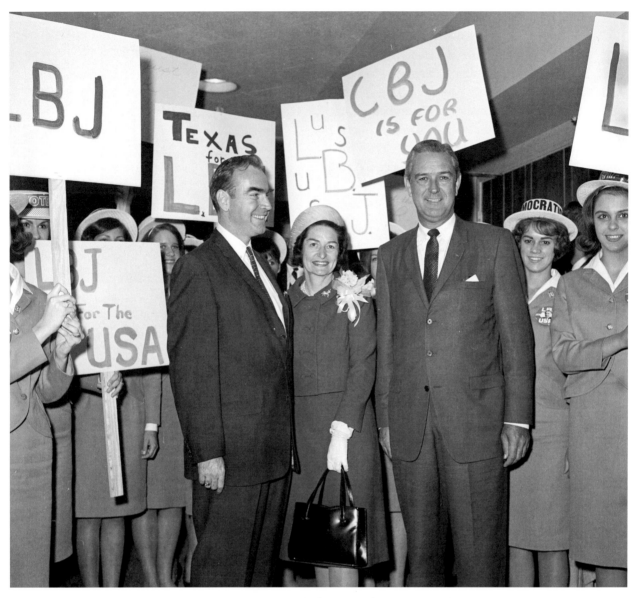

Jim Wright, Lady Bird Johnson, and John Connally (1917–1993) campaigning for Johnson, October 1964.

John B. Connally

John B. Connally was born in 1917 in Wilson County, Texas, near Floresville. He went to the University of Texas, becoming friends with future congressman J. J. "Jake" Pickle. In 1939, he went to work for Congressman Lyndon Johnson, assisting him in his unsuccessful 1941 and successful 1948 U.S. Senate campaigns. Connally was elected to three terms as governor, and in Dallas, on November 22, 1963, was shot and wounded in the same attack that killed President Kennedy. He later changed political parties and was appointed U.S. secretary of the treasury by President Richard Nixon. Connally died in 1993 from what many thought were complications from the 1963 shooting.

Bob Eckhardt

Bob Eckhardt, a liberal Democrat, was born in Austin in 1913. He was elected to Congress in 1966 from Houston, and remained a thorn in the side of the Republican Party until he was defeated in 1981 by Jack Fields. He was an expert on oil and gas issues and a renowned orator. Eckhardt was also known for his political cartoons, which lampooned prominent elected officials of his era. He died in 2001.

Bob Eckhardt (1913–2001), 1970.

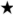

John Tower (1925–1991) on horseback, circa 1970s.

John Tower

John Tower, a Republican, was born in Houston in 1925. He served in the Senate from 1961 (winning a special election to replace Lyndon Johnson) to 1985, when he did not run for reelection. He was the first Republican U.S. senator from Texas since Reconstruction and was considered the father of the modern Republican Party in the state. A leading expert in American defense and the armed services, Tower served as President Ronald Reagan's chief U.S. negotiator for the 1985–1986 arms reduction talks with the Soviet Union. President George H. W. Bush nominated Tower as secretary of defense but he failed to receive Senate confirmation to the cabinet position. Tower was killed in a plane crash in 1991 with his daughter Marian.

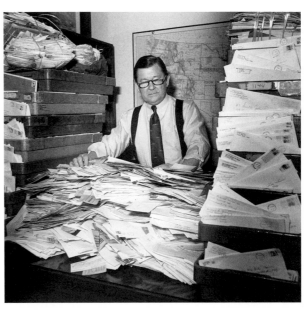

Tower looking through his mail, circa 1970s.

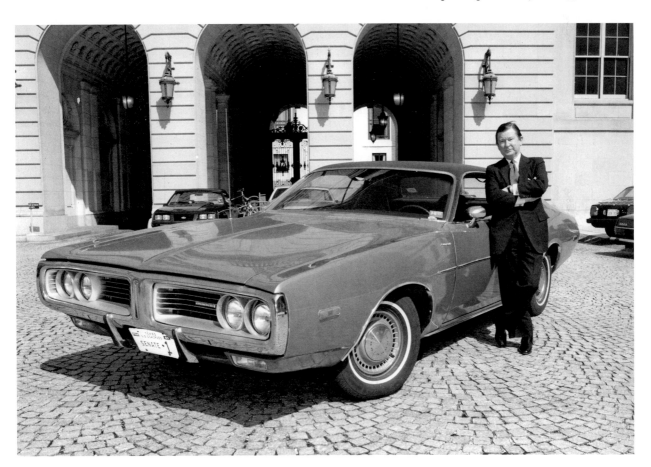

Tower with his elderly Plymouth after his staff had refurbished it, circa 1970s.

Jim Wright

Jim Wright was born in Fort Worth in 1922. Prior to entering politics, he flew as a bombardier in the South Pacific during World War II. While serving as the mayor of Weatherford, he ran for Congress in 1954 against the establishment candidate, Wingate Lucas. He won, and was reelected every election cycle until 1988. As a protégé of Speaker Sam Rayburn, Wright rose through the Democratic leadership to become House majority leader and then Speaker. He retired from Congress in 1989 and returned to Fort Worth.

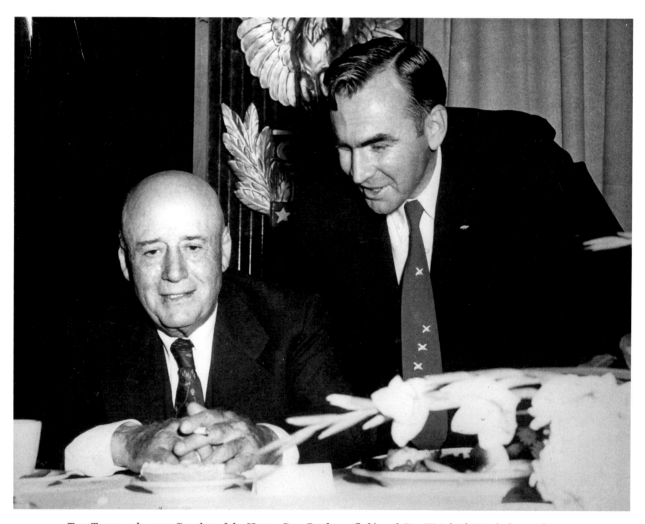

Two Texans who were Speaker of the House, Sam Rayburn (left) and Jim Wright (1922–), date unknown.

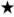

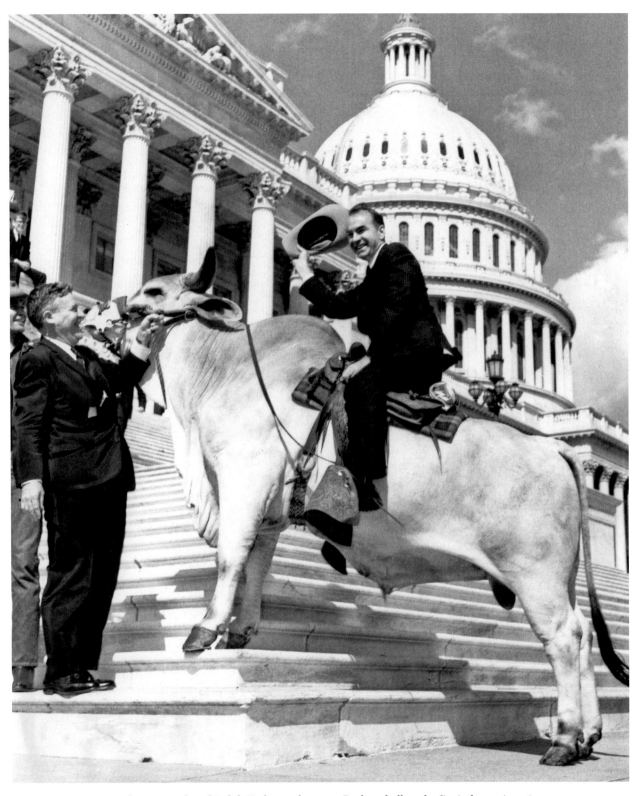

Wright, mounted, and Ralph Yarborough tame a Brahma bull on the Capitol steps in 1964.

Jack Brooks

Jack Brooks was born in Louisiana but moved to Beaumont at an early age. He was educated at the University of Texas in Austin where he also received a law degree. After serving in the Texas legislature, he was elected to Congress in 1952, where he served until 1995. Senator Lyndon Johnson and Speaker Sam Rayburn served as mentors during his early career in Congress. Brooks's tenure included serving as chairman of the House Judiciary Committee. He was present during the swearing-in of Lyndon Johnson as president after the Kennedy assassination, and he can be seen to the right of Johnson in the famous picture taken aboard Air Force One. A Marine veteran known for his frank and colorful expressions, Brooks was once labeled "the executioner" by President Richard Nixon. After Congress, Brooks retired to Beaumont. He died in 2012.

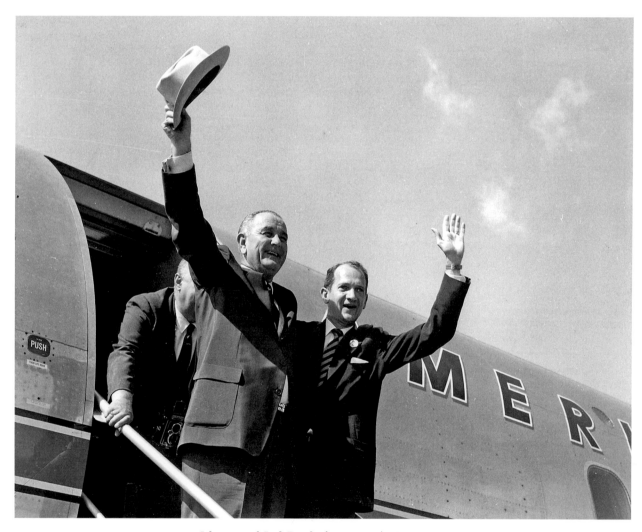

Johnson and Jack Brooks (1922–2012), circa 1960s.

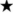

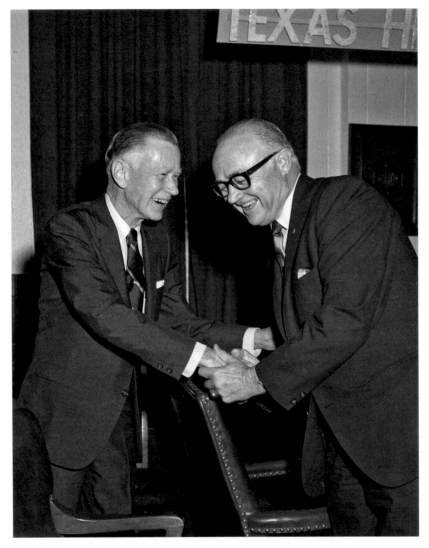

Preston Smith (1912–2003), right, and Dewitt Greer, the head of the
Texas Highway Department, in an undated photograph.

Preston Smith

Preston Smith was born in Williamson County, Texas, in 1912. He moved to Lubbock to attend Texas Tech, graduating in 1934. After working in the movie theater business, he was elected to the Texas House in 1944. In 1956, Smith was elected to the first of three consecutive terms in the Texas Senate, then was elected lieutenant governor in 1962. When Governor John Connally decided not to seek reelection in 1968, Smith ran for, and was elected, governor, serving until 1973. He was a tireless campaigner, driving himself all over Texas in his private car. Although he was never charged with a crime as a result of the Sharpstown scandal, he was nonetheless tainted by it and finished behind Dolph Briscoe Jr. and Frances "Sissy" Farenthold in the 1972 Democratic primary. Smith died in 2003.

Charlie Wilson

Charlie Wilson, born in 1933 in East Texas, graduated from the U.S. Naval Academy in 1956. After his military service, he entered politics, serving first in the Texas legislature and then, from 1973 until 1996, in Congress. There, he earned the nickname "Goodtime Charlie" because of his flamboyant lifestyle. In the 1980s he provided extensive military assistance to the Afghan resistance fighting the occupying Soviet army. A movie, *Charlie Wilson's War*, told the story of his exploits in Afghanistan during this time. Wilson retired from Congress in 1996 and passed away in 2010.

Wilson and a cowboy church in his district, date unknown.

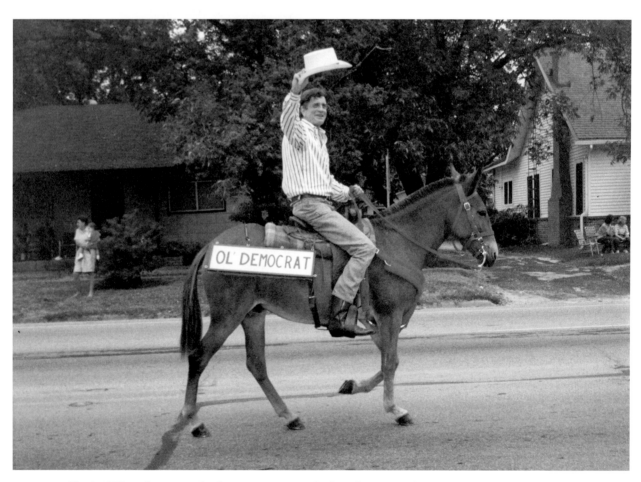

Charlie Wilson (1933–2010) riding a Democratic "donkey" during a reelection campaign, date unknown.

Barbara Jordan

Barbara Jordan was born in 1936 in Houston. After receiving her law degree from Boston University, she practiced law in her hometown. After losing two races for state representative to Willis Whatley, she was the first African American woman elected to the Texas Senate; she served from 1967 to 1973. She was elected to Congress in 1972 and served until 1978, distinguishing herself as an eloquent speaker, particularly during the Watergate hearings. After serving as an aide to Governor Ann Richards and teaching at the LBJ School of Public Affairs at UT Austin, she died in 1996.

Barbara Jordan (1936–1996) with, from left, state senator Chet Brooks, House Speaker Gus Mutscher, and astronaut Neil Armstrong at the Texas Capitol, date unknown.

Jordan at the Democratic National Convention, 1976.

Lloyd Bentsen Jr.

Lloyd Bentsen Jr. was born in 1921 and served in the Army Air Corps during World War II. After serving in the U.S. House, he defeated George H. W. Bush for a Senate seat in 1970. He held the seat from 1971 to 1993. He was the Democratic candidate for vice president in 1988 and is remembered for his famous rejoinder to Republican Dan Quayle in their debate: "Senator, you are no Jack Kennedy." Bentsen went on to serve as secretary of the treasury under President Bill Clinton. He died in Houston in 2006.

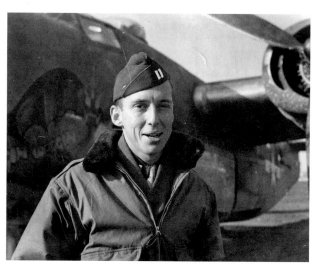

Lloyd Bentsen Jr. (1921–2006) during World War II, date unknown.

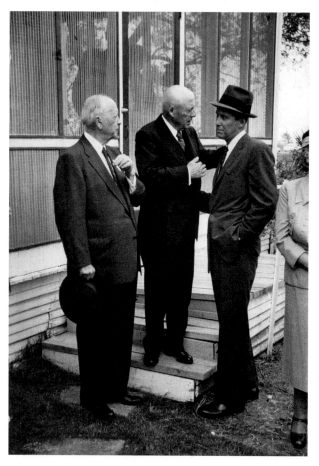

Speaker Sam Rayburn, in the middle, with his hand on Bentsen's shoulder, circa 1950. The other man is unidentified.

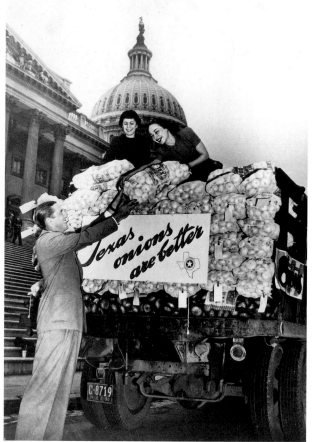

Onions from Bentsen's congressional district in South Texas, circa 1950.

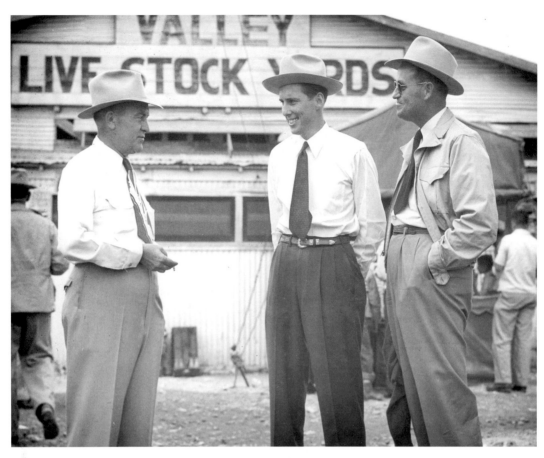

Campaigning in South Texas, circa 1950. Bentsen is in the middle.

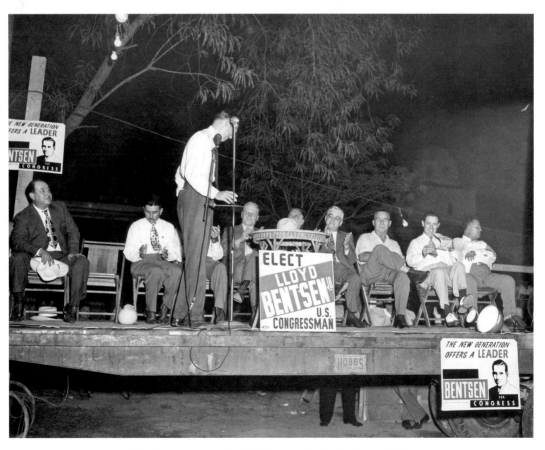

Bentsen campaigning for Congress in South Texas, 1950.

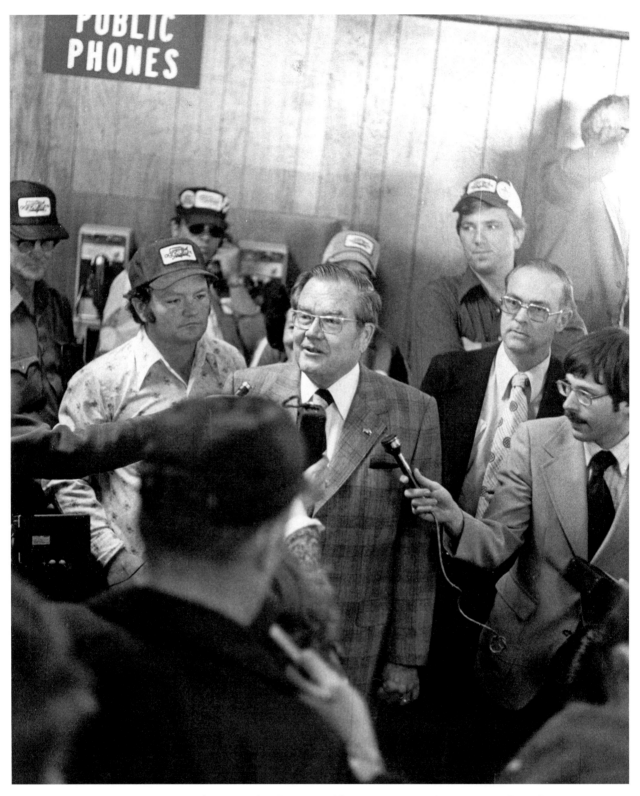

Governor Dolph Briscoe Jr. (1923–2010) with a group of farmers protesting farm prices in the mid-1970s.

Dolph Briscoe Jr.

Dolph Briscoe Jr. was born in Uvalde in 1923. After graduating from the University of Texas and serving in the army during World War II, he was elected to the Texas House in 1948, where he sponsored the popular farm-to-market road legislation. In 1968, he lost a race for governor, but ran again in 1972 and won. In 1974, he was elected to the first four-year term for governor in Texas history. During his term, many important bills were enacted, including open meeting and open record acts, reforms to administrative law practices, property tax reforms, and legislation increasing support for education. Briscoe lost the Democratic primary to Attorney General John Hill in 1978 and returned to banking and ranching in Uvalde. He died in 2010.

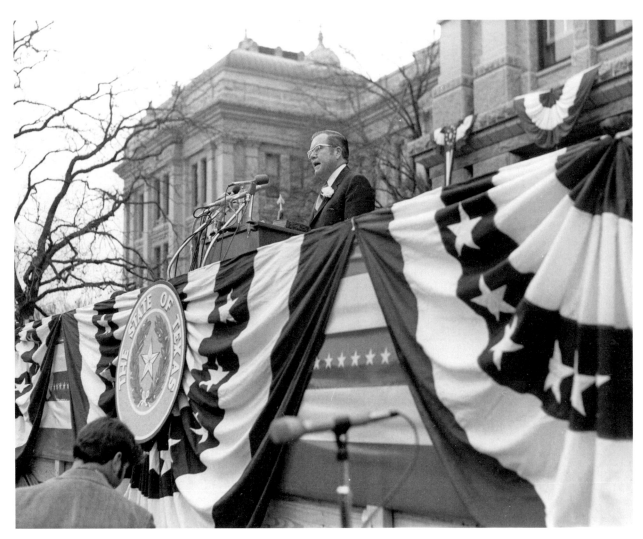

Governor Briscoe at his 1972 inauguration.

Frances Farenthold

Frances "Sissy" Farenthold was elected to the Texas House from Corpus Christi in 1968. While serving, she became a member of the "Dirty Thirty" group that opposed Speaker Gus Mutscher, who was caught up in the Sharpstown scandal. In 1972, Farenthold ran against a large field for governor, but was defeated by Dolph Briscoe Jr. She ran again in 1974, lost, and retired from public office.

Frances Farenthold (1926–) at a campaign yard party in 1972.

Farenthold and Barbara Jordan, date unknown.

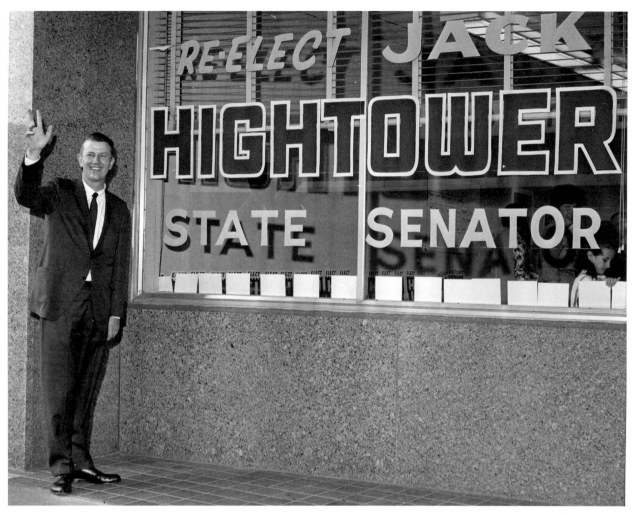

Jack Hightower (1926–2013), circa 1960s.

Jack Hightower

Jack Hightower, a Democrat, was born in 1926 in Memphis, Texas. He served in the navy in World War II. He served one term in the Texas House (1953–1955), was district attorney in Vernon from 1955 to 1961, served five terms as state senator, and was elected to Congress in 1978, where he remained until 1985. Hightower was elected to the Texas Supreme Court in 1988 and resigned in 1996. An avid bibliophile, he was interested in American and Texas history. Hightower died in 2013.

Jack and Colleen Hightower campaigning in West Texas, circa 1960s.

J. J. "Jake" Pickle

J. J. "Jake" Pickle, born in 1913 in Roscoe, was educated at the University of Texas at Austin. After working in public relations, he was elected to Congress in 1963, representing a district in Austin. A Democrat, he served until 1995, working closely over the years with President Johnson. Pickle chaired the important Social Security subcommittee of the Ways and Means Committee. He died in 2005.

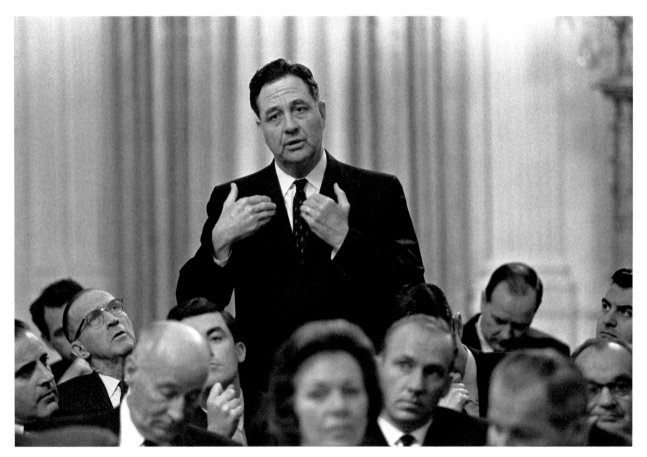

J. J. "Jake" Pickle (1913–2005) at a congressional reception in the Green Room of the White House, February 1967.

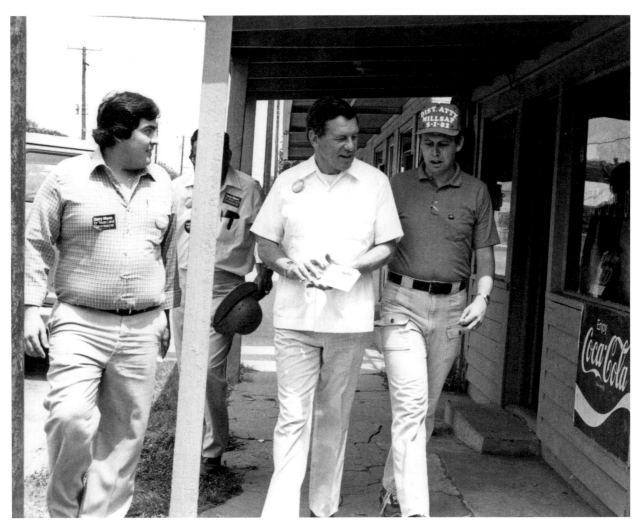

Bill Hobby Jr. (1932–), in white, campaigning in South Texas in 1982.

William P. "Bill" Hobby Jr.

Bill Hobby Jr. was born in Houston in 1932. His father was Governor William P. Hobby Sr. and his mother was Oveta Culp Hobby, the first Secretary of Health, Education, and Welfare and commander of the Women's Army Corps in World War II. Both of his grandfathers also served in the Texas legislature. Hobby served as Senate parliamentarian before being elected lieutenant governor in 1972. He then served four more four-year terms beginning in 1974. Leaving office in 1993, Hobby taught at the LBJ School of Public Affairs, UT Austin, and Rice University, and served as chancellor of the University of Houston.

George H. W. Bush

George Herbert Walker Bush was born in Connecticut in 1924. His father was Senator Prescott Bush. He moved to Midland in the late 1940s to enter the oil industry. By 1964, he had moved to Houston where he was elected to two terms in Congress, 1967–1969. Bush served as vice president for eight years under Ronald Reagan and was elected president in 1988. He presided over the successful Gulf War of 1991, but was defeated for reelection in 1992 by Democratic nominee Bill Clinton. Bush then retired to Houston.

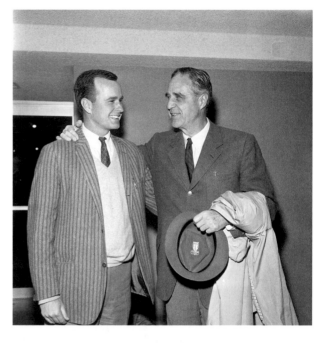

George H. W. Bush (1924–) with his father, Connecticut senator Prescott Bush, date unknown.

George H. W. Bush during his 1964 campaign for a seat in the U.S. Senate, which he lost.

Bob Bullock

ob Bullock was born in Hillsboro in 1929. He was educated at Texas Tech and received his law degree at Baylor in 1958. Elected to the Texas House in 1956, he went on to serve as assistant attorney general, secretary of state, and Texas comptroller. After three terms as comptroller, he ran for lieutentant governor and was elected in 1990 and again in 1994. Despite having a very public drinking problem, several marriages, and an explosive temper, Bullock is considered one of the most talented political leaders in Texas history. Although a lifelong Democrat, he worked well with Republican governor and future president George W. Bush. He died in 1999.

Bob Bullock (1929–1999) in a campaign photo from 1994.

William P. Clements Jr.

William (Bill) Clements was born in Dallas in 1917 and was educated at Southern Methodist University. After a successful career in the oil industry, he was appointed U.S. deputy secretary of defense from 1971 to 1977. In 1978, he won a contested Republican primary and defeated Democrat John Hill to become the first Republican Texas governor since Reconstruction. He lost the governor's post to Democrat Mark White in 1982, but recaptured it four years later, this time defeating White. Clements later served as chairman of the SMU Board of Governors. He died in Dallas in 2011.

Governor Bill Clements (1917–2011), 1978.

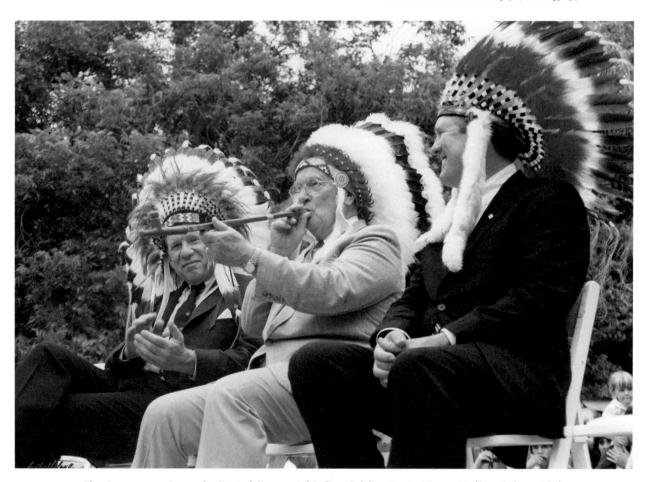

Sharing a peace pipe at the Capitol Centennial Indian Celebration in May 1988 (from left to right): Lieutenant Governor Bill Hobby Jr., Governor Bill Clements, and Speaker of the House Gib Lewis.

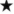

Mark White

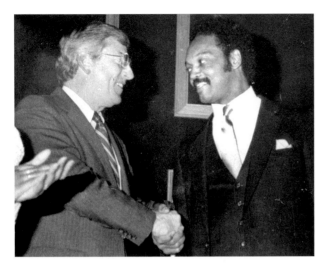

ark White was born in Henderson and educated at Baylor. He was appointed Texas secretary of state in 1973 by Governor Briscoe and was elected attorney general in 1978. In 1982 he defeated Republican governor Bill Clements, who returned the favor by beating White in 1986. It was during White's term as governor that the famous "no pass, no play" law was passed for high school athletics.

Mark White (1940–) with Jesse Jackson during Jackson's campaign for president, 1984.

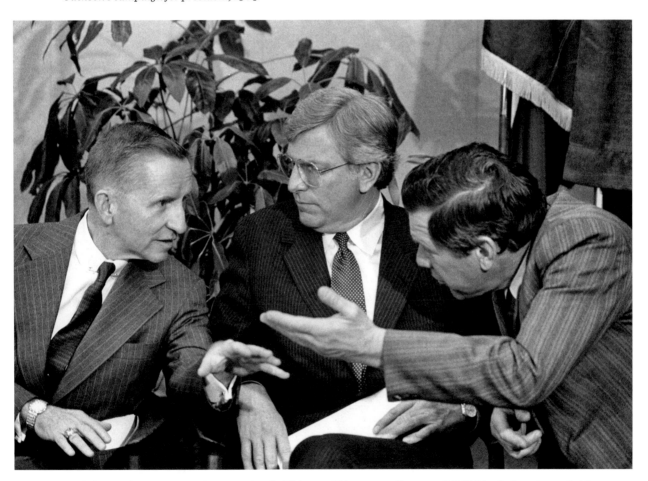

From left to right, Ross Perot, Governor Mark White, and Lieutenant Governor Bill Hobby Jr. in 1984, probably discussing the "no pass, no play" legislation during the education session of the Texas legislature.

Azie Taylor Morton

Azie Taylor Morton was born in Dale, Texas, in 1936. After graduating from Huston-Tillotson University, she moved to Washington and became involved with the Democratic Party.

In 1977, President Jimmy Carter appointed Morton the first African American treasurer of the United States. She served until 1981. Morton died in 2003.

Azie Taylor Morton (1936–2003) with President Carter, 1977.

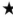

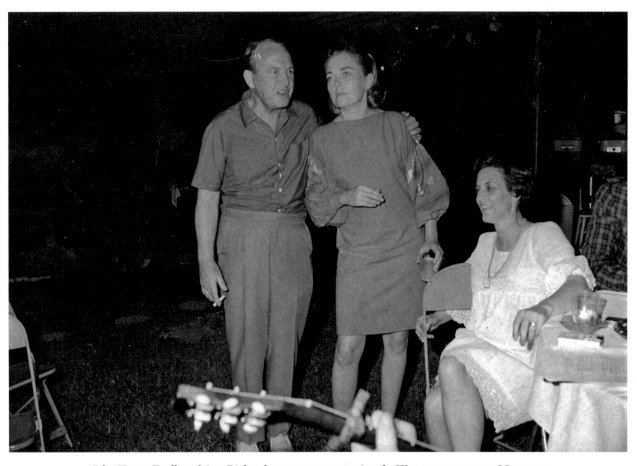

John Henry Faulk and Ann Richards at a party protesting the Watergate cover-up, May 1974.

John Henry Faulk

John Henry Faulk was born in Austin in 1913. His father had been Travis County attorney and a criminal defense lawyer. In 1939 Faulk graduated from the University of Texas, where he had become interested in Texas folklore. While in the army, he began telling stories on the radio and, in 1946, moved to New York where he began a successful career as a talk show host and humorist. Blacklisted in the mid-1950s, Faulk ultimately prevailed in a lawsuit against the blacklisting entity. He moved back to Austin and, in 1984, ran for Congress unsuccessfully. Faulk became a popular storyteller and personality on the *Hee Haw* television series in the early 1970s.

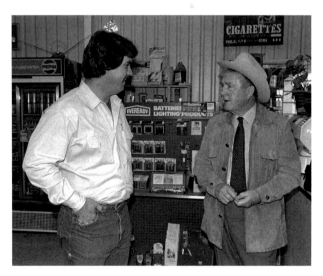

John Henry Faulk (1913–1990), on the right, speaking with an unidentified man during his run for Congress, 1983.

Ann Richards

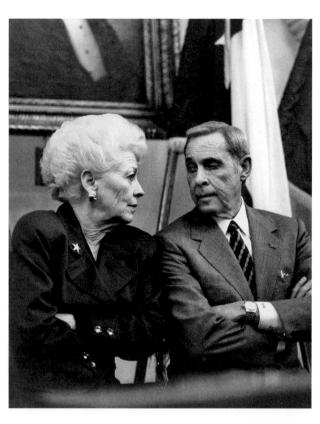

Ann Willis was born outside of Waco in 1933. She was educated at Baylor and taught school after marrying attorney David Richards. She volunteered in a number of political races and causes and, in 1976, was elected Travis County commissioner. In 1982, she was elected Texas state treasurer, making her the first woman to hold a statewide office since Miriam Ferguson in 1932. In 1990 Richards was elected Texas's first woman governor since Ferguson. She was defeated for reelection in 1994 by George W. Bush. In later years, she worked as a political consultant. Richards died in 2006.

Governor Ann Richards (1933–2006) and Lieutenant Governor Bob Bullock had a love/hate relationship, as this photo, circa 1991–1993, clearly shows.

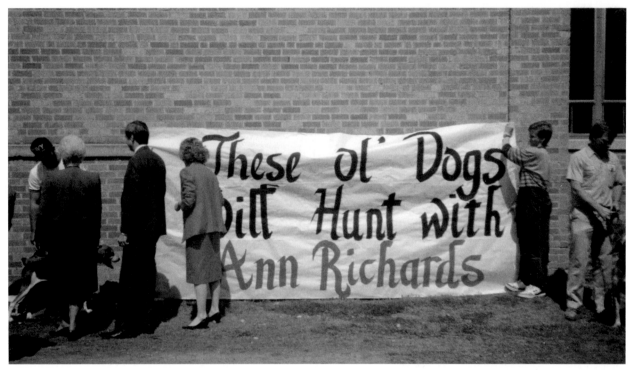

Richards rally in April 1989, with a sign playing on her slogan "that dog won't hunt."

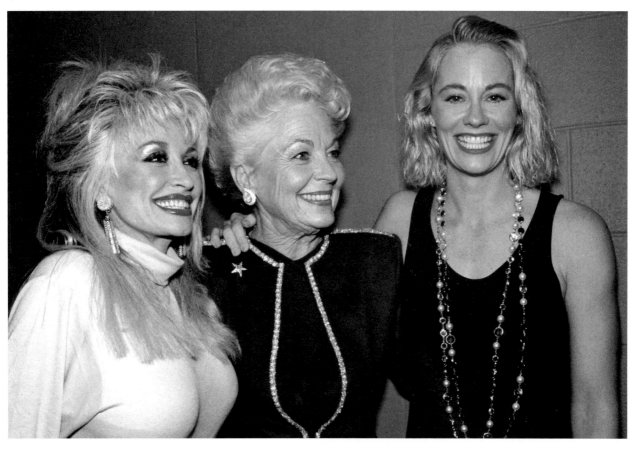

Richards with Dolly Parton and Cybill Shepherd, 1991.

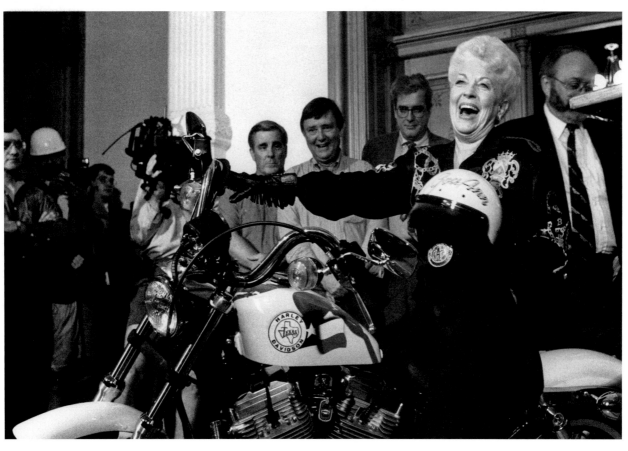

Governor Richards on a Harley, on her sixtieth birthday in 1992.

(above) Standing together on the floor of the Texas House are two state representatives at the beginnings of their illustrious careers. On the left is Sarah Weddington; she gained fame as the lawyer who argued Roe vs. Wade *before the U.S. Supreme Court in 1972, and won. She is talking to Kay Bailey (Hutchison), who served in the Texas House until 1977 before going on to serve as Texas treasurer and U.S. senator.*

(right) Senator Kay Bailey Hutchison (1943–) riding in a rodeo parade, March 2005.

Kay Bailey Hutchison

Kay Bailey Hutchison was born in Galveston in 1943. After graduating from UT Law School, she worked as a television reporter in Houston. A Republican, she was elected to the Texas House of Representatives in 1972 and became Texas treasurer in 1990. Winning a 1993 special election for a U.S. Senate seat, she became the first woman to represent Texas in that body. Hutchison served until 2012.

Kent Hance

Kent Hance served as a Texas state senator, a U.S. congressman (defeating George W. Bush), and Texas railroad commissioner. He also ran unsuccessfully for governor and U.S. senator. Before retiring, he served as chancellor at Texas Tech University.

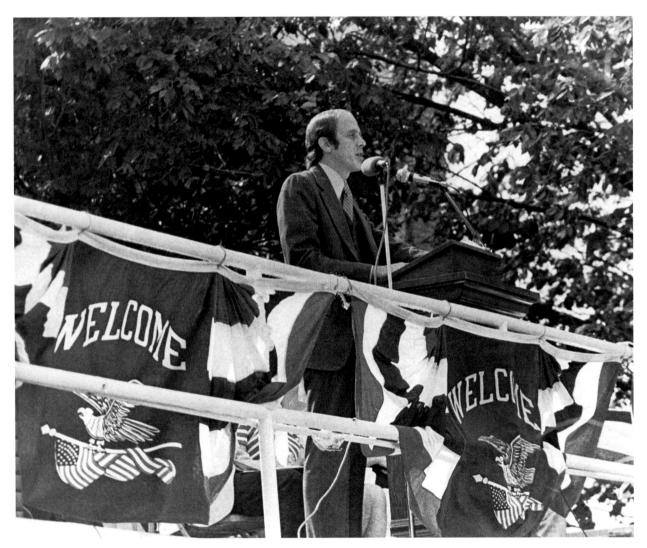

Kent Hance (1942–), circa 1978.

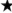

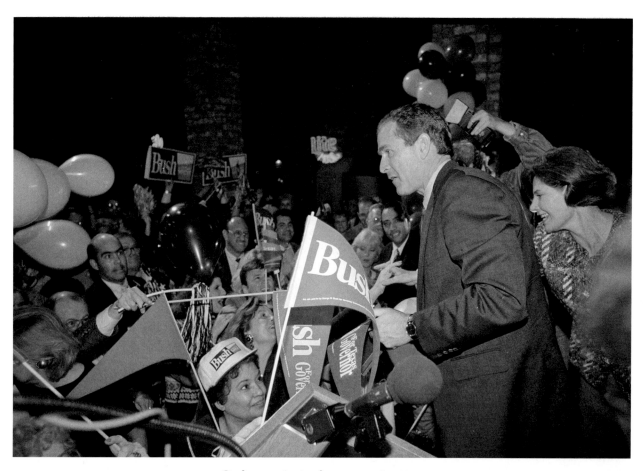

Bush campaigning for governor in 1994.

George W. Bush

George W. Bush, son of a president, was himself elected to that position twice, in 2000 and 2004. Born in Connecticut, he was raised in Midland and Houston. He ran for Congress from Midland in 1978, losing to Kent Hance. He was elected Texas governor in 1994 and again in 1998, then left Texas for the presidency. After his second term in the White House ended, Bush returned to the state, buying a home in Dallas.

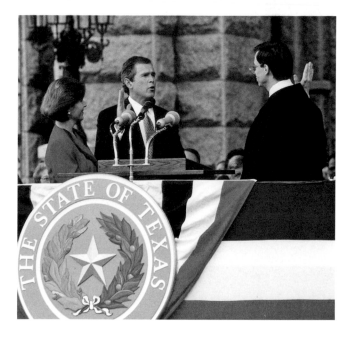

*George W. Bush (1946–) at his 1994
gubernatorial inauguration.*

Rick Perry

Rick Perry, from Paint Rock, Texas, near Abilene, was elected to the Texas House of Representatives as a Democrat in 1984. Changing his allegiance to the Republican Party, he was elected Texas agriculture commissioner in 1990 and lieutenant governor in 1998. On December 21, 2000, he became the forty-seventh governor of Texas when George W. Bush resigned to become president. Perry was elected to three additional terms, becoming the longest-serving governor in Texas history.

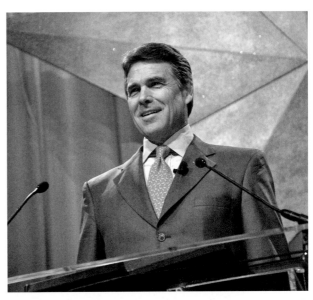

Governor Rick Perry (1950–) speaking to the 2010 State Republican Convention.

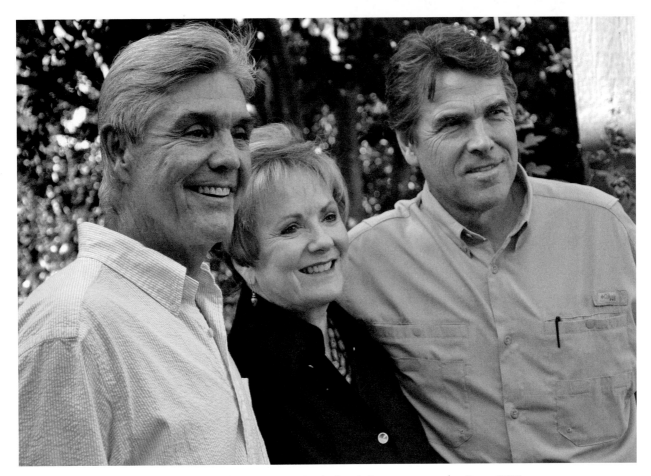

Governor Perry campaigning in Weatherford with future congressman Roger Williams and Congresswoman Kay Granger from Fort Worth in July 2010.

NOTES

INTRODUCTION. PHOTOGRAPHY AND POLITICS

1. "By 1848, three years before his death, Edward Burleson had moved his family to San Marcos Springs (modern day Aquarena Springs in San Marcos). It was the only time in his marriage and family life that Burleson and his family had lived close enough to enjoy the luxuries and conveniences of a town." John H. Jenkins and Kenneth Kesselus, *Edward Burleson: Texas Frontier Leader* (Austin: Jenkins Publishing Company, 1990), 368–371.

2. Dr. Rufus C. Burleson to Henry Arthur McArdle, October 31, 1887, *The McArdle Notebooks: The Battle of San Jacinto* (Texas State Library and Archives Commission), 98.

3. Frank Wagner, "William DeRyee," *The Handbook of Texas Online*, Texas State Historical Association.

4. David Haynes, *Catching Shadows: A Directory of Nineteenth-Century Texas Photographers* (Austin: Texas State Historical Association, 1995).

5. William DeRyee and R. E. Moore, *The Texas Album, of the Eighth Legislature, 1860* (Austin: Printed by Miner, Lambert, & Perry, 1860). Prints & Photographs #1991/137, Texas State Library and Archives Commission.

6. Cecil Harper Jr., "Martin D. Hart," *The Handbook of Texas Online*, Texas State Historical Association.

7. Alwyn Barr, "John Leal Haynes," *The Handbook of Texas Online,* Texas State Historical Association.

8. William Crawford, *The Keepers of Light* (Dobbs Ferry, NY: Morgan & Morgan, Inc., 1979), 6.

9. John Slate, "Interview with Bob Thomas, April 22, 1993," audio recording, accession #1992/101, Texas State Library and Archives Commission.

10. Numerous quotes from Harry Cabluck, interview by John Anderson, October 9, 2012.

11. Susan Sontag, *On Photography* (New York: Delta Publishing Company, 1977), 7.

12. Bonar explains that she almost passed up an August 1989 trip on an environmentally themed boat down the Texas coast with gubernatorial candidate Ann Richards, after gaining access to her entourage. Ave Bonar, *With Ann: A Journey across Texas with a Candidate for Governor* (Austin: Papageno, Inc., 1991).

13. Ave Bonar, interviews by John Anderson, November 2012.

14. Bob Banta, "Photographer of politicians leaves images, shares stories," *Austin American-Statesman*, March 8, 1992; John Anderson, "A Visual Chronicle of State Government," *Texas Libraries*, Vol. 53, No. 1 (Spring/Summer 1992).

15. Peggy Fikac, "Photographer a fixture around the Capitol," *Dallas Morning News*, December 20, 1987.

16. Chuck McDonald had taken a leave of absence as deputy press secretary in the governor's office to work on the midterm elections, especially Lena Guerrero's campaign as it was considered emblematic of the Richards administration. McDonald recalls, "I remember being tasked with going to the Governor's Mansion on many occasions from '90–'94 with bad news about a poll or something that had gone astray with an appointee or state employee. One day I was coming up the back stairs, from the downstairs kitchen to the tiny upstairs apartment, and she started yelling at me, 'I know that's you, Chuck McDonald, and they're sending you over with something horrible to tell me.' She was laughing by the time I got to the top of the stairs. Then I gave her whatever bad news I had that day." Chuck McDonald, e-mail interview with John Anderson, November 8, 2012.

CHAPTER 2. REFORM AND GROWTH FROM THE NINETEENTH TO THE TWENTIETH CENTURY

1. Lewis L. Gould, *Progressives and Prohibitionists: Texas Democrats in the Wilson Era* (Austin: University of Texas Press, 1973), 225–228.

2. Norman D. Brown, *Hood, Bonnet, and Little Brown Jug: Texas Politics, 1921–1928* (College Station: Texas A&M University Press, 1984), 3.

CHAPTER 3. TEXAS IN THE GREAT DEPRESSION AND WORLD WAR II

1. Patrick Cox, "John Nance Garner," in Kenneth E. Hendrickson Jr., Michael L. Collins, and Patrick Cox, *Profiles in Power: Twentieth Century Texans in Washington* (Austin: University of Texas Press, 2004).

2. Patrick Cox, *The First Texas News Barons* (Austin: University of Texas Press, 2004), 213–216.

CHAPTER 4. MODERN TEXAS

1. Robert Dallek, *Lone Star Rising: Lyndon Johnson and His Times, 1908–1960* (New York: Oxford University Press, 1991), 346–347.

2. Patrick L. Cox and Michael Phillips, *The House Will Come to Order: How the Texas Speaker Became a Power in State and National Politics* (Austin: University of Texas Press, 2010), 98–108.

3. Robert Calvert and Arnoldo De Leon, *The History of Texas* (Wiley-Blackwell, 2007), 410, 443.

SELECTED BIBLIOGRAPHY

Barr, Alwyn. *Reconstruction to Reform: Texas Politics, 1876–1906*. Austin: University of Texas Press, 1971.

Barta, Carolyn. *Bill Clements, Texian to His Toenails*. Austin: Eakin Press, 1996.

Blodgett, Dorothy, Terrell Blodgett, and David L. Scott. *The Land, The Law, and the Lord: The Life of Pat Neff, Governor of Texas 1921–1925; President of Baylor University 1932–1947*. Austin: Home Place Publishers, 2007.

Briscoe, Dolph, as told to Don Carleton. *Dolph Briscoe: My Life in Texas Ranching and Politics*. Austin: Center for American History, University of Texas at Austin, 2008.

Brown, Norman D. *Hood, Bonnet, and Little Brown Jug: Texas Politics, 1921–1928*. College Station: Texas A&M University Press, 1984.

Burton, Michael C. *John Henry Faulk: The Making of a Liberated Mind—A Biography*. Austin: Eakin Press, 1993.

Calvert, Robert, and Arnoldo De Leon. *The History of Texas*. Wiley-Blackwell, 2007.

Cantrell, Gregg. *Stephen F. Austin: Empresario of Texas*. New Haven: Yale University Press, 2001.

Connally, John, with Mickey Herskowitz. *In History's Shadow: An American Odyssey*. New York: Hyperion, 1994.

Connally, Tom, as told to Alfred Steinberg. *My Name Is Tom Connally*. New York: Thomas Y. Crowell Co., 1954.

Cotner, Robert C. *James Stephen Hogg: A Biography*. Austin: University of Texas Press, 1959.

Cox, Patrick. *The First Texas News Barons*. Austin: University of Texas Press, 2004.

—— and Michael Phillips. *The House Will Come to Order: How the Texas Speaker Became a Power in State and National Politics*. Austin: University of Texas Press, 2010.

Dallek, Robert. *Lone Star Rising: Lyndon Johnson and His Times, 1908–1960*. New York: Oxford University Press, 1991.

Fehrenbach, T. R. *Lone Star: A History of Texas and the Texans*. New York: American Legacy Press, 1983 ed.

Gould, Lewis L.. *Progressives and Prohibitionists: Texas Democrats in the Wilson Era*. Austin: University of Texas Press, 1973.

Guttery, Ben R. *Representing Texas: A Comprehensive History of U.S. and Confederate Senators and Representatives from Texas*. BookSurge Publishing, 2008.

Haley, James L. *Passionate Nation: The Epic History of Texas*. New York, London, Toronto, and Sydney: Free Press, 2006.

——. *Sam Houston*. Norman: University of Oklahoma Press, 2002.

——. *Texas: An Album of History—From the Frontier to Spindletop*. Garden City, New York: Doubleday and Co., 1985.

Hardeman, D. B., and Donald C. Bacon. *Rayburn: A Biography*. Austin: Texas Monthly Press, 1987.

Hendrickson, Kenneth E. Jr., Michael L. Collins, and Patrick Cox, eds. *Profiles in Power: Twentieth Century Texans in Washington*. Austin: University of Texas Press, 2004.

Jenkins, John H., and Kenneth Kesselus. *Edward Burleson: Texas Frontier Leader*. Austin: Jenkins Publishing Company, 1990.

Kinch, Sam, and Stuart Long. *Allan Shivers: The Pied Piper of Texas Politics*. Austin: Shoal Creek Publisher, Inc., 1973.

Knaggs, John R. *Two Party Texas: The John Tower Era, 1961–1984*. Austin: Eakin Press, 1986.

Paulissen, May Nelson, and Carl R. McQueary. *Miriam: The Southern Belle Who Became the First Woman Governor of Texas*. Austin: Eakin Press, 1994.

Proctor, Ben H. *Not Without Honor: The Life of John H. Reagan*. Austin: University of Texas Press, 1962.

Sterling, Ross S., and El Kilman, edited and revised by Don Carleton. *Ross Sterling, Texan*. Austin: The Center for American History and The University of Texas Press, 2006.

Welch, Jane Rayfield. *The Texas Governor*. Dallas: G.L.A. Press, 1977.

———. *The Texas Senator*. Dallas: G.L.A. Press, 1978.

OTHER SOURCES

The Handbook of Texas: A Dictionary of Essential Information. 3 volumes. The Texas State Historical Association, 1952 [1976].

The Handbook of Texas Online. Texas State Historical Association.

Members of the Texas Congress 1836–1845, Members of the Texas Legislature 1846–1992, Texas Senate Engrossing and Enrolling, Senate Reproduction, 1992.

Presiding Officers of the Texas Legislature, 1846–2002. Texas Legislative Council, 2002.

PHOTOGRAPHIC SOURCES

3 Courtesy of Texas State Library & Archives Commission.

4 Courtesy of Texas State Library & Archives Commission.

14 Prints & Photographs Collection, di_08331, The Dolph Briscoe Center for American History, The University of Texas at Austin.

15 Bryan (Lewish Randolph) Papers, di_08308, The Dolph Briscoe Center for American History, The University of Texas at Austin.

16 Prints & Photographs Collection, di_08333, The Dolph Briscoe Center for American History, The University of Texas at Austin.

17 (*left*) Prints & Photographs Collection, di_02290, The Dolph Briscoe Center for American History, The University of Texas at Austin.

17 (*right*) Courtesy of the Rosenberg Library, Galveston, Texas.

18 Prints & Photographs Collection, di_08233, The Dolph Briscoe Center for American History, The University of Texas at Austin.

19 Courtesy of the Library of Congress.

20 Prints & Photographs Collection, di_08230, The Dolph Briscoe Center for American History, The University of Texas at Austin.

21 Prints & Photographs Collection, di_01227, The Dolph Briscoe Center for American History, The University of Texas at Austin.

22 San Diego History Center.

23 Courtesy of the Library of Congress.

24 Prints & Photographs Collection, di_08232, The Dolph Briscoe Center for American History, The University of Texas at Austin.

25 (*top*) Prints & Photographs Collection, di_08232, The Dolph Briscoe Center for American History, The University of Texas at Austin.

25 (*lower left*) Courtesy of the Rosenberg Library, Galveston, Texas. Photo by Mathew Brady.

25 (*lower right*) Courtesy of the Rosenberg Library, Galveston, Texas.

26 Courtesy of Texas State Library & Archives Commission.

27 Courtesy of Texas State Library & Archives Commission.

28 Created by H. R. Marks, Prints & Photographs Collection, foth_0584, The Dolph Briscoe Center for American History, The University of Texas at Austin.

29 PICB 10311, Austin History Center, Austin Public Library.

30 University of Texas San Antonio Libraries Special Collections.

31 (*top*) DeGolyer Library, Southern Methodist University, Dallas, Texas, Ag.2008.2005.

31 (*bottom*) Palm (Swante) Papers, di_08301, The Dolph Briscoe Center for American History, The University of Texas at Austin.

32 Courtesy of the Library of Congress.

33 (*left*) Courtesy of the Library of Congress.

33 (*right*) Anderson County Musuem.

34 Courtesy of the Library of Congress.

35 Courtesy of the Library of Congress.

36 Courtesy of Texas State Library & Archives Commission.

37 Courtesy of the Library of Congress.

38 Courtesy of Texas State Library & Archives Commission.

39 Courtesy of Texas State Library & Archives Commission.

40 Courtesy of the Library of Congress.

41 DeGolyer Library, Southern Methodist University, Dallas, Texas, Ag.2008.2005.

42 (*top*) Harry Ransom Center, The University of Texas at Austin.

42 (*bottom*) Courtesy of Texas State Library & Archives Commission.

43 (*left*) Texas Collection and University Archives, Baylor University.

43 (*right*) Courtesy of the Rosenberg Library, Galveston, Texas.

52 Courtesy of the Library of Congress.

53 Courtesy of Texas State Library & Archives Commission.

54 (*left*) Hogg (James Stephen) Papers, di_08245, The Dolph Briscoe Center for American History, The University of Texas at Austin.

54 (*right*) Prints & Photographs Collection, di_08318, The Dolph Briscoe Center for American History, The University of Texas at Austin.

55 **(top)** Hogg (James Stephen) Papers, di_08311, The Dolph Briscoe Center for American History, The University of Texas at Austin.

55 **(middle)** Hogg (James Stephen) Papers, di_08244, The Dolph Briscoe Center for American History, The University of Texas at Austin.

55 **(bottom)** Photograph by Mom Photographer, Hogg (James Stephen) Papers, di_08309, The Dolph Briscoe Center for American History, The University of Texas at Austin.

56 Hogg (James Stephen) Papers, di_08242, The Dolph Briscoe Center for American History, The University of Texas at Austin.

57 **(top)** Courtesy of Texas State Library & Archives Commission.

57 **(bottom)** Sam Houston Museum.

58 **(top)** Courtesy of the Library of Congress.

58 **(bottom)** Hogg (James Stephen) Papers, di_08246, The Dolph Briscoe Center for American History, The University of Texas at Austin.

59 **(left)** Courtesy of the Library of Congress.

59 **(right)** Prints & Photographs Collection, di_08316, The Dolph Briscoe Center for American History, The University of Texas at Austin.

60 **(top)** Prints & Photographs Collection, di_08328, The Dolph Briscoe Center for American History, The University of Texas at Austin.

60 **(bottom)** Photographed by G. F. Dohring, Terrell (Alexander Watkins) Papers, di_08241, The Dolph Briscoe Center for American History, The University of Texas at Austin.

61 Harry Ransom Center, The University of Texas at Austin.

62 PICA17440, Austin History Center, Austin Public Library.

63 **(upper left)** UT Arlington.

63 **(upper right)** W. R. Poage Legislative Library, Baylor University.

63 **(bottom)** Courtesy of the Library of Congress.

64 Hogg (James Stephen) Papers, di_08243, The Dolph Briscoe Center for American History, The University of Texas at Austin.

65 The Abilene Photograph Collection at Hardin-Simmons University.

66 **(top)** Courtesy of the Library of Congress.

66 **(bottom)** Courtesy of Texas State Library & Archives Commission.

67 Erwin E. Smith (1886–1947), crowd around courthouse waiting for appearance by Joseph Weldon Bailey, U.S. Senator from Gainesville, Texas, Gelatin dry plate negative, Amon Carter Museum of American Art, Fort Worth, Texas, Bequest of Mary Alice Pettis, © Erwin E. Smith Foundation.

68 Courtesy of Texas State Library & Archives Commission.

69 Prints & Photographs Collection, di_08235, The Dolph Briscoe Center for American History, The University of Texas at Austin.

70 Photograph by Underwood and Underwood Publisher, Prints & Photographs Collection, di_08231, The Dolph Briscoe Center for American History, The University of Texas at Austin.

71 **(top)** DeGolyer Library, Southern Methodist University, Dallas, Texas, Ag.2008.2005.

71 **(bottom)** DeGolyer Library, Southern Methodist University, Dallas, Texas, Ag.2008.2005.

72 Lanham (Samuel Willis Tucker) Papers, di_07421, The Dolph Briscoe Center for American History, The University of Texas at Austin.

73 **(top)** Photographed by Clogenson, Dallas, Texas, Lanham (Samuel Willis Tucker) Papers, di_07418, The Dolph Briscoe Center for American History, The University of Texas at Austin.

73 **(bottom)** Lanham (Samuel Willis Tucker) Papers, di_08330, The Dolph Briscoe Center for American History, The University of Texas at Austin.

74 **(top)** Houston Metropolitan Research Center. Houston Public Library, Houston, TX. Special Collections; SC 329-5.

74 **(bottom)** Harry Ransom Center. The University of Texas at Austin.

75 **(top)** Prints & Photographs Collection, di_08234, The Dolph Briscoe Center for American History, The University of Texas at Austin.

75 **(bottom)** Courtesy of the Library of Congress.

76 C02730, Austin History Center, Austin Public Library.

77 Crane (Martin McNulty) Papers, di_08259, The Dolph Briscoe Center for American History, The University of Texas at Austin.

78 Jack Wilson Collection.

79 Courtesy of the Library of Congress.

80 **(top)** Photograph by Walton Photo, Colquitt (Oscar Branch) Papers, di_08294, The Dolph Briscoe Center for American History, The University of Texas at Austin.

80 **(bottom)** Prints & Photographs Collection, di_08329, The Dolph Briscoe Center for American History, The University of Texas at Austin.

81 **(top)** Colquitt (Oscar Branch) Papers, di_08291, The Dolph Briscoe Center for American History, The University of Texas at Austin.

81 **(middle)** Moore Memorial Library, Texas City, Texas.

81 **(bottom)** Prints & Photographs Collection, di_08239, The Dolph Briscoe Center for American History, The University of Texas at Austin.

82 Courtesy of the Bell County Museum.

83 **(top)** University of Texas San Antonio Libraries Special Collections.

83 **(bottom)** Prints & Photographs Collection, di_06864, The Dolph Briscoe Center for American History, The University of Texas at Austin.

84 **(top)** Prints & Photographs Collection, di_06861, The Dolph Briscoe Center for American History, The University of Texas at Austin.

84 **(bottom)** Ferguson (James Edward) Collection, di_02364, The Dolph Briscoe Center for American History, The University of Texas at Austin.

85 **(top)** Austin History Center, Image #C03419.

85 **(bottom)** University of Texas San Antonio Libraries Special Collections.

86 Photograph by The Studio Deane, Beaumont, Texas, Hobby (William, Sr.) Family Papers, di_08266, The Dolph Briscoe Center for American History, The University of Texas at Austin.

87 Hobby (William, Sr.) Family Papers, di_08267, The Dolph Briscoe Center for American History, The University of Texas at Austin.

88 (*top*) From the Collections of the Texas/Dallas History Archives Division, Dallas Public Library.

88 (*bottom*) From the Collections of the Texas/Dallas History Archives Division, Dallas Public Library.

89 (*top*) Courtesy of the Library of Congress.

89 (*bottom*) Photograph by New York Herald, Burleson (Albert S.) Collection, di_08264, The Dolph Briscoe Center for American History, The University of Texas at Austin.

90 Courtesy of the Library of Congress.

91 (*left*) Courtesy of the Library of Congress.

91 (*right*) Courtesy of the Library of Congress.

92 ND-41-153-01, Austin History Center, Austin Public Library.

93 (*top*) McCallum (Jane Y. and Arthur N.) Papers, di_08327, The Dolph Briscoe Center for American History, The University of Texas at Austin.

93 (*bottom*) Photograph by Neal Douglass, McCallum (Jane Y. and Arthur N.) Papers, di_08263, The Dolph Briscoe Center for American History, The University of Texas at Austin.

94 PICA 16817, Austin History Center, Austin Public Library.

95 (*top*) Photograph by Robert Runyon, Runyon (Robert) Photograph Collection, RUN08685, The Dolph Briscoe Center for American History, The University of Texas at Austin.

95 (*bottom*) Photograph by Robert Runyon, Runyon (Robert) Photograph Collection, RUN08882, The Dolph Briscoe Center for American History, The University of Texas at Austin.

96 Texas Collection and University Archives, Baylor University.

97 (*top*) Photo courtesy of Southwest Collection/Special Collections Library, Texas Tech University, Lubbock, Texas, SWCPC, 57 (Z).

97 (*bottom left*) Texas Collection and University Archives, Baylor University.

97 (*bottom right*) Texas Collection and University Archives, Baylor University.

98 (*top*) PICB 06174, Austin History Center, Austin Public Library.

98 (*bottom*) C02822, Austin History Center, Austin Public Library.

99 C02862, Austin History Center, Austin Public Library.

100 Courtesy of Texas State Library & Archives Commission.

101 (*top*) Sterling (Ross) Papers, di_08321, The Dolph Briscoe Center for American History, The University of Texas at Austin.

101 (*bottom*) Houston Metropolitan Research Center. Houston Public Library, Houston, TX. Special Collections; RG D 0005, fol. 0699 (Houston Press).

110 Charles C. Bailey Collection.

111 Photograph by Lewison Studio, San Antonio, Prints & Photographs Collection, di_08229, The Dolph Briscoe Center for American History, The University of Texas at Austin.

112 (*top*) Library of Congress, Prints & Photographs Division, photograph by Harris & Ewing, LC-DIG-hec-02728.

112 (*bottom*) Garner (John Nance) Papers, di_08270, The Dolph Briscoe Center for American History, The University of Texas at Austin.

113 Garner (John Nance) Papers, di_08305, The Dolph Briscoe Center for American History, The University of Texas at Austin.

114 (*top*) Garner (John Nance) Papers, di_08283, The Dolph Briscoe Center for American History, The University of Texas at Austin.

114 (*bottom*) Garner (John Nance) Papers, di_08282, The Dolph Briscoe Center for American History, The University of Texas at Austin.

115 Garner (John Nance) Photograph Collection, di_02065, The Dolph Briscoe Center for American History, The University of Texas at Austin.

116 Rayburn (Sam) Papers, di_03292, The Dolph Briscoe Center for American History, The University of Texas at Austin.

117 (*top*) Rayburn (Sam) Papers, di_08248, The Dolph Briscoe Center for American History, The University of Texas at Austin.

117 (*bottom left*) Rayburn (Sam) Papers, di_08247, The Dolph Briscoe Center for American History, The University of Texas at Austin.

117 (*bottom right*) Reynolds Studio, Mabank, Texas, Rayburn (Sam) Papers, di_08261, The Dolph Briscoe Center for American History, The University of Texas at Austin.

118 Rayburn (Sam) Papers, di_08250, The Dolph Briscoe Center for American History, The University of Texas at Austin.

119 (*top*) Rayburn (Sam) Papers, di_08252, The Dolph Briscoe Center for American History, The University of Texas at Austin.

119 (*bottom*) Rayburn (Sam) Papers, di_08256, The Dolph Briscoe Center for American History, The University of Texas at Austin.

120 Library of Congress, Prints & Photographs Division, photograph by Harris & Ewing, LC-DIG-hec-23857.

121 (*top*) Photograph by Woodallen, Houston, Jones (Jesse Holman) Papers, di_08312, The Dolph Briscoe Center for American History, The University of Texas at Austin.

121 (*bottom*) Jones (Jesse Holman) Papers, di_08313, The Dolph Briscoe Center for American History, The University of Texas at Austin.

122 (*top*) Library of Congress, Prints & Photographs Division, photograph by Harris & Ewing, LC-DIG-hec-25997.

122 (*bottom*) LBJ Library photo by Yoichi Okamoto.

123 (*top*) Library of Congress, Prints & Photographs Division, photograph by Harris & Ewing, LC-DIG-hec-22676.

123 (*bottom*) W. R. Poage Legislative Library, Baylor University.

124 Library of Congress Prints & Photographs Division, photograph by Harris & Ewing, LC-DIG-hec-28164.

125 Library of Congress, Prints & Photographs Division, photograph by Harris & Ewing, LC-DIG-hec-23981.

126 Library of Congress, Prints & Photographs Division, photograph by Harris & Ewing, LC-DIG-hec-23117.

127 Library of Congress, Prints & Photographs Division, photograph by Harris & Ewing, LC-H22-D- 4111.

128 (*top*) Library of Congress, Prints & Photographs Division, photograph by Harris & Ewing, LC-DIG-npcc-15680.

128 (*bottom*) Library of Congress, Prints & Photographs Division, photograph by Harris & Ewing, [reproduction number] LC-DIG-hec-24657.

129 Photograph by Ellison Photo, Colquitt (Oscar Branch) Papers, di_08292, The Dolph Briscoe Center for American History, The University of Texas at Austin.

130 (*top*) Prints & Photographs Collection, di_08238, The Dolph Briscoe Center for American History, The University of Texas at Austin.

130 (*bottom*) University of Texas San Antonio Libraries Special Collections.

131 (*top*) ND-55-A004-01, Austin History Center, Austin Public Library.

131 (*bottom*) Houston Metropolitan Research Center. Houston Public Library, Houston, TX. Special Collections; MSS/457-052.

132 Courtesy of Texas State Library & Archives Commission.

133 (*top*) Courtesy of Texas State Library & Archives Commission.

133 (*bottom*) Courtesy of Texas State Library & Archives Commission.

134 (*top*) ND-41-174-01, Austin History Center, Austin Public Library.

134 (*bottom left*) University of Texas San Antonio Libraries Special Collections.

134 (*bottom right*) Photo courtesy of Southwest Collection/Special Collections Library, Texas Tech University, Lubbock, Texas, SWCPC, 57 (G).

135 ND-41-173-01, Austin History Center, Austin Public Library.

136 (*top*) PICA17440, Austin History Center, Austin Public Library.

136 (*bottom*) Jones (Jesse Holman) Papers, di_08314, The Dolph Briscoe Center for American History, The University of Texas at Austin.

137 Photograph by Fox Tone Pictures, Thompson (Earnest) Papers, di_08290, The Dolph Briscoe Center for American History, The University of Texas at Austin.

148 Lockheed Martin.

149 (*top*) Rayburn (Sam) Papers, di_08251, The Dolph Briscoe Center for American History, The University of Texas at Austin.

149 (*bottom*) Courtesy of Texas State Library & Archives Commission.

150 Charles C. Bailey Collection.

151 (*left*) ND-54-A002-01, Austin History Center, Austin Public Library.

151 (*right*) ND-48-A046-01, Austin History Center, Austin Public Library.

152 (*left*) Photograph by Fred Harvey Restaurants and Shops, taken by the Photomatic, Rayburn (Sam) Papers, di_08332, The Dolph Briscoe Center for American History, The University of Texas at Austin.

152 (*top right*) LBJ Library photo by unknown.

152 (*bottom right*) University of Texas San Antonio Libraries Special Collections.

153 (*top*) Port Arthur Library.

153 (*bottom left*) From the Collections of the Texas/Dallas History Archives Division, Dallas Public Library.

153 (*bottom right*) From the Collections of the Texas/Dallas History Archives Division, Dallas Public Library.

154 (*top*) UT Arlington.

154 (*bottom left*) The Abilene Photograph Collection at Hardin-Simmons University.

154 (*bottom right*) Photograph by Russell Lee, Lee (Russell) Photograph Collection, di_07909, The Dolph Briscoe Center for American History, The University of Texas at Austin.

155 AS60-29475-3, Austin History Center, Austin Public Library.

156 Photograph by Harris and Ewing, Rayburn (Sam) Papers, di_08257, The Dolph Briscoe Center for American History, The University of Texas at Austin.

157 Courtesy of the Library of Congress.

158 Photograph by Fort Worth Star Telegram, Rayburn (Sam) Papers, di_08253, The Dolph Briscoe Center for American History, The University of Texas at Austin.

159 (*top*) W. R. Poage Legislative Library, Baylor University.

159 (*bottom*) UT Arlington.

160 LBJ Library photo by unknown.

161 LBJ Library photo by Yoichi Okamoto.

162 (*top*) Gonzalez (Henry B.) Papers, di_08306, The Dolph Briscoe Center for American History, The University of Texas at Austin.

162 (*bottom*) Photograph by Russell Lee, Lee (Russell W.) Papers, di_08302, The Dolph Briscoe Center for American History, The University of Texas at Austin.

163 Gonzalez (Henry B.) Collection, di_08307, The Dolph Briscoe Center for American History, The University of Texas at Austin.

164 Wilson (Will R., Jr.) Papers, di_08285, The Dolph Briscoe Center for American History, The University of Texas at Austin.

165 Wilson (Will R., Jr.) Papers, di_08325, The Dolph Briscoe Center for American History, The University of Texas at Austin.

166 ND-46-269-01, Austin History Center, Austin Public Library.

167 (*top*) University of Texas San Antonio Libraries Special Collections.

167 (*middle*) Photography by Russell Lee, Lee (Russell W.) Papers, di_08288, The Dolph Briscoe Center for American History, The University of Texas at Austin.

167 (*bottom*) Photography by Russell Lee, Lee (Russell W.) Papers, The Dolph Briscoe Center for American History, The University of Texas at Austin.

168 Charles C. Bailey Collection.

169 University of Texas San Antonio Libraries Special Collections.

170 (*left*) Photograph by Russell Lee, Magnum Photo, Lee (Russell W.) Papers, di_08295, The Dolph Briscoe Center for American History, The University of Texas at Austin.

170 (*right*) Photograph by Russell Lee, Magnum Photo, Lee (Russell W.) Papers, di_08298, The Dolph Briscoe Center for American History, The University of Texas at Austin.

171 (*top*) Photograph by Russell Lee, Magnum Photo, Lee (Russell W.) Papers, di_08296, The Dolph Briscoe Center for American History, The University of Texas at Austin.

171 (*middle*) Photograph by Russell Lee, Magnum Photo, Lee (Russell W.) Papers, di_08297, The Dolph Briscoe Center for American History, The University of Texas at Austin.

171 (*bottom*) Photograph by Russell Lee, Magnum Photo, Lee (Russell W.) Papers, di_08300, The Dolph Briscoe Center for American History, The University of Texas at Austin.

172 (*top*) University of Texas San Antonio Libraries Special Collections.

172 (*bottom*) Hardin-Simmons University.

173 (*top*) UT Arlington.

173 (*bottom*) Houston Metropolitan Research Center. Houston Public Library, Houston, TX; Special Collections; RGAG 1558.

174 (*top*) W. R. Poage Legislative Library, Baylor University.

174 (*bottom*) ND-58-262-01, Austin History Center, Austin Public Library.

175 From the Collections of the Texas/Dallas History Archives Division, Dallas Public Library.

176 (*top*) Photograph by Russell Lee, Lee (Russell W.) Papers, di_08289, The Dolph Briscoe Center for American History, The University of Texas at Austin.

176 (*bottom*) Photograph by Russell Lee, Lee (Russell W.) Papers, di_08303, The Dolph Briscoe Center for American History, The University of Texas at Austin.

177 Yarborough (Ralph) Papers, di_08274, The Dolph Briscoe Center for American History, The University of Texas at Austin.

178 (*top*) Yarborough (Ralph) Papers, di_08273, The Dolph Briscoe Center for American History, The University of Texas at Austin.

178 (*bottom*) Yarborough (Ralph) Papers, di_08272, The Dolph Briscoe Center for American History, The University of Texas at Austin.

179 Yarborough (Ralph) Papers, di_08269, The Dolph Briscoe Center for American History, The University of Texas at Austin.

180 Photograph by Russell Lee, Lee (Russell W.) Papers, di_08286, The Dolph Briscoe Center for American History, The University of Texas at Austin.

181 Photograph by Russell Lee, Lee (Russell W.) Papers, di_08287, The Dolph Briscoe Center for American History, The University of Texas at Austin.

182 W. R. Poage Legislative Library, Baylor University.

183 (*top*) UT Arlington.

183 (*bottom*) UT Arlington.

184 UT Arlington.

185 Photograph by Russell Lee, Lee (Russell W.) Papers, di_08304, The Dolph Briscoe Center for American History, The University of Texas at Austin.

186 Southwestern University.

187 (*top*) Southwestern University.

187 (*bottom*) Southwestern University.

188 Rayburn (Sam) Papers, di_08249, The Dolph Briscoe Center for American History, The University of Texas at Austin.

189 Yarborough (Ralph) Papers, di_08268, The Dolph Briscoe Center for American History, The University of Texas at Austin.

190 Port Arthur Library.

191 From the Collections of the Texas/Dallas History Archives Division, Dallas Public Library.

192 (*top*) Dolores Thomas, Wilson Campaign Manage. Courtesy of Stephen F. Austin East Texas Research Center.

192 (*bottom*) Dolores Thomas, Wilson Campaign Manage. Courtesy of Stephen F. Austin East Texas Research Center.

193 (*top*) Courtesy of Texas State Library & Archives Commission.

193 (*bottom*) Photograph by Houston Chronicle, Bentsen (Lloyd) Papers, di_08280, The Dolph Briscoe Center for American History, The University of Texas at Austin.

194 (*top*) Bentsen (Lloyd) Papers, di_08275, The Dolph Briscoe Center for American History, The University of Texas at Austin.

194 (*bottom left*) Bentsen (Lloyd) Papers, di_08279, The Dolph Briscoe Center for American History, The University of Texas at Austin.

194 (*bottom right*) Photograph by U.S. Senate Photograph, Bentsen (Lloyd) Papers, di_08278, The Dolph Briscoe Center for American History, The University of Texas at Austin.

195 (*top*) Photograph by Kerr Snyder and Associates, Donna, Texas, Bentsen (Lloyd) Papers, di_08277, The Dolph Briscoe Center for American History, The University of Texas at Austin.

195 (*bottom*) Photograph by Bob Struby Photography, McAllen, Texas, Bentsen (Lloyd) Papers, di_08276, The Dolph Briscoe Center for American History, The University of Texas at Austin.

196 Charles C. Bailey Collection.

197 Charles C. Bailey Collection.

198 (*top*) Farenthold (Frances Tarlton) Papers, di_08323, The Dolph Briscoe Center for American History, The University of Texas at Austin.

198 (*bottom*) Farenthold (Frances Tarlton) Papers, di_08322, The Dolph Briscoe Center for American History, The University of Texas at Austin.

199 (*top*) W. R. Poage Legislative Library, Baylor University.

199 (*bottom*) W. R. Poage Legislative Library, Baylor University.

200 LBJ Library photo by Yoichi Okamoto.

201 Photograph by Linda Palmer, Hobby (William, Sr.) Family Papers, di_08260, The Dolph Briscoe Center for American History, The University of Texas at Austin.

202 (*top*) Houston Metropolitan Research Center. Houston Public Library, Houston, TX; RG D 0006N-5885 (*Houston Post*).

202 (*bottom*) George Bush Presidential Library and Museum.

203 W. R. Poage Legislative Library, Baylor University.

204 (*top*) From the Collections of the Texas/Dallas History Archives Division, Dallas Public Library.

204 (*bottom*) Hobby (William, Sr.) Family Papers, di_08258, The Dolph Briscoe Center for American History, The University of Texas at Austin.

205 (*top*) From the Collections of the Texas/Dallas History Archives Division, Dallas Public Library.

205 (*bottom*) Photographed by Larry Murphy, Hobby (William P., Sr.) Family Papers, di_05952, The Dolph Briscoe Center for American History, The University of Texas at Austin.

206 Courtesy: Jimmy Carter Library.

207 (*top*) Faulk (John Henry) Papers, di_08262, The Dolph Briscoe Center for American History, The University of Texas at Austin.

207 (*bottom*) Photograph by Alan Pogue, Faulk (John Henry) Papers, di_08324, The Dolph Briscoe Center for American History, The University of Texas at Austin.

208 (*top*) Richards (Ann W.) Papers, di_07759, The Dolph Briscoe Center for American History, The University of Texas at Austin.

208 (*bottom*) Richards (Ann W.) Papers, di_08293, The Dolph Briscoe Center for American History, The University of Texas at Austin.

209 (*top*) Courtesy of Texas State Library & Archives Commission.

209 (*bottom*) Richards (Ann W.) Papers, di_07744, The Dolph Briscoe Center for American History, The University of Texas at Austin.

210 (*top*) Courtesy of Texas State Library & Archives Commission.

210 (*bottom*) Courtesy of East Texas Research Center, Stephen F. Austin State University.

211 Photo courtesy of Southwest Collection/Special Collections Library, Texas Tech University, Lubbock, Texas.

212 (*top*) Associated Press.

212 (*bottom*) Courtesy of Texas State Library & Archives Commission.

213 (*top*) Courtesy of the Office of the Governor.

213 (*bottom*) Courtesy of the Office of the Governor.

INDEX

Campbell, Tom, 76
Carter, Amon, Sr., 105, 106, 117, 159
Carter, Jimmy, 206
Casey, Bob, 147
Cass County (Texas), 122
Cavazos, Eddie, 144
Chandler (Texas), 177
Charlie Wilson's War, 192
Cherokee War, 27
Chilton, Horace, 58
Cisneros, Henry, 146
Civilian Conservation Corps (CCC), 105
civil rights, 139, 152, 177; in Texas, 140, 141–143, 144
Civil Rights Act of 1957, 142
Civil War, 2, 14, 26, 29, 33, 36, 39, 40, 42, 43, 72; and photography, 12–13
Clark, Edward, 2, 12
Clark, George, 46, 53, 54
Clark, Ramsey, 78, 157
Clark, Thomas C., 78, 156–157
Cleburne (Texas), 77
Clements, William P. "Bill," Jr., 146, 204, 205
Clinton, Bill, 147, 194, 202
Coke, Richard, 13, 39, 40, 53
College Station (Texas), 147
Collin County (Texas), 37
Collins, Jim, 146
Colquitt, Oscar Branch, 78, 80–81
Comanche, 43
Communist Party, 108, 124
Confederate army, 26, 52; uniform of, 15, 36, 41; veterans group, 69
Confederate States of America (or Confederacy), 3, 12, 33, 35, 38, 45
Connally, John B., 140, 143–144, 183, 184, 191
Connally, Tom, 90, 94, 128
Constitution of 1876, 13, 39, 89
Cornyn, John, 147
Corpus Christi (Texas), 144, 198
Corsicana (Texas), 59, 151
Cos, Martín Perfecto de, 27
Cotulla (Texas), 152
Craddick, Tom, 146
Crane, Martin McNulty, 77
Crawford, William, 4
Crisp, Charles, 59
Crockett, David (Davy), 11, 127
Cryer, Bill, 8
Cuero Turkey Trot, 81
Culberson, Charles, 33, 46, 64, 72, 75, 80
Culberson, David, 64

Cumberland Law School (Tennessee), 122, 131
Cunningham, Minnie Fisher, ix, 48, 94, 145

Dale (Texas), 206
Dallas (Texas), 6, 118, 129, 135, 157, 164, 175, 204, 212; aircraft manufacturing in, 107; campaigning in, 153; Kennedy assassination in, 143, 183, 184; minority politicians from, 144, 145; race riots in, 47; Republicans from, 146; State Democratic Convention in, 154; Texas Centennial Exposition in, 106; United Press International in, 5; voting in, 88
Dallas County (Texas), 120
Dallas Morning News, 47, 106
Daniel, Jean, 174
Daniel, Price, 174, 175
Daniel, Price, Jr., 174
Davidson, A. B., 81
Davis, Arlon B. "Cyclone," 180–181
Davis, Edmund J., 12, 13, 29, 39, 40, 41, 72
Davis, James H. "Cyclone," 46, 79
Davis, Jefferson, 26, 33, 35
Dayton (Texas), 174
Dealey, Samuel D., 107
Dee, Sandra, 174
de la Garza, Kika, 146, 147
DeLay, Tom, 147
Delco, Wilhelmina, 145
Del Rio (Texas), 74
Democrats/Democratic Party, 47, 58, 59, 67, 75, 91, 104, 120, 122, 125, 126, 128, 159, 161, 163, 166, 170, 175, 177, 185, 188, 192, 199, 200, 203, 206; and the end of Reconstruction in Texas, 13; and Martin Dies Jr., 108, 124; and National Conventions, 145, 193; in presidential elections, 140, 183, 194, 202; in primaries, 48, 90, 94, 143, 154, 191, 197; during Prohibition, 48; and State Conventions, 154, 169; in Texas, 26, 46, 48, 53, 140–141, 143, 144, 146, 170, 204, 213; and William Jennings Bryan, 56, 57; and women, 48, 93, 144, 146
Denison (Texas), 107, 173
DeRyee, William, 2, 4
Dewey, Tom, 140, 159
De Zavala, Adina, 111
De Zavala, Lorenzo, 12
Díaz, Porfirio, 74
Dies, Martin, Jr., 107–108, 124, 160
"Dirty Thirty," 144, 198

Dixiecrat Party, 140
Dobie, J. Frank, 140
Doughton, Robert, 122
Driscoll, Clara, 111

Eastland (Texas), 65
East Texas, 16, 52, 54, 108, 116, 122, 160, 166, 180, 192; campaigning in, 119, 176; native Americans in, 18; oil fields in, 137; political bosses in, 141; race riots in, 47; segregation in, 142–143
Eckhardt, Bob, 147, 185
Edom, Cliff, 6
Edwards, Chet, 147
Eighteenth Amendment, 48, 91, 145
Eisenhower, Dwight D., 107, 116, 140, 166, 172–173
El Campo (Texas), 101
El Paso (Texas), 70, 71, 74, 144, 146, 149, 160
Elroy (Texas), 170
English, Carolene, 182
Exxon, 50

Farenthold, Frances "Sissy," 144–145, 191, 198
Farmer's Alliance, 46
Farmersville (Texas), 107
Faulk, John Henry, 207
Felig, Arthur ("Weegee"), 5
Ferguson, James Edward "Pa," 48, 50–51, 77, 82–85, 87, 90; and the Ferguson machine, 99
Ferguson, Miriam A. Wallace "Ma," 50–51, 82, 84, 85, 100, 146, 167, 208; and the Ferguson machine, 99
Ferguson Forum, 50
Fields, Jack, 185
Floresville (Texas), 167, 184
Ford, John Salmon "Rip," 13, 41
Fort Worth (Texas), 63, 72, 123, 136, 146, 188, 213; American Air Force Training Command in, 107; and Amon Carter Sr., 105, 106, 117, 159; Blackstone Hotel, 154; Burris Mills, 135; and the first live television broadcast in Texas, 158; Hotel Texas, 183; photography in, 5; T&P Station, 159
Fort Worth Star-Telegram, 103

Galveston (Texas), 55, 94, 210
Garner, John Nance, 49, 104, 106, 112–115, 121, 136, 140, 159
Garrett, Clyde, 160